ARTIST'S
DRAWING
TECHNIQUES

ARTIST'S
DRAWING
TECHNIQUES

 Penguin
Random
House

Senior Editor	Georgina Palffy
Senior Art Editor	Saffron Stocker
Editors	Nikki Sims, Katie Hardwicke
US Editors	Megan Douglass, Michelle Melani
Editorial Assistant	Alice Horne
Designers	Emma Forge, Tom Forge, Helen Garvey, Vanessa Hamilton, Simon Murrell
Jacket Designer	Steven Marsden
Jackets Coordinator	Laura Bithell
Producer (Pre-production)	Catherine Williams
Senior Producer	Ché Creasey
Creative Technical Support	Sonia Charbonnier, Tom Morse
DTP Designers	Satish Chandra Gaur, Rajdeep Singh, Anurag Trivedi
Pre-Production Manager	Sunil Sharma
Managing Editor	Dawn Henderson
Managing Art Editor	Marianne Markham
Art Director	Maxine Pedliham
Publishing Director	Mary-Clare Jerram

First American Edition, 2017
Published in the United States by DK Publishing
345 Hudson Street, New York, New York 10014

Copyright © 2017 Dorling Kindersley Limited
DK, a Division of Penguin Random House LLC
17 18 19 20 21 10 9 8 7 6 5 4 3 2 1
001–294124–Aug/2017

A catalog record for this book is available from the
Library of Congress.
ISBN 978-1-4654-6174-2

DK books are available at special discounts when purchased
in bulk for sales promotions, premiums, fund-raising, or
educational use. For details, contact: DK Publishing Special
Markets, 345 Hudson Street, New York, New York 10014
SpecialSales@dk.com
Printed and bound in China

A WORLD OF IDEAS:
SEE ALL THERE IS TO KNOW

www.dk.com

Contents

The basics

Pencil

1 Beginner techniques

2 Intermediate techniques

3 Advanced techniques

Charcoal

1 Beginner techniques

2 Intermediate techniques

3 Advanced techniques

Pen and ink

Colored pencil

Pastels

1 Beginner techniques

2 Intermediate techniques

3 Advanced techniques

The basics

Getting started

GRAB A PENCIL AND PAPER AND START DRAWING

Drawing is the basis from which we start all artworks. This primary discipline improves with practice and requires just a pencil and paper. The urge to record the world around us is age-old. Whether a drawing is a natural representation or a more expressive and abstract creation is up to you and what interests and excites you. Drawing opens up opportunities to become confident in composing scenes, choosing subjects, and creating finished artworks.

Building confidence

There is no wrong or right way to draw (just your way), and everyone can draw. It may well be that you haven't done much drawing since you were a child, but children draw without hesitation and with much enjoyment—you need to know that it's possible to improve and to enjoy the activity of drawing.

Whether you're a beginner or a more established artist, everyone can improve and build upon skills they already have. For those who have not drawn for a while, starting to draw can be daunting. If you can overcome any worries, such as finding your own style and learning to get the best from your subject matter, drawing will be a rewarding and inspiring exercise.

Drawing is a discipline that benefits from practice, and you will certainly find your confidence grows with the more drawing you can do. Drawing does not have to be purely about accuracy (though measuring is a part of it, see pp.20–21); it's a representation of how you see the world and capturing what's vital about that—the colors, the atmosphere, the excitement—for the viewer. This book is packed with techniques to help you improve—whatever your level—and explore the world of drawing, from the monochromatic pencil or charcoal to the multicolored world of pastel.

Choosing a subject

Where do you begin? All you need is a pencil and paper and something to draw. Take a look around at what is available to you within your own domestic setting. Drawing objects found at home can be a useful starting point. To create an interesting drawing, you

Monochromatic media
Pencil is often the first medium that artists turn to. Affordable and readily available, pencil is effective for quick sketches, line drawing, and tonal work—as here, using hatching and crosshatching to build form.

Experimental drawing

You may feel confident and happy with your medium of choice, whatever that is, but trying new media opens up another realm of possibilities in terms of quality of line, tonal shading, and emphasis.

need to find a subject that interests and inspires you. Drawing a favorite pair of shoes or a cup and saucer may appeal to some artists, while others may prefer to seek out something natural and organic, whether that be the classic still life arrangement of a bowl of fruit, or a rural landscape. If you enjoy the process of drawing the holes in a colander, for instance, then the resulting image will be joyful, too.

But even when you find a subject that's enjoyable to draw, it doesn't mean it's necessarily easy. Looking—really looking—at the world and translating this to the page takes time, energy, and practice. Improve your skills and explore different media using the many techniques and advice in this book, and the rewards are boundless.

Realism and representation

Before you start to draw, you will want to consider the intention of your drawing—is your aim to portray your subject in a lifelike manner, to record a visual memory, or to play with reality in some way?

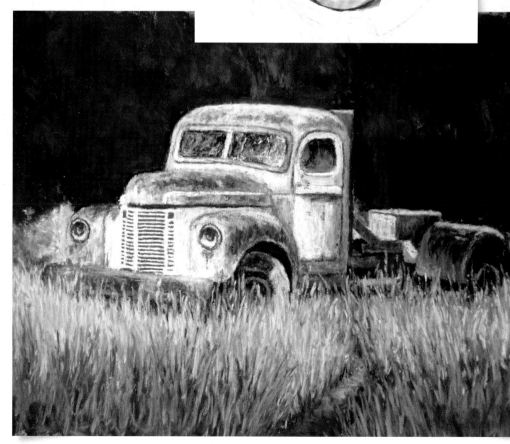

Embracing color

Whether you choose pastel, colored pencil, or pen and ink, the world of color is at your fingertips. See how working with color can push your drawing skills and creative expression in new directions.

Aspects of drawing

SOME BASIC ELEMENTS FOR SUCCESSFUL ARTWORK

Whether you're embarking on a series of quick sketches or a long and detailed still-life study, it pays to consider a number of basic elements—all of which will contribute to the overall effect of your work. Being aware of each of these elements will help you to develop your own style, be it realistic and representational or abstract and expressive.

Composition

This is one of the most important considerations of your work. Composition is how the elements of a drawing are arranged within the picture plane to create varied effects. Using compositional devices, such as cropping, viewpoint, and perspective (see pp.18–19), creates focus and gives you control over a composition. Rearrange still-life subjects or edit picture elements to achieve the perfect harmony.

Focused line

Develop your mark-making skills to create varied types of line, to define shapes, use as outlines, or use as guides. More controlled drawing creates a more static artwork style.

Gestural line

Quick gestural sketches (great in charcoal or soft pencil) can be developed further, or left as they are, capturing the essence of a subject and energy of the moment in just a few lines.

Realistic representation Abstract interpretation

> "The true joy
> of drawing is that
> there is no correct style,
> everyone has their own
> interpretation."

Expression

The true joy of drawing is that there is no correct style, everyone has their own interpretation. An understanding of all the aspects covered here will aid you as an artist, but it is your personal response and means of representation that make it individual to you. Detailed and controlled work is as valid as a gestural expressionistic approach.

Tone

Being able to identify strong contrasts between dark and light areas of a drawing will bring your subject matter to life. As well as suggesting mood, emphasizing tonal differences confers a 3-D element. In fact, you can suggest form solely through the use of tone.

Color

You can introduce the vibrancy of color into your drawings through various media, from ink to pastels. Not only can color be used to represent what you see in real life, it can add mood, expression, and drama. Using color confidently can be useful in composition, leading the eye and creating points of interest.

Drawing from observation and imagination

EXPLORING DIFFERENT AVENUES TO FIND INTERESTING SUBJECTS

Going out and about to draw from life can be hugely rewarding, but focusing on an interior scene or domestic setting can be equally useful—it's finding what interests you. Gathering information from photos may be the only way to draw your chosen subject, but as long as you're aware of the downsides, you can draw interesting and amazing artworks.

DRAWING FROM PRIMARY SOURCES

Drawing the world around you, be it in a life-drawing class or outdoors, enables you to see and capture the shapes and forms of life. To do this, you need to look hard and work fast to capture the salient details. The more controlled drawing of a still life, however, gives you time to observe texture, outline, and color.

Different poses offer new and sometimes challenging viewpoints

Quick sketching sharpens observational skills

Loose lines give energy to a drawing

Drawing from life—pros and cons

PROS	CONS
■ Allows quick sketches	■ Time constraints—often have to work fast to capture moving people and deal with weather
■ Offers good practice for gestural lines	■ Requires commitment
■ A huge variety of locations	■ Can be slightly intimidating to draw in public arenas
■ Potential for change of scale and medium	

DRAWING FROM SECONDARY SOURCES

Using a camera to record details while you're out and about or to capture a scene in a fast-moving situation is a bonus when you return to a drawing later on. Collecting together images that interest you—from photos, magazines, or online— is also a great way of solidifying inspiration and completing interesting drawings. Such a scrapbook can become a useful reference to work in conjunction with your sketchbooks (see pp.22–23). Do be aware that in some circumstances you may need to ask permission to take pictures.

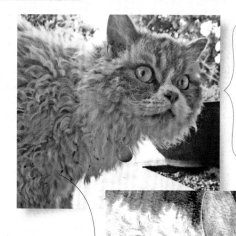

Drawing from photographs
Using your own photos of memorable events, family members, or pets can be a great way to create unique drawings. Such photos can inform sketches drawn from life.

Drawing from references—pros and cons

PROS	CONS
■ Offers detailed information from sources not easily accessible (such as wild animals)	■ Flat, less definition in print or photos
■ The variety of images	■ Copyright issues, if a direct copy
■ Widens range of subject matter	■ Can discourage personal investigation and going out and about

It's easier to capture the furry texture while the cat is still, in the photo

Ink works well as a medium to suggest softness

COMBINING THE TWO

Drawing from life with back-up sketches or photos is an ideal approach for many artists. Not all artists use photos, but many use preliminary sketches to complete a drawing's details and their imagination can fill the gaps. Even if you're drawing an imaginary scene, grounding it in details you've observed makes it more believable.

Building character from an early sketch
Certain faces will stand out from the crowd, so make rough sketches or take photos so that you can include such characters later on.

Locating people
People are often on the move, so sketching rough positions, of customers at a café, for instance, allows you to complete the details in a drawing later. Such thumbnail sketches are useful in deciding on the final composition, too.

Drawing inside and outside

HOW YOUR SURROUNDINGS INFLUENCE YOUR DRAWING

It is undeniable that drawing in different locations can benefit your drawing confidence. Drawing inside offers consistency, control, and time. Working outside brings with it all kinds of challenges and demands that build on your skills and opens up new areas of subject matter. Outdoor scenes can be transitory, overwhelming, and at the mercy of weather changes, but can offer amazing views, very different environments, and useful references.

DRAWING INDOORS

Few people have the luxury of a studio, so most likely you will be working at a kitchen table or desk within your home. Interiors have their advantages due to a more controlled environment: a consistency of light and of subject matter. If you can allocate a more permanent corner to work in—with reference materials pinned up on a board and pens and brushes within easy reach—you'll find you can seize those spare moments to develop or finish work and be creative more often.

Drawing inside—pros and cons

PROS	CONS
■ Offers highly controlled conditions, including lighting	■ Can encroach on your daily living space
■ Can potentially leave a project set up in situ and finish later	■ Lots of equipment needs storing away and getting out each time
■ A range of subject matter easily at hand	■ Can be solitary if drawing alone

Multicolored pens fit neatly in a jar

Keep pencils in the box for easy storage

Organize materials within the extending drawers

Studio setup
An easel can be invaluable when you need to work on an upright surface or fix a position in terms of light. Work can be left on the easel—and perused from time to time—for finishing up later.

Organize to maximize drawing time
Art tool boxes offer plenty of storage for materials and equipment. Once they're open, you're ready to draw.

Small sketchbooks can fit in the tool box as well

DRAWING IN A GROUP OR SOLO

Choosing whether to draw alone or with other people—indoors or outdoors—is a matter of personal preference. Drawing lends itself to solitary working, and learning to draw by yourself can be productive. Sketching a group of objects or a view in a quiet moment will build on your body of work. Conversely, the dynamics of a group throw up ideas for discussion, support, and suggestions on how to develop your practice and flourish as an artist. Life-drawing classes can be the catalyst for getting you started. The commitment of attending a class can spur you on, with a tutor on hand to direct your observation. Most communities have a variety of art groups led by an artist who can introduce you to basic drawing exercises and advise on media. It can be a great place to experiment with materials before investing in products.

DRAWING OUTDOORS

The romantic image of an artist setting up an easel and drawing from nature is a familiar one, but for drawing purposes you can travel quite lightly. A sketchbook, plus a selection of pencils and an eraser, fit easily into a bag. If you don't use a hardback sketchbook, then try out a small drawing board with clips to hold the paper. A folding stool is handy, too. Depending on what you wish to draw, try a few loose sketches from different viewpoints before committing to a longer drawing. Your subject matter might dictate the time frame. For example, animals will constantly move, requiring quicker, looser drawings; backup photography in this case is essential.

Drawing outside—pros and cons

PROS	CONS
▪ Wide variety of views or scenes	▪ At the mercy of changing weather and transient subject matter
▪ Great for loosening up and practicing quick sketches	▪ Awkward public spaces
▪ Can be a social activity	▪ Varying light levels or seasonal changes

Folding stool

Portable equipment

It's good to be prepared so you avoid wasting opportunities when drawing outside. Rubber bands come in handy (to hold sketchbook pages on a windy day), a compact pencil case offers the essentials, and a folding stool is a welcome seat.

Folding easel

Easels that fold for ease of carrying and other items of transportable equipment come into their own for holding materials and keeping paper dry and secure.

Lightweight roll-up pencil carrier

Composition

POINTERS TO HELP IMPROVE YOUR DRAWINGS

How objects sit within a drawing or pictorial space—the arrangement of its elements—is something that you will train your eye to see. It is what gives a picture its purpose. It will depend, to some degree, on the subject matter: for instance, you can arrange a still life just so, layering objects one in front of the other and selecting height or width to fit an ideal composition but when it comes to an outside environment, being able to choose a view may be more challenging. There are, however, still "rules" to consider.

CROPPING OPTIONS

How you frame your view can change the impact of your drawing's composition by creating different focal points and cropping out distractions. When drawing from a photo, you can play about with varied views by making a simple tool—two L-shaped pieces of black or neutral card. Lay these pieces on your image to discover the best and most interesting format for your composition.

The rule of thirds
This "rule" helps you to create a balanced image. With time, it'll become second nature. Divide your picture plane equally into thirds—three columns and three rows—to create a nine-square grid. Balance comes where the horizon in an image is either a third up from the bottom or a third down from the top.

Square
A great way to focus in on a feature and cut out superfluous details is to use a square crop. Still-life compositions work well in this format, as do scenes with an off-center focus.

Landscape
Perfect for outdoor scenes offering a wider expanse, this orientation also works well when the focus appears stretched along a horizontal plane.

Portrait
Vertical objects lend themselves to this crop. Portrait crops suit figures, architecture, and close-ups.

CHANGING VIEWPOINTS

Deciding where to draw your object from can dramatically change the impact of your work. In certain scenes, such as outdoor locations, the horizon dictates the most natural viewpoint. Without a horizon, the most natural view will be your eye level, but it's interesting to explore drawing from other angles to see if it suggests a more dynamic focus.

Bird's-eye view
Looking at objects from above, often used with landscapes or aerial photography. Perfect for creating a sense of height.

Eye-level view
Eye level is the meeting of the horizon with the ground. Most pictures are drawn looking in front of you—a natural view.

Worm's-eye view
The most exaggerated view, looking up from the ground to an object above. Lends itself to architecture and life drawing.

A SUCCESSFUL COMPOSITION

When starting to compose drawings, it's useful to discover pointers that will help you create a successful still life or select a scene outdoors that will translate well to the page. When drawing outdoors, it's often the horizon and the landscape that will help define your composition. But whether you're drawing indoor or outdoor scenes, be aware of these three types of composition—S-, V-, and L-shaped.

The plant in the urn makes the upright of the "L"

S-shaped composition
Most commonly used in landscapes, the aim is to use the sinuous line to lead your eye from the end of the "S" to a more distant object.

V-shaped composition
It works best as a flattened triangular shape, as in lines of perspective (see pp.20–21), creating a natural dynamic that leads to a focal point.

L-shaped composition
Look for a strong vertical to frame your picture on one side (it doesn't have to be the left-hand side) and balance this with a horizontal feature, sitting at right angles, leading the eye across and toward the opposite side of the picture.

Perspective and measuring

PORTRAYING REALISTIC SCALE AND PROPORTIONS

You'll be surprised how you can naturally read perspective and use it skilfully within your artwork; it is the means to placing objects within the space you are drawing. Being aware of how linear perspective works will help you recreate depth and three-dimensional space. Knowing how to measure objects from real life to make an accurate representation of their proportions will result in pleasing and balanced drawings.

LINEAR PERSPECTIVE

It's important to know that all parallel lines appear to converge at the same vanishing point on the horizon. If you were to draw lines on the tops and bases of these beach huts, for example, you'll see that these two lines converge as they move away from you. Linear perspective means that objects closest to you appear largest and diminish in size as they move into the distance.

A line of perspective

The fingertips appear larger near the picture plane

Vanishing point
Lines of perspective converge on the horizon at a vanishing point. The size of objects diminishes along the lines.

Simple verticals
Because of the arrangement of the beach huts, the vertical lines are drawn as parallel, which reinforces the viewpoint.

Foreshortening
This can prove a hard view to get right; measuring with a pencil (see opposite) will certainly prove invaluable. An object's perspective becomes exaggerated when you sit too close to it. Foreshortening is often seen with figure drawing or interiors, where elements mislead your eye and the natural understanding of what you see.

Learning some basics about what proportions a figure is made up of or how to measure sizes of nearby objects with a pencil may take practice to master, but soon they'll become completely natural parts of your drawing process. Over time you may be able to read the lay of the land by eye through roughly plotting lines and measurements, but it can be a reassuring way to get more accurate verticals and horizontals placed first before embarking on a concentrated piece of work. By sketching out the main placements of objects, you'll be sure to avoid any crashing in the middle of the page or out-of-scale details.

A head makes a great unit of scale

An arm measures roughly three "heads" from shoulder to fingertip

A head as a unit of scale
To work within the correct proportions, particularly for life drawing, the head can be a super useful unit of measuring. An average adult will stand at 7–8 heads tall. Using a pencil as a measuring tool (see below), work out the division of units within the body. You will also be able to compare the relative sizes of the torso and limbs, leading to a greater confidence in sketching.

■ Using a pencil
Hold your pencil out in front of you with a straight arm. Align the top of the pencil with the top of the line to be measured. Close one eye and use your thumb as a sliding level. Move it up and down the pencil until it matches the length of the line. Hold your thumb in place and transfer the pencil to the page, laying the pencil on the correct line of your drawing and adjust to match.

The thumb slides to measure the length of the line

The same length of pencil is drawn on the page

Measurements are taken of all other lines

Comparative measurement
By choosing one line to use as a measure, you can build the drawing in the right proportions by measuring how other lines relate to the first: half as long or twice as long, for instance.

Measuring angles
Use a pencil in a similar way to above, but this time turn the hand so the pencil is parallel to the edge in question. For instance, with pencil in hand, assess the slope of a hut's roof then transfer it to your drawing. Now, quickly sketch vertical edges of the widths of the huts. Finding angles this way makes it easy to see how the angles change throughout a scene—and to draw them!

Measure some angles against verticals

Angles can be assessed against horizontals, too

Sketchbooks

A WONDERFUL RESOURCE FOR DRAWING

A sketchbook is one of the most important and much-loved pieces of drawing material. Get into the habit of carrying a small sketchbook with you at all times and jot down ideas or draw things from your everyday life. Any doodles and musings might be the germ of a bigger idea.

The purpose of a sketchbook

A sketchbook acts as an extension of your thoughts, allowing you to commit ideas to memory: details you noticed at an art exhibition, interesting cloud shapes, or sketches of people running in a park. You can work on ideas at home and take time to experiment with materials or different kinds of line without feeling the need for everything to look well formed or perfect. No sketchbook page needs to be a work of art in itself; what a sketchbook needs to be is a useful record of a subject for you, so you can recall details later or rely on sketches or photos stuck in for extra material. So, sketchbooks become highly personal records of those things that profit your work and inform you as an artist.

Sketching people
The more you draw, the better your drawings will become. Whether you choose to capture moving figures or a still sculpture, each time you draw the human form, it'll be improved.

Your choice of sketchbook size may change over time as your style of work becomes more confident, but certainly a 5.5 x 8.5-inch ringbound with unruled, heavyweight paper fits easily into a bag. If you want to work at a bigger scale, sketchbooks come in all manner of sizes and formats (square, landscape, portrait, and even concertina versions). Buy good-quality sketchbooks, which give a finished feel, for translating ideas to a more polished artwork.

On the move
Wherever you're sitting still, there's an opportunity to be drawing. In a train, bus, plane, or (as here) a car, practice your observational skills and capture the experience of travel.

Around the home

Interesting subjects can present wherever you are, including at home. As you draw more, you'll start to notice more; beauty can appear in the most mundane of places.

How to use a sketchbook

There is no right or wrong way to use a sketchbook; feel free to use whatever medium, scale, or imagery you like. Use the pages to draw out your ideas; there is no reason to handle the page in the conventional way. If your drawing goes over the center or off the page, so be it. They can be useful as notebooks and scrapbooks. Many artists stick in significant photos, collages, or cuttings to aid their drawing work. Some artists write accompanying notes with their sketches, containing additional relevant information, or sometimes just random musings—a telephone number you've spotted while out and about, or a local art-supplies shop.

If you are using wet materials, let them dry before shutting your book. Always fix charcoal or pastel work with fixative, or layer tissue between the paper sheets, so your work doesn't spoil. The main idea is to

On cultural visits

There are plenty of opportunities (and needs) to sit down on visits to galleries and museums. Carry your sketchbook and pen to capture buildings of note.

On vacation

A harbor may offer a welcome change of scene. Don't worry about drawing across the middle of the pages to complete the scene.

enjoy using and developing your sketchbooks; they'll become an ever more interesting record of your artistic progression.

> "There is **no right or wrong way to use a sketchbook.** You can use whatever **medium, scale, or imagery** you like."

Vocabulary of color

UNDERSTANDING THE BASICS OF COLOR AND HOW TO USE IT

Drawing is often thought of in more monochromatic terms—certainly learning and enjoying working in black and white will significantly help your understanding of tonal and color work. Once you have become more familiar with the color terms and range of palettes, you can begin to transform your artworks and expand your enjoyment of using other materials.

◼ The color wheel

The color wheel, as shown here, is one representation of color and color theory. It illustrates all the basic colors; think of a rainbow. It also shows how colors are related to one another (and what happens when you mix them together) and demonstrates primary, secondary, and tertiary colors.

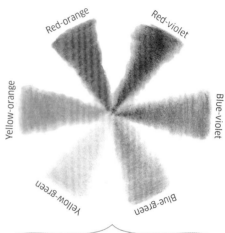

Primary colors

Red, yellow, and blue are primary colors. These are colors you cannot create using other colors. But you can mix primary colors together to create all other hues.

Secondary colors

If you mix one primary color with another, you create a secondary color. For instance, blue and yellow make green, red and blue make violet, and yellow and red make orange.

Tertiary colors

Mix a secondary and a primary color and you'll create a tertiary color. For example, a red (primary) mixed with a violet (secondary) becomes a red-violet (tertiary).

◼ Describing colors

You can describe any color using three basic elements: saturation, hue, and value. Adjusting hue with white or black creates tints and shades.

Saturation

This refers to the richness of a pure color. Above, the color goes from low saturation (left) to high.

Hue

A hue is the name given to a color on the color spectrum. Basically, it's one of the colors or combinations of the primary, secondary, and tertiary colors.

Value

Value (or tone) refers to the measure of the lightness or darkness of a color. Colored drawings benefit greatly from using a good range of tonal values throughout.

The same blue with added white

Tint

Colors that have been mixed with white are known at tints or graduations. As increasing amounts of white are added, the original color becomes paler.

Dulling down the blue with black

Shade

Colors that are mixed with black are called shades. Black is always the dominant color, but it can help to create a range of different strengths from one color.

■ Color temperature

Using color opens up new opportunities of investigating your drawing skills. Trying variations is key; don't be afraid to resist naturalistic color, for instance, and look at distorting colors. Experimenting with combining media—ink over a one-color wash or pastels over colored pencils—can be a fabulous way to create luminosity. Being aware of a color's temperature can help you create the right mood and palette.

Warm colors
The hues within the yellow, orange, and red spectrum are generally referred to as warm colors. They're more reminiscent of natural light and heat differences. Such colors naturally advance in a scene.

Cool colors
The remaining half of the color wheel—violet, blue, and green—belong to the cooler color temperatures. Such colors are perfect for creating more soothing and calming elements within your pictures.

| Warm blue | Cool blue | Warm yellow | Cool yellow | Warm red | Cool red |

Versions of a color
A color, such as yellow, has a multitude of hues that fit under that umbrella term, some of which will be warm and some cool. Here we show two contrasting versions of blue, yellow, and red hues.

■ The basics of value

Value and tone both describe the lightness and darkness of a hue; we tend to talk of tone in monochromatic drawings and value in multicolored artworks, but they both refer to the same quality. To achieve a variety in values across an image, it can help to first reduce it to black and white and assess the different values there. By matching the value and not necessarily the color, you can build an interesting and rich drawing that has both depth (realized through gradations of color) and contrast (through juxtaposing a light and a dark value).

A grayscale
This grayscale has nine gradations, from white at one end to black at the other; the gray in the middle has a middle value or midtone.

Black White

Low
key High
key

A red scale
This color scale has the same number of gradations as the grayscale above, starting from a pale pink at one end to a dark red at the other.

Dark red Pale pink

Low-key artwork
When the colors within a picture are described by their value and the values used are mostly dark, then that image is said to be in a low key.

High-key artwork
Conversely, when the colors within a picture are mostly light in value, then that image is said to be in a high key.

Choosing a medium

DECIDING WHICH MEDIUM TO USE

The wealth of media available means that you may be uncertain about where to start. But experiment is the order of the day—see it as an opportunity to advance your work. It can be a good idea to join an art group, where you may be able to try out varied media before investing in expensive materials yourself. Perhaps a good place to start is an artist's work that you are drawn to—what medium does it use? And there are no rules about sticking to one medium—a combination of different media can result in surprising and inspiring results.

PENCIL

The first and most useful choice for drawing is the pencil. Aim to have a good mix of grades, say from 2H to a softer 5B. The harder the lead, the lighter the line - great for outlining or more controlled work; the softer the lead, the darker the line - fantastic for dramatic mark-making and contrasting tonal values. The softer pencils can smudge and dirty the paper, but an eraser can cut through to give a sharp white contrast. As well as graphite, there are charcoal pencils, which are good for shading and looser lines.

Pencil—pros and cons

PROS
- Cheap and portable
- Different lines and effects produced with different grades of pencil
- Removable with an eraser

CONS
- Can break easily
- Softer pencils can smudge on the paper
- Harder pencils can indent the paper
- Need regular sharpening

Pencil portrait
Choosing the right grades of pencil for the lines you want to produce will create a drawing full of life, contrast, and texture. Use swift and energetic lines combined with more controlled marks to convey different features.

DIGITAL DRAWING

Anything you can draw with in the real world has likely been translated into digital form, so sketching on a digital tablet can mimic a pencil, pen, charcoal, pastel, ink, paint, brush, palette knife, and aerosol spray. Use your tablet for drawing, writing, and doodling, all in one place, instead of having different notebooks and scraps of paper. The most obvious benefit of drawing on a tablet is its portability: with just one small device (some even fit into a large pocket) you have access to a multitude of tools and materials that would otherwise constitute a whole art kit. What's more, you can use it anywhere—in a café, gallery, or at the kitchen table—without needing space to spread out or making a mess. Another advantage is that no one knows you are drawing!

CHARCOAL

Charcoal is hugely versatile and comes in many forms. It is perfect for gestural mark-making and also rich, blended surfaces, offering a wide gray scale from a matte black to the bright white of the paper with all the grays in between. You can buy willow charcoal sticks, or vine, which is thinner and more liable to break, requiring a lightness of touch. Snapping charcoal sticks can produce sharp edges, useful for details. Other commonly used forms include compressed pencils or sticks in differing levels of hardness.

Charcoal—pros and cons

PROS
- Breaks easily when you need a sharp edge
- Can be layered up and blended to create rich and varied shades
- Encourages expressive marks and an uninhibited approach

CONS
- Breaks easily, especially when you don't want it to
- Messy; it needs fixing to prevent it from transferring to other surfaces
- Less good for detail

Charcoal acrobat
Using charcoal can be a good way to loosen up your drawing, especially if you're doing quick, gestural drawings of a moving subject. Charcoal lines can be easily smudged to suggest tone and maintain movement in the drawing.

PEN AND INK

Drawing pens come in an array of varying types and thicknesses. Designed to deliver a consistent flow of ink, the quality of their drawn lines is richer for it. There are also brush pens with a paintbrush-style tip that replicate a painterly line. Ink can be watered down as a wash or used undiluted for an intense color. A dip pen used in combination with drawing ink can result in more irregular or interestingly ink-spattered lines.

Pen and ink—pros and cons

PROS	CONS
■ Ink is available in a range of colors	■ Not all pens work with a wash, and some can bleed or discolor
■ India ink gives a lacquerlike finish that won't run once dry	■ Good-quality drawing pens and ink are expensive
■ You can vary the line quality depending on the drawing pen used	■ Need various brushes and dip pen nibs to achieve varied lines

Pen and ink line perspective
Using black ink and the white of your paper, various shades can be achieved by using varied line widths and qualities, and drawing short, hatched lines close together or further apart.

COLORED PENCIL

Drawing with colored pencils can be a little less forgiving than using regular graphite pencils and demands some testing. The range of colors is certainly appealing, and hues can be blended together with varying pressure, crosshatching, or layering; using the side of the lead gives a softer block of color. Water-soluble pencils allow a larger coverage of the page and, used as you would watercolors, once dry they can be worked over with another pencil.

Colored pencil—pros and cons

PROS	CONS
■ Available in a wide range of colors, which can be blended	■ Not easily removable or erasable
■ Variants have different properties, such as water-soluble pigment	■ Good-quality colored pencils are expensive
■ Permanence; no need to fix or protect	■ Need regular sharpening

Colored pencil portrait
A lightness of touch can create a characterful portrait, even when working with a limited palette of colors. Overlaying colors offers a valuable way to play with texture and tone.

Of all the media, pastels come in the most dazzling range of colors. As a rule, soft pastels are round, hard pastels come in a square form, and oil pastels are of a thicker and stickier consistency. Pastels are available in pencil form for underdrawing and for more precise details. The array of colors available can be multiplied by the mixing of pastels on the page; blending with a finger or feathering colors one over the other means that drawing with pastels is a real hands-on affair. It encourages you to get your fingers dirty. That said, they are one of the unruliest mediums and can take a little getting used to, but the finished results will be worthwhile. Fixative is a regular feature of working with softer pastels to avoid contaminating other work with the dust and undesired smudging.

Pastels—pros and cons

PROS
- Huge array of vibrant colors
- Portable, tactile, and easy to use
- Work on a variety of textured surfaces or supports

CONS
- Good-quality pastels are expensive
- Messy; soft and hard pastels create pigment dust as they're used
- Transferable; fixing is necessary to prevent the pigment from falling off the support

Colorful cockerel
Multicolored subjects aren't the only ones to draw, but they do allow the vibrancy and multitude of pastel colors to shine bright. Pastels work best on a textured surface with a tooth – here wood – which holds the pigment in place.

Scumbling with pastels
This technique of drawing uses the side of the pastel and a light touch. Basically, you apply a thin layer of one color over the top of another color—the base layer. Such a technique allows you to convey color and texture.

Pencil

Drawing with **pencil**

A fundamental tool for artists, graphite pencils are used for a wide range of writing and drawing applications, from quick sketches to detailed technical drawing. You can find a pencil—graded for relative hardness on a scale of 9H to 9B—suited to any subject. Experiment with graphite sticks or powder for even greater expression. The versatility of mark-making when using pencil appeals to artists of all abilities and drawing styles.

The following pages explore the qualities of different forms of graphite and how to use them for best effect. Practical guidance is given in three sections—beginner, intermediate, and advanced—through 14 different approaches to drawing in graphite pencil. Each section culminates in a showcase drawing, where all the techniques are brought together.

1 Beginner techniques

■ See pp.38-49

In the first section, you will learn about how pencil grips affect the marks you make, as well as how to use varied weights of line, negative space, and different types of hatching to best effect in your drawings.

2 Intermediate techniques

■ See pp.50-61

In this section, see how to frame and compose a scene, how cross-contour marks are used to suggest volume, and explore water-soluble graphite, as well as using varied pencil grades and pattern to suggest depth and tone.

Beginner showcase drawing (see pp.48-49)

Intermediate showcase drawing (see pp.60-61)

Graphite has been widely used as a drawing medium since the 16th century, when a large seam of natural graphite was discovered in Cumbria, in the north of England. The solid graphite was sawed into strips and bound in string or sheepskin to make drawing implements. The modern pencil—with its core of powdered graphite mixed with clay and then encased in wood—was invented by Nicolas-Jacques Conté in France in 1795. Prior to the discovery of graphite, metalpoint or silverpoint was used by the Old Masters to achieve fine, precise gray marks similar to those that we now associate with graphite pencil drawing, but it did not offer the same versatility.

Working in pencil

Graphite pencils are affordable and portable, making them an accessible material to begin drawing with. Their precision can sometimes be off-putting for the beginner, but graphite sticks provide a more expressive alternative. Pencils can be sharpened to a fine point, which they retain more easily than their charcoal counterparts, making them well suited to linear drawing and hatching techniques. A delicate range of light grays can be achieved with the harder H grades of pencils, while dense, soft tones are produced by the softest B grades—although these will never quite achieve the black of charcoal.

Pencil can be easily removed with an eraser without smudging, making it ideal for sketchbook work or underdrawing in other media. However, by applying varied techniques and exploiting the range of marks available, you can make a pencil drawing an artwork in itself.

3 Advanced techniques

■ See pp.62-73

In the final section, find out how to use an eraser to draw light into dark, and mask and stencil in your drawings, as well as exploring techniques for rendering fur, layering graphite, and drawing reflective surfaces.

Advanced showcase drawing (see pp.72-73)

Pencil and graphite

HOW TO CHOOSE YOUR DRAWING TOOL

Graphite pencils are the most widely available drawing material. They can be sharpened to a fine point to make gray, linear marks on the page that can be easily erased. Different grades of pencil produce a range of marks from precise lines to soft shading. Graphite is also available in solid stick form, or as a powder that can be rubbed into the paper surface.

It is important to make sure that you are drawing with the type and grade of graphite that is best suited to your task. Practice drawing swatches and tonal gradients with different grades of pencil to familiarize yourself with their particular characteristics.

Pencil grades

Pencil "leads" do not contain lead, although naturally occurring graphite does look very similar to lead ore, and lead was used for metalpoint drawing before the discovery of graphite. Pencil cores and solid graphite sticks are made from a mixture of powdered graphite and clay in varying proportions, with the hardness of the core measured on an HB scale, from the hardest, palest grade 9H through to the softest, darkest grade 9B, with HB at the center and the "F" grade sitting between HB and H. A narrower grading of 1–4 is also used in the US with a #2 pencil equivalent to an HB.

Hard "H"-grade pencils can be sharpened to a fine point, which they will hold for longer, making them suitable for precise technical drawing. They have a more limited tonal range and produce subtle grays, making them suitable for adding pale tones to a sketch. Soft "B"-grade pencils have a wider tonal range than "H" pencils and make darker, grainier marks, making them best suited to sketching, with the softest grades best reserved for the darkest darks in a drawing.

Different forms of graphite

Conventionally, graphite cores are contained in wooden casings—usually cedar wood—that can be sharpened with a traditional pencil sharpener, a mechanical or electric sharpener, or

| 9B | 8B | 7B | 6B | 5B | 4B | 3B | 2B | B | HB | F | H | 2H | 3H | 4H | 5H |

Sketching pencils
Pencil sets are available that provide a range of grades for sketching. Some pencils are also water-soluble, giving you the option of adding water, or dipping into water, to produce line and wash sketches or softened strokes.

Tools
Keep a pencil sharpener and eraser handy. Use a kneadable eraser to lift graphite powder.

Kneadable eraser Pencil sharpener

Plastic eraser

Graphite powder
A loose, fine powder that can be used for smudged tones over large areas. Apply with a brush, cloth, or your finger to a slightly textured surface.

a knife. Different sharpeners will give different lengths of point. A pencil or compressed graphite stick is held in the hand and gives you control and immediacy over your drawings.

For large areas of tone, graphite powder is an alternative option. It can be collected from sharpening solid graphite sticks or purchased in preground form, and applied with a range of tools including your fingers, or brushes, stumps, cloths, and rags.

Clutch and mechanical pencils have replaceable cores of varying sizes from 2mm to 5.6mm that produce a constant line, and can be used in much the same way as conventional pencils but reduce the necessity of sharpening.

Erasing and shaping tools
Graphite can be easily corrected or removed using an eraser. A hard plastic eraser can be cut or shaped to produce a clean edge for "drawing" lines into smudged marks, or use a kneadable eraser to lift out tones from graphite powder. Although it holds its place on the page more easily than charcoal, graphite can be deliberately smudged with a cloth, stump, or tortillon.

> "A pencil is the **fundamental** artist's tool, taking you from quick sketches to **sophisticated,** detailed studies."

Graphite stick

Types of pencil
Pencil grades range from hardest (9H) to softest (9B), producing a range of tones. Using a combination of pencil grades in one drawing will add variety.

6H 7H 8H 9H

Graphite sticks
A versatile drawing tool, graphite sticks are made of compressed graphite powder and can produce a broader side stroke than a standard pencil.

Graphite blocks
Available in different grades and colors, graphite blocks are useful for shading large areas and creating smooth tones. Water-soluble blocks give additional options.

Pencil supports

CHOOSING A SURFACE FOR PENCIL DRAWINGS

Pencil drawings are typically made on loose paper or in sketchbooks, and suit a range of paper types. Even if you find yourself without your preferred drawing supports, the chances are you will be able to find a pencil to draw with and notebook paper, discarded cardboard, or even the backs of envelopes to draw on.

Your choice of paper will significantly affect the outcome of your drawing. Explore the qualities of different papers and the marks that different forms of graphite make on them.

Paper

You can work in a notebook, sketch pad, or on loose paper. If you are drawing with pencil on loose paper you should use a board to support the surface, secured with clips or masking tape. Make sure the board is smooth and even, since rough surfaces under your paper will show through in your

drawing. Drawing paper is a standard choice for pencil drawings because it has a very slight texture over which the pencil can move easily and freely, with fluid marks.

Pencil can be used on any weight of paper–120-200gsm drawing paper is ideal, with heavier paper, over 200gsm, providing a firm and resilient surface for vigorous hatching or eraser-based techniques, and a good surface for pencil washes. Be aware that hard grades of pencil may dent the paper and very soft grades may be difficult to fully erase.

Heavily textured papers may interrupt the continuity of your pencil mark and affect the smoothness of the line, but are suitable for use with soft pencils where shading and softened edges are required. Pencil sits well on colored paper, although darker tones will often exaggerate the reflective, silvery quality of graphite.

Preserving drawings

Pencil does not smudge as easily as charcoal and does not need to be fixed, although graphite powder may benefit from spray fixative to hold it. In order

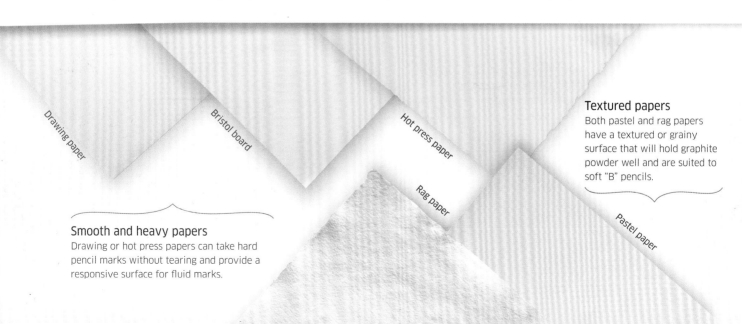

Drawing paper

Bristol board

Hot press paper

Rag paper

Textured papers
Both pastel and rag papers have a textured or grainy surface that will hold graphite powder well and are suited to soft "B" pencils.

Pastel paper

Smooth and heavy papers
Drawing or hot press papers can take hard pencil marks without tearing and provide a responsive surface for fluid marks.

Mounting paper
For a smooth drawing surface you will need a hard board—a varnished wooden board is ideal—and masking tape or clips to attach the paper to prevent it slipping.

Notebook
A hardback, pocket-sized notebook and sketching pencil are easy to carry for sketching outdoors or when inspiration strikes. Keep an eraser and sharpener on hand, too.

to preserve drawings made in soft graphite on loose paper you may want to store them between sheets of acid-free tracing or drawing paper. Drawings made in very soft graphite or graphite powder in sketchbooks should be drawn on one page of a double-page spread, leaving the facing page blank to minimize the chance of the graphite smudging.

Sketchbooks
Graphite pencil is an ideal sketching medium—it is clean and portable and is perfect for drawing in sketchbooks while on the move. Beware of dropping your pencils and shattering their cores when you are out and about! Always carry a sharpener with you to ensure you can achieve the point you require, and an eraser for corrections.

Choosing a sketchbook
Think about how you intend to use your sketchbook; does it need to fit in a pocket for quick sketches, or do you need to work large for life drawing classes? Will you use it for mixed media or washes? Always choose a sketchbook with good-quality drawing paper.

> "Explore the qualities of different papers and the range of marks that you can make with graphite in its many forms."

Sketchbooks
A spiral binding provides the option of working over a double or single page.

Sketch pads
Available in a selection of paper types, sizes, and weights, gummed pads of paper are easier to store and transport than loose sheets, providing a fresh sheet each time.

Basic mark-making

PUTTING PENCIL TO PAPER

Pencils are versatile drawing tools. When you are learning to draw it is important to explore the range of marks that your pencil is capable of. The speed at which you make a mark, the pressure you apply, and the way in which you hold your pencil all contribute toward how a line appears on the page.

Pencil grips

How you hold your pencil will offer varying levels of control and determine how much of the tip or side makes contact with the paper. You can change grip over the course of a drawing to achieve a range of marks.

Handwriting grip
A conventional handwriting grip, when held in your dominant hand, allows you the most control over the point of the pencil but limits the range of your marks. It is most useful for detailed marks. Try using your non-dominant hand, too.

Distant grip
Holding your pencil with a light grip halfway down the shaft keeps your marks loose, with only a small amount of control. This pencil grip is suited to making quick sketches and expressive marks for capturing a subject with continuous lines.

Overhand grip
Holding your pencil from above allows you to keep the pencil at a shallow angle to the page. This pencil grip allows you to use the side of the graphite core as you draw. It is a loose grip that enables broad marks or blocking in tone quickly.

Simple, day-to-day objects like these old boots make good subjects for quick, linear studies to practice your observation and mark-making skills, using a range of pencil grips for different marks.

You will need

2B pencil

- 2B pencil
- Sharpener
- Drawing paper

A pair of old boots

1 Loose and lively
Your first impressions of a subject are likely to be broad and general, and your first marks should reflect this. A distant grip allows you to loosely sketch in the big shapes of your subject, establishing its overall appearance and scale on the page.

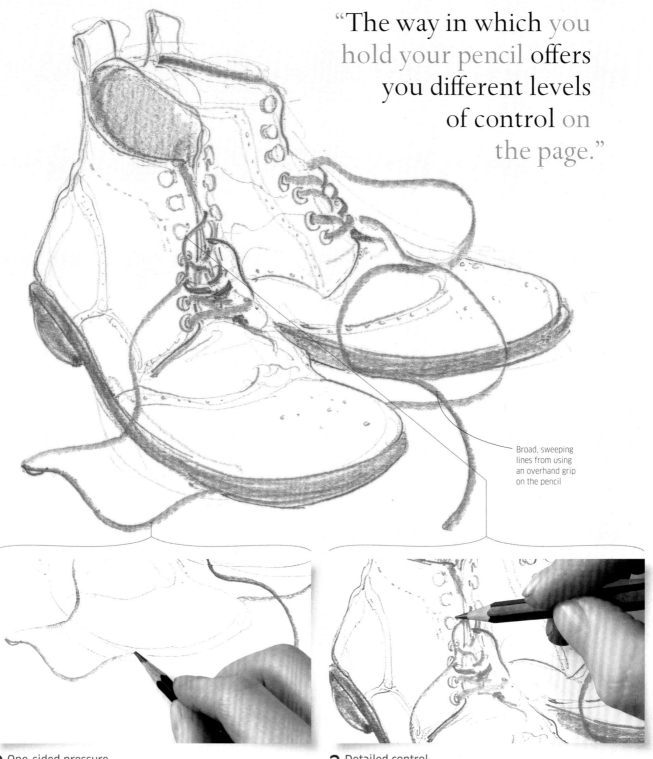

"The way in which you hold your pencil offers you different levels of control on the page."

Broad, sweeping lines from using an overhand grip on the pencil

2 One-sided pressure
An overhand grip is as imprecise as the distant hold –only allowing you control of one edge of the broad mark from the side of the pencil. Use this grip for drawing broad, efficient marks for the laces or blocking in tone.

3 Detailed control
Now that you have established the shapes on the page, you can use a more precise mark to pin down key lines and small details (using the controlled handwriting grip), using the loose structure of the earlier stages for guidance.

Negative space

SEEING THE SHAPES BETWEEN

When you are making an observational drawing of a complex subject, it can help to begin by drawing the negative spaces around and in between the positive forms in order to see the main subject more objectively. Think of the drawing like a jigsaw puzzle: each shape in your subject– negative or positive–must fit together with all of the shapes that surround it.

▨ Compositional assistance

Seeing and drawing the negative spaces around a composition can help you to check that the proportions work and focus on the shapes that make up the composition. Use a viewfinder–a piece of cardboard with an aperture of the same dimensions as your picture plane cut out of its center–to isolate a view and create clear negative spaces between the edge of your subject and its frame.

Viewing a composition
It is hard not to be informed by what you know rather than what you see–so you may see this composition as a preconceived idea of a spider plant in a pot, rather than discerning the shapes, both positive and negative, that make it up.

Spider plant in a pot

Using a viewfinder
The viewfinder helps to frame an interesting composition. You can clearly see the proportions and shapes of the negative spaces around the plant. Once these are blocked in, it is easier to pick out the internal negative spaces and positive forms.

Framed by a viewfinder

A crop taken from the middle of this spider plant– using a viewfinder–makes an excellent subject for a shape study. The white wall behind makes it easier to see negative spaces.

1 Initial sketch
Make a light sketch of the positive shapes of the plant in HB pencil. Establish its scale and position, leaving the drawing just visible.

2 Trapped spaces
Draw the trapped spaces–the negative spaces between the leaves–with a 3B pencil, focusing on the shapes of the spaces rather than the positive shapes of the subject.

You will need

HB pencil 3B pencil

- Viewfinder
- HB, 3B pencils
- Sharpener
- Eraser
- Drawing paper

A spider plant

"Learning to see the space between—or negative space—can help to **identify** the positive forms ."

3 Surrounding spaces
Next, draw the shapes that are bounded by the edges of the viewfinder, bridging the gap between the outer edges of the plant and the box that surrounds them.

4 Positive subject
Now elaborate on the silhouetted white shape of the positive subject by drawing in the edges and surface texture of the leaves.

Hatching and crosshatching

CREATING TONE WITH LINES

Hatching uses swiftly drawn parallel lines to create an impression of tone; hatching that overlaps is known as crosshatching. Within a drawing, you can achieve variations in light (and dark), shape, and texture by using an appropriate style of hatching.

▨ Hatching effects

Effective hatching uses marks made in one direction, laid down confidently and quickly. Practice filling spaces with consistent hatching, and varying the pressure and spacing of your marks to create gradients of tone. Overlap hatching marks to build texture and density.

Hatching gradient, changing the spacing

Regular hatching Hatching gradient, changing the pressure

Simple hatching styles
Quick, confident marks in one direction with consistent pressure create a flat and even tone. For variety in tone, use more or less pressure, or change the spacing of the marks.

Crosshatching styles
Overlapping hatch marks builds tone in a controlled way. Opposing directions of diagonal marks create a lattice of lines, darkening the tone—a third direction makes it darker still.

Two directions of hatching Three directions of hatching

This arrangement of cylindrical vessels provides an ideal subject for exploring gradients of light and dark with hatching and crosshatching. The style of hatching reinforces the absence of surface texture.

You will need

2B pencil 6B pencil

- 2B, 6B pencils
- Sharpener
- Eraser
- Drawing paper

Still life of kitchen vessels

1 Line drawing
Use a sharp 2B pencil to sketch out the shapes of the pots on the page, beginning with a light, loose line and refining the outline with a more confident edge once you have a feel for its position.



2 Initial hatching

With a loose hold on a 2B pencil, establish large, simple shapes of light tone with swift, diagonal hatching. Vary the weight and density of your marks. Don't be afraid to hatch over lines and clean them up later with an eraser.

3 Hatching over lines

Avoid pulling your pencil off the page at outlines; this saps energy from your marks and creates an unwanted halo of light around tonal shapes. Use an eraser as a drawing tool to tidy up edges that have been hatched over.

4 Dense marks

Stand back from the drawing and look at your subject, flicking your eyes back and forth to decide which parts of the drawing need to be darker. Build up the density of darker shadows with more parallel marks.

5 Building layers
Create denser, darker tonal areas using crosshatching, building up two or more layers of hatching in different directions. Make diamond shapes at first, then a combination of vertical and horizontal marks to help reinforce the cylindrical nature of these objects.

6 Darkest tones
Selectively draw in the darkest edges with a sharp 6B pencil and reinforce shadows with dark hatching. Ensure your marks retain their identity. Note that other styles of crosshatching can help to convey shape and texture.

"Confident mark-making is key to effective hatching and crosshatching."

Weight of line

VARYING YOUR MARKS

Varying the pressure on your pencil will create a range of different weights of mark that can be employed for different purposes. Lightly drawn marks made at an earlier stage of drawing can be easily erased or worked over. A line that varies in weight along its length suggests a certain energy and movement, because it takes a confident approach and looser pencil hold to achieve this type of line. Use a heavy, dark line to root a drawing to the page.

PUTTING IT INTO PRACTICE

A life-drawing class is an ideal environment for practicing swift, linear mark-making. It's usual to start the session with quick poses followed by some longer ones. This drawing was made from a model in a reclining pose over a 45-minute period.

You will need

HB pencil 2B pencil 6B pencil

- HB, 2B, 6B pencils
- Sharpener
- Drawing paper

A reclining nude

1 Fast underdrawing
Use an HB pencil to make quick, light marks that capture the overall shape of the model. These first lines will help you to navigate your way around the figure and will eventually be obscured by heavier marks.

2 Light marks
A second layer of light marks in 2B pencil can help to clarify the structure of the body, building on the underdrawing's "scaffolding" and imparting energy.

Highlights are simply left without any marks

Choosing your weight

It is important to consider what kind of line you will employ to describe a particular subject—explore a range of different line weights in your drawing (light and quick gestural marks, continuous lines of varying weight, and definite and intentional heavy marks). You'll soon develop what you could call a "vocabulary of drawn marks" that suit your intentions; it'll become second nature.

Varied line weight
Light marks pick out the profile. Heavier marks draw attention to the features and imply the shadows of the jaw.

Consistent line weight
An even weight of line, deliberately drawn, implies clarity of observation and creates a flat, stylized portrait.

3 Confident, varied lines
Once you are happy with the earlier lines, bring a more varied series of marks into the drawing, altering the pressure as you draw.

4 Simple tones
Using swift, parallel lines, build up simple blocks of tone to sculpt the form of the figure and bring the highlighted shapes of the body forward in relation to the darker backdrop.

5 Darkest darks
Switch to a sharp 6B pencil to emphasize the darkest lines in order to create contrasts that draw the eye.

The heaviest marks are made with the softest pencil

Title **Still life with three pumpkins**
Artist **Katarzyna Kmiecik**
Medium **Grades B–6B graphite pencils**
Support **Drawing paper 300gsm**

Weight of line

« See pp.46–47

Varied weights of line have been used to establish the initial composition and to emphasize the different materials, in particular the loose folds of the fabric.

Negative space

« See pp.40–41

Looking at the negative spaces between and around the positive forms of the objects has helped the artist to define the shapes and proportions of the still life.

Mark-making: loose marks

« See pp.38–39

Holding the pencil with a variety of grips helps to produce a range of marks, including the loose, textural marks of the tasseled fabric.

Showcase drawing

In this deceptively simple drawing of a classical still life, several of the core beginner techniques have been brought into play. Negative space has been used to establish the arrangement of objects, and varied marks, hatching, and crosshatching have been used to build up form and tone.

Hatching

« See pp.42–45

Hatched lines following the contours of the pumpkin have been used both to build up tone and to suggest the large vegetable's weighty, rounded form.

Crosshatching

« See pp.42–45

Lines crosshatched in a curved diamond pattern over the initial layer of hatching have been used to suggest the knobs on the skin of the smaller pumpkin.

Mark-making: smooth marks

« See pp.38–39

Long marks have been used to imply the smooth surface of the foreground fabric, in contrast to the shorter marks on the third pumpkin.

Linear compositions

FRAMING YOUR VIEW

Small, simple thumbnail sketches will help you to explore a range of compositions before committing to a final view for a more detailed drawing. Make 10-minute sketches in differently sized boxes to think more creatively about how to compose a drawing.

▇ Simplifying what you see

You can use a viewfinder (see p.18) to isolate your subject, searching for an engaging composition as you might when you are looking for a view to photograph. Draw in the key lines of the composition first, then elaborate on the shapes of light and dark.

A photograph of an interior
When you are looking for interesting arrangements of shape and shadow, an everyday scene can often provide a surprisingly engaging subject for a compositional sketch. This staircase has strong, contrasting verticals and diagonals.

Simple lines
When you are breaking down a composition, start with simple lines that cut through the picture plane, helping you to see the large, interacting shapes within.

A simple sketch based on the framework of lines
Sketch in the shapes of shadows with simple hatched marks, creating a thumbnail that could inspire a more detailed drawing.

These thumbnail sketches were the result of exploring an interior with a sketchbook and pencil, searching for, and sometimes contriving, interesting views of the space. Once you've sketched a few compositions, choose your favorite to work up.

Abstract shapes
A successful image should work as an abstract arrangement of shapes as well as a collection of objects. The interacting light and dark rectangles in this sketch sit in contrast with, and draw attention to, the round form of the apple.

Strong horizontal lines underscore the jugs

Unusual angles
Explore unusual angles when composing your subject. The bowl from another composition is here viewed from above. The circle of its rim and setting in the square picture plane frame a central pear.

Directional elements
Composition can lead the eye to small elements of a picture. The diagonal of the staircase in this composition joins the diagonal of the shadow on the floor to point to the pair of slippers kicked off and left in front of the bottom step.

Triangles
In this anchored composition, three points of interest—jugs, bowl, and painting—create a triangle around the central shape of the chair.

"Thumbnail sketches will help you to explore a range of compositions."

Dark blocks bookend the row of jugs, keeping the eye moving back and forth

Simple composition
A composition needn't be complex to work. This composition is simple— the horizontal of the shelf underlines the jugs; dark blocks either side keep the eye moving back and forth along the row.

Roving eye
The gap between sofa and table creates a path for the eye as it moves around the image. The lamp on the left stops the eye moving off the page, as does the dark curtain on the right.

Visual path

Contouring 3-D forms

SUGGESTING MASS AND VOLUME

To create 3-D form, use lines to evoke the contours of the surfaces you're exploring. Hatching in the direction of a surface will also emphasize the 3-D qualities of your subject. Light and shade help to create the illusion of mass and volume, and the direction of contour-like marks originates a drawing with a solid sense of form.

▨ Braceletting

A subject drawn using only an outline looks inevitably flat (see top picture below)—whereas using marks that curve around a subject (as in the way a bracelet curves around a wrist) can suggest the convex or concave nature of that surface. See how the subtle change of the direction of the curved lines (below) creates a stick with a different form altogether, with different parts of the branch appearing to recede or come forward.

Contour of a stick

Cross-contour marks in one direction

Cross-contour marks in the opposite direction

PUTTING IT INTO PRACTICE

Vegetables are such satisfying subjects to draw, with a wondrous variety of surfaces and shapes. Subtle striations on the surfaces of the mushrooms and squash made it easier to discern their forms.

You will need

2B graphite stick

4B graphite stick

- 2B, 4B graphite sticks
- Eraser
- Sharpener
- Drawing paper

A vegetable selection

Quick, loose outline

1 Initial sketch
With a loose hold on the 2B graphite stick, quickly establish the shapes of the vegetables. Hold the vegetables to get a feel for their mass and surface and let your tactile experience feed into the drawing.

2 Contour around form
Use swift curving marks to contour around the forms of the vegetables, spiralling around their shapes with curved (bracelet) lines; avoid drawing fixed outlines.

3 Edge definition
Use a varied weight of line to define the shapes of the vegetables, paying attention to the negative space between them and refining the voluminous forms on the page.

4 Cross-contour along form
Make marks in an opposite direction to your earlier contours, creating cross-hatching that curves with the surface of the subject to suggest a fully developed 3D form.

5 Final touches
Develop the cross-hatching, using earlier energetic lines to guide more considered marks. Reserve the 4B stick for the darkest darks, erasing highlights where necessary.

Soft tones

BLENDING PENCIL WITH WATER

Watercolor pencils and sticks behave like regular pencils when they are applied dry. But when water is added, this type of graphite dissolves and can then be moved around the page in a controllable way, allowing you to introduce new tones and textures to your drawing using a brush and water. Once it is dry, you can continue drawing on top.

▨ Creating a tonal gradient

It's a good idea to experiment with this medium so that you get a good feel for how the water changes the graphite before committing to using it in a drawing. Start by creating a cross-hatched gradient of tone, then wet and blend the marks with a loaded watercolor brush. Work from light to dark and continue blending in this way to create a smooth tone.

A drawn gradient
Create a gradient from dark to light across the paper, using hatching and cross-hatching to build the density of marks and thus tone.

A watery brush
Load your brush with water and, starting at the lighter side of the hatched gradient, wet the page and move the brush gently across to the darker tones.

Super-smooth tone
Repeated wetting and blending of the graphite marks with the brush results in a wonderfully smooth tone; the more blending done, the smoother the tone.

In this study, big shapes were sketched fast and early, with gestural lines to account for the constant shifting of the cloud forms. Tone was added at a later stage and then darkened by wetting the graphite.

You will need

6B stick or pencil

- 6B water-soluble graphite stick or pencil
- Hot-press watercolor paper
- Sharpener
- Watercolor brush
- Plastic eraser

Cloudscape

Gestural lines capture cloud forms

1 Fast work
To capture the feel of an ever-changing subject, quickly sketch its outline to delineate shapes before they become totally indistinguishable. Combine multiple cloud forms.

2 Cloud-like marks
Build up sculptural tone with contour marks to suggest cloud forms, using observations of similar clouds to support your memory of the initial shapes you drew. Use reference photographs, too.

3 Contrasts—light and dark

Use tone in the picture's background to emphasize contrasts in the cloud, exaggerating the darks behind highlights and the lights behind shadow shapes.

4 Liquid graphite

Selectively add water to the drawing to dissolve and blend the graphite, using your brush to move the pool of dark around the page, as if it were ink or watercolor paint.

5 Lighten up

When the paper is fully dry, use a plastic eraser to lighten any parts of the drawing that have become too dark. Bear in mind that it is difficult to remove wetted graphite entirely.

Creating depth

SUGGESTING DISTANCE USING PENCIL GRADES

More detail is visible in nearby subjects, which also show greater contrasts between light and dark planes compared to the soft transitions and light tones in the distance. You can use a variety of pencil grades to match these changes in tone and create a sense of depth in a sketch, using hard pencils for light, distant tones and denser shading from soft pencils in the foreground.

Pencil grade tonal ranges

Pick the grade of pencil most suitable for each stage of your drawing. Soft, dark pencils are more versatile and have a broader tonal range; hard, light pencil grades can achieve a more varied range of delicate grays.

Tonal scale in 4B
The soft, dark 4B pencil has a wide tonal range and can achieve very dark tones, but tends to create grainy light tones.

Tonal scale in 4H
A hard, pale 4H pencil has a limited tonal range—it can't make marks as dark as a softer pencil, but it can make more varied light tones.

Five-grade tonal scale
To achieve the widest, smoothest tonal range, use several grades of pencil—4B, 2B, HB, 2H, and 4H—using each one for the most suitable part of the tonal scale.

This street scene—based on sketches made in the street in the photograph—was drawn in stages, using shading from hard and soft pencils to build the tonal range from light background to dark foreground.

1 Main structures in 4H
Make an initial sketch of the street—think of the composition like a theater and this sketch as a stage onto which props might be arranged later. If you are sketching from life, you'll need to draw in the still parts of the composition before the moving figures.

2 Figures in 2H
Loosely jot in the positions of figures, adjusting them to make satisfying arrangements if necessary. Note outlines of shapes and of any contrasts of tone, highlights, or shadows.

3 Light tones in 2H
Hard pencils needn't be used just for precise lines—hold the 2H at a shallow angle to swiftly block in a range of pale grays across the drawing. Follow the changing angles of the surface planes with the direction of your pencil strokes.

You will need

4H pencil | 2H pencil | HB pencil | 2B pencil | 4B pencil

- 4H, 2H, HB, 2B, 4B pencils
- Sharpener
- Eraser
- Drawing paper

Street scene

4 Midtones in HB
Add midtones and develop the detail in the midground, leaving the foreground loosely sketched in for the time being.

5 Dark tones in 2B
Use a 2B to build up the foreground tone, strengthening it with swift hatching and pushing hard to establish dark areas of focus.

6 Darkest darks in 4B
Finally, pick out the darkest darks in the foreground with a sharp 4B pencil, darkening the nearest shadows to throw them forward.

Pattern and repetition

REPEATING MARKS FOR DEPTH AND TEXTURE

When seen up close, each flower and leaf in a garden has its own identity; viewed from far away, those individual forms become absorbed in a mass of repeating shapes. Experiment with repetitive mark-making to create patterns that suggest the texture of the subject and imply depth as they recede.

▩ Creating distance with pattern

As you develop repeating marks for a mass of pattern, create variety in the larger, nearer masses. Make smaller, more regular marks as the pattern recedes to imply the diminishing scale created by the perspective.

Larger, complex, near pattern
Create a pattern of marks that represents the essence of the foliage or flowers that you're drawing. It doesn't have to match exactly, but it does have to give a good representation of its appearance.

Distant, simple pattern
Scale down and simplify the larger-scaled pattern for using in the background and more distant areas of the drawing.

Combined marks
The pattern of marks you use should diminish as the eye retreats to the most distant parts of the view being drawn.

This garden was drawn on a cloudy day, making it easier to focus on the patterns in flowerbeds and trees rather than on the tonal qualities of the scene. Opt for overcast conditions for tackling this technique.

1 Initial composition
Begin with a loose, linear sketch—a simple underdrawing will help to establish the composition on the page. Think about how your eye will move through the scene.

2 Blocks of pattern
Look for trees and flowerbeds with foliage that could be drawn with repeating patterns, and use a light but confident line to define the shape of each contrasting block.

3 Small patterns
Fill the blocks with patterns formed of small, tight marks, working down and across the page. Create an impression of distance using small, simple, and repetitive marks.

You will need

3B pencil

- 3B pencil
- Eraser
- Sharpener
- Drawing paper

Up the garden path

"Create variety as you develop repeating marks for a mass of pattern."

4 Large shapes

Define any clear shapes that are not filled by pattern. Give some thought to how they are framed by the surrounding detail, and create focal points of white space to draw the eye through the scene.

5 Near pattern

When you reach the foreground, make your marks larger and more varied, picking out the groups of leaves that catch your eye and drawing attention to their particular shapes.

Artist **Jake Spicer**
Title **Chanctonbury Ring**
Medium **A range of soft and hard pencil grades, water-soluble graphite**
Support **Drawing paper 200gsm**

Composition: holding blocks

≪ See pp.50–51

The vertical shapes of trees provide blocks on the left and right of this composition, keeping the eye (and focus) from slipping off the page.

Creating depth

≪ See pp.56–57

Varied pencil grades have been used—harder pencils in the background and softer pencils in the foreground—to suggest depth through tonal variation.

Contouring 3-D forms

≪ See pp.52–53

Cross-contours—also known as braceletting marks—going around the surface of the tree trunks help to suggest their round, three-dimensional forms.

Showcase drawing

This view down a woodland path on a clear winter's day gives an opportunity to explore the techniques of drawing from the intermediate section. Various pencil grades imply the depth of the woodland and the path disappearing from view, while contouring give the trees their form.

Composition: leading the eye

≪ See pp.50–51

The path leads the viewer's eye from the central anchor of trees up the path and into the woods. The tones and patterns reinforce this.

Pattern and repetition

≪ See pp.58–59

Repeated leaf marks, grasses, and tree trunks fill different areas of this drawing with representative patterns, which also suggest distance as they get smaller.

Soft tones

≪ See pp.54–55

Water-soluble graphite was selectively added and wetted with a brush at a late stage of the drawing to darken parts of the composition and create areas of soft tone.

Drawing with an eraser

ACHIEVING HIGHLIGHTS THROUGH ERASING

An eraser is an important drawing tool—it is a way of drawing light back into dark by removing graphite marks to expose the light paper beneath. This technique works especially well with graphite powder. Start by rubbing the graphite onto the surface of your paper to provide an excellent midtone base. You can then draw lights with the edge of an eraser or lift out larger areas with the side of an eraser for soft tonal transitions.

PUTTING IT INTO PRACTICE

Low evening sunshine in this rural landscape created shapes and patterns of light and dark, ideal for erased highlights. Light transitions of tone were lifted out and the sharp detail of the grass was drawn into the foreground.

You will need

Graphite powder | 2B pencil | 6B pencil

- Graphite powder
- 2B, 6B pencils
- Soft cloth or paper towel
- Eraser
- Sharpener
- Drawing paper

1 Initial ground
Sprinkle graphite powder onto the paper selectively, concentrating the powder in the places where shadows will be darkest. Use the cloth to rub the powder onto the page, aiming to cover the whole surface with a little graphite.

2 Erased highlights
Use the eraser to rub away large shapes of light, with particular focus on negative spaces of light like those between the branches of the tree. When you are dealing with a soft transition of tone, use the broad side of the eraser to lift graphite away.

Rural landscape

Subtractive tone

Graphite powder, either purchased or saved from sharpening graphite sticks, makes for an even midtone ground—a mass of hatched marks would achieve a similar effect. Practice drawing with an eraser to explore the range of tones, shapes, and marks that can be created.

Graphite powder ground
Sprinkle a little graphite powder onto a flat page and use a soft cloth or paper towel to rub the graphite into the surface, gently blowing away any excess.

Erased lights
Use a clean, sharp-edged eraser to rub away shapes of light, pressing hard to erase the brightest highlights—imagine a sphere lit from the left as the subject.

Additional darks
Use a graphite pencil to darken the shadows in your subject, sharpen the outlines of objects, and to increase the contrast by darkening the background behind the highlights.

Soft transitions of tone are achieved by lifting out the graphite base

3 Dark tones
Use a 2B pencil to build up areas of dark tone, using your full range of patterned marks and hatching to suggest the textures of the hedges and distant wooded hills. Use a 6B pencil selectively to darken the deepest shadows that you can see.

4 Final highlights
Putting lots of pressure behind your mark, drag the sharpest edge of your eraser across the page to create sharp highlights in the foreground, picking the bright edges of foliage out from the dark undergrowth.

Masking and stenciling

USING MASKS TO CREATE TONAL HIGHLIGHTS

The white of the page will usually create the brightest highlight that you will be able to achieve in your drawing—preserving that light early, while building dark tones elsewhere, will help you to achieve dramatic contrasts. Draw with masking fluid for controlled shapes, or use masking tape like a stencil to achieve crisp, linear edges.

■ Applying masking fluid

Masking fluid is most often used in watercolor painting techniques, but it can also be used in conjunction with graphite powder. Read the instructions on your particular brand of masking fluid before using it in your drawing and use a heavy drawing paper, such as Bristol vellum, to minimize buckling when the fluid is applied.

Apply with a brush
Use a soft brush to apply the liquid masking fluid to the paper in the shape you require. Be generous with the fluid without flooding the area.

Add graphite powder
Allow the fluid to dry for 20 minutes, then apply graphite powder to the area with a dry brush or cloth—be careful not to remove the dry fluid as you apply the powder.

Remove the mask
Use your fingernail or the tip of a knife to lift the edge of the dried fluid and peel it away, revealing the preserved white area and clean edges against the darker graphite tones.

The complex mechanisms of a clock create crisp edges that suit sharp contrasts of tone. Liquid masking fluid is applied with a brush to mask the brightest tone of the metal.

You will need

2B pencil 4B pencil Graphite powder

- 2B, 4B pencils
- Graphite powder
- Masking tape
- Masking fluid
- Brush
- Stump
- Eraser
- Sharpener
- Bristol vellum

Clock mechanism

1 Line drawing
Use a 2B pencil to draw the outlines of your subject, lightening the contours with an eraser once you are finished to provide a base on which to mask out your shadow shapes and highlights.

2 Masking tape
Draw in the darkest tones first by masking off the bright, straight-edged shapes with tape. Use a 4B pencil to hatch even blocks of dark tone right up to the edge.

3 Masking fluid
Apply masking fluid using the pale contours as a guide, rubbing graphite powder over your drawing selectively and peeling off the dried fluid to create crisp, highlighted shapes.

4 Blend tones
Use a stump to soften some tonal edges and blend gradients of tone where required, taking the smudged tone across the revealed white paper, creating a midtone.

5 Darken shadows
Use a 4B pencil to hatch darker shadows, clarifying the edges of some tonal shapes to add form and redrawing defined areas, such as the edges of individual cogs.

Fur and hair

CREATING SURFACE TEXTURES

Your sense of touch can inform the marks that you use for describing a surface. When you are drawing hair or fur, the length, weight, and direction of your mark-making can suggest texture and direction of that fur, while at the same time creating the impression of tone.

◼ Fur textures

You can describe the different types of fur and hair with a vocabulary of marks. Trace the path of the animal's hairs with your eye and let your pencils follow the same flow on the page—making your marks in the directions that you might imagine stroking the animal. However, observe the characteristics of the fur or hair of the particular animal you are drawing—dogs' hair, for example, can be long, short, wiry, smooth, or curly.

Short hair
When you are building up tone in the coat of a short-haired animal, use short, sharp marks from your thumb and finger to suggest the tone and texture. Observe the difference between rough, silky, and smooth hair on different types of animal.

Long hair
Light reflects off the coat of a well-groomed, long-haired dog in a similar way to human hair. Use long marks to build up the flowing, shiny texture.

Curly hair
A thick, curly coat reflects light less readily—pick out the dark shadows at the base of a curl and follow the direction of the curling hairs as you build up texture.

PUTTING IT INTO PRACTICE

This dog was drawn from a photograph of a similar pose, because this pet doesn't like to sit still for long. When drawing from secondary references, like this, you may wish to draw from more than one photo.

You will need

2H pencil HB pencil 2B pencil

- ◼ 2H, HB, 2B pencils
- ◼ Eraser
- ◼ Sharpener
- ◼ Drawing paper

A sleeping dog

1 Initial sketch
Using the HB pencil, sketch in the big shapes of the body of the dog with big, gestural shapes, paying as much attention to the negative spaces surrounding the subject as the dog itself. Think about the shape of the dog's body underneath its fur.

2 Key shapes definition

Look for features to use as landmarks for the drawing: ears, snout, paws, and the shape around the eyes. Define these early, but adjust as you refine the drawing.

"A vocabulary of marks describes different types of fur and hair."

3 General tone

Now with the 2B pencil, use swift, light hatching marks to develop the shapes of shadow in the dog's body and surroundings. This could include the local tone of the dog's markings or the shadows on its body.

4 Darkest tones

Use your 2B pencil to add extra weight to any dark lines (and 2H for light tones) that you can see in the dog, clarifying the shape of its features and adding further tone to the nose, eyes, and ears as you draw.

5 Surface texture

Now that all the details of the pose are established, you can spend some time on the fur. Build up tone and texture with short, sharp marks made in the direction that you would stroke the dog; make heavier marks, or use a softer grade of pencil, for the darker areas of fur.

Layering graphite

COMBINING LINEAR AND TONAL LAYERS

The dual vocabularies of linear and tonal mark-making are often combined in drawings. Line is used to make sense of a subject on the page and to clarify the edges of shapes, where tonal marks allow us to represent the world as we see it by suggesting the play of light and dark to create the illusion of form. Here we use powdered graphite, in addition to graphite pencils, to emphasize the tonal differences within the scene.

PUTTING IT INTO PRACTICE

There's a lot going on in this harbor scene in every plane—foreground, middle ground, and background. Choose a subject that offers you the same range of shapes, textures, and tones.

You will need

Graphite powder | HB pencil | 4B pencil

- HB and 4B pencils
- Graphite powder
- Eraser
- Sharpener
- Stump or tortillon
- Drawing paper

A harbor scene

1 A simple outline

Establish the scene with a simple, linear sketch in HB pencil, with the weight of line suggesting the definition of boundaries. Use a light, loose mark for the water's edge and a more confident line for denoting the outline of the nearby boats and buildings.

2 Application of graphite powder

In this next layer of the drawing, use a paper stump or tortillon to apply the graphite powder to create tonal layers that will build on the linear framework of your earlier pencil sketch.

▓ Applying graphite powder

Powdered graphite is the same graphite found in graphite pencils but it's finely ground into a powder. You can selectively apply such powder to a line drawing— it can be sprinkled, brushed, smudged, rubbed, or dabbed onto your drawing. How you choose to apply, though, will give you varying levels of control. Using powdered graphite in this way can help to create super-smooth textures and dark grounds.

Dabbed with a paper towel

A paper towel, stretched over a finger and dipped into the powder, allows you to apply masses of tone quickly, without smearing from the grease from your skin.

Controlled with a stump

For more precise control, dip a paper tortillon or stump into the powder and apply soft tone more deliberately and carefully than with a cloth.

The soft 4B pencil can reinforce sharp edges

3 Highlights using an eraser

Remove the graphite next, to bring light back into the drawing. Pick out the highlights with the edge of the eraser and clean up other shapes within the drawing that may well have become smudged by the graphite powder.

4 Clarifying the darks

Using a sharp 4B pencil, pick out the darkest darks in the scene, adding a layer of crisp edges and soft dark tones to draw focus to areas of interest and to clarify shapes that were established in earlier layers of the drawing.

Reflective and transparent surfaces

DRAWING GLASS AND METAL OBJECTS

Drawing a reflective or transparent surface is an exercise in objectivity. As well as drawing the subject, you may find you have to draw a distorted view of the surroundings reflected on its surface or seen through it.

▨ Drawing what you see

We tend to see objects as we expect them to look, not as they actually appear. But when you draw similar-shaped objects made of varied materials, you see how different the shapes of light and dark within them appear.

Wooden ball
Opaque, wood has very little reflective quality. The reflection of light from its surface suggests only the ball's form and the direction of the light source.

Glass ball
Both reflective and transparent, this glass ball reflects light from a window from its own surface as well as magnifying it onto the surface of the table in front of it.

Steel ball
Polished metal is highly reflective but opaque. It reflects the room around it, distorted by the curve of its surface. When you draw the ball you draw the room, too.

Create your own still life to practice capturing the reflective and transparent qualities of the surfaces of objects from different materials. Here, the wine bottle with its dark, reflective glass and matte label sits alongside a transparent wine glass (containing opaque wine) and a reflective, metal olive bowl.

1 Initial sketch
A sketch in HB pencil establishing the objects will help you to compose the still life on the page and adjust the proportions of the objects before pinning down the outlines.

2 Object shapes
Lightly erase the pencil sketch in the places where the line disappears from view before clarifying the outline of the bottle, glass, and bowl in HB.

The line of the bottle behind the wine is no longer there

3 Tonal shapes
Draw the shapes of light, middle, and dark tones that you can see within the outlines of your subjects. Make no assumptions—look for the edges of the light and dark shapes and draw in a light line as a placeholder; you can fill in with tone later.

4 Light tones
Leaving the very brightest reflections white and avoiding the dark shadows, use a 2H pencil to hatch in the light tones, using your earlier tonal shapes.

You will need

2H pencil HB pencil 4B pencil

- 2H, HB, 4B pencils
- Erasers (kneaded and plastic)
- Sharpener
- Drawing paper

A reflective still life

5 Midtones
Switch back to the HB pencil to build up tone across the remaining tonal shapes, varying the weight and density of your hatching to recreate the variation you see in the tone.

6 Dark tones
Shade the darkest tones in dense, heavy marks with your 4B pencil, adding further layers of dark over any midtones that need to be darker. Feel free to switch to an even softer, darker pencil if the subject calls for it.

"Simply translate the shapes of light and dark onto the page as you perceive them."

Artist **Jake Spicer**
Title **Francesca at the mirror**
Medium **HB-2B pencils, graphite powder**
Support **Drawing paper**

Drawing with an eraser

≪ See pp.62–63

Details have been lifted out in the fabric using an eraser to draw light back into the areas of graphite powder midtones.

Creating hair texture

≪ See pp.66–67

Hair texture has been built up in flowing lines over an initial sketched structure, using HB to build up the mass of tresses, and 2B for the darkest areas.

Masking with fluid

≪ See pp.64–65

Masking fluid was selectively painted onto the robe before graphite powder was added. The fluid was then removed at a later stage to create clean highlights.

Showcase drawing

In this drawing, all of the techniques in the section have been explored in a partially masked and layered drawing showing hair texture and a plethora of reflective and transparent surfaces. Midtones have been added with graphite powder, and lightest lights lifted out with an eraser.

Reflective surfaces

≪ See pp.70–71

The transparent bottles were developed in several stages using 2H, HB, and 2B pencils, with the highlights lifted out at the end with the sharp point of an eraser.

Masking with tape

≪ See pp.64–65

Masking tape, cut to shape with a craft knife, was used to mask off the light areas of the mirror when the graphite powder was added to the midtones of the background.

Layering with fixative

≪ See pp.68–69

The drawing was built up in layers of graphite powder and hatching, with a stump used to shape the powder. Layers were fixed along the way before details added.

Charcoal

Drawing with **charcoal**

Charcoal is a velvety black medium that creates a dense, dark mark on the page. As a drawing medium, it is almost exclusively used for artistic applications and is ubiquitous in life drawing classes and artists' studios. Charcoal is naturally expressive and allows you to lay down large areas of tone quickly through fluid marks. The range of marks and tones that can be achieved in charcoal make it a perfect medium for studies that might later be translated into paint.

On the following pages, you can find information about different forms of charcoal and their uses. Then, practice and develop your skills through 15 different approaches to charcoal drawing grouped in beginner, intermediate, and advanced sections. A showcase drawing at the end of each section demonstrates the combined techniques in a single subject.

1 Beginner techniques

- See pp.82–93

In the first section, you will explore gestural drawing and how to isolate shadow shapes, as well as learning how to smudge effectively, use the eraser as a drawing tool, and separate color from tone when you look at a subject.

2 Intermediate techniques

- See pp.94–105

In the second section, find out how to suggest volume, learn to use charcoal and white media on midtone paper, discover more about chiaroscuro, and create tonal thumbnail compositions and stippling effects.

Beginner showcase drawing (see pp.92–93)

Intermediate showcase drawing (see pp.104–105)

As a simple by-product of fire, charcoal was easily accessible to our prehistoric cave-dwelling ancestors. Some of the oldest surviving charcoal drawings—animals drawn on stones in the Apollo 11 Cave in southwest Namibia—are estimated to be 25–28,000 years old.

As a readily accessible and affordable drawing material, charcoal has been widely used by artists throughout history, mainly for studies, especially portraiture and figure drawing. It remains a popular medium in contemporary drawing practice.

Characteristics of charcoal

Willow or vine charcoal has a twiglike appearance. It makes marks readily and smudges easily, which encourages expressive mark-making. For greater control, compressed charcoal in the form of sticks or pencils is a good choice when darker, denser marks are required.

Charcoal sticks tend to be soft and fail to hold a point for long, making them poorly suited to precise work. However, some forms of charcoal stick can be honed with sandpaper. Charcoal pencils, with their compressed charcoal cores, can be sharpened to a fine point with a craft knife when required.

Most forms of charcoal can be erased relatively easily, making them ideal media for subtractive drawing techniques in which highlights are created by erasing the dark medium from the paper—working dark to light. However, the ease of erasure can be a disadvantage while drawing, because it is easy to accidentally rub off the marks as you make them, and it can also make it difficult to preserve drawings unless adequately fixed.

3 Advanced techniques

■ See pp.106–117

In the final section, modulate tone to add depth and create atmosphere, discover layering and fixing techniques, and a straightforward portrait method. Find out how to combine different kinds of charcoal.

Advanced showcase drawing (see pp.116–17)

Charcoal

THE QUALITIES OF CHARCOAL

In order to exploit the expressive nature of charcoal to suit your drawing style, choose between traditional sticks of willow or vine, or use compressed forms for more control. The ability to smudge or erase charcoal is part of its appeal—use tools such as stumps and erasers to enhance the effect.

Experiment with as many forms of charcoal as possible to explore their various qualities—some forms suit some techniques and subjects more than others.

Willow and vine sticks

Charcoal is easy to apply, leaving a smooth line that can be readily corrected or adapted as the particles sit on the surface of the paper. The best quality and richest depth of tone are achieved from sticks of willow and vine, although other woods are occasionally used. These forms of charcoal are essentially charred sticks baked in a kiln, and are lightweight, brittle, and irregular in shape. Willow charcoal is soft and produces velvety marks; it wears down quickly and is easy to smudge and erase. Harder charcoal sticks can be sharpened to a point with a knife or sandpaper and will make a more precise mark.

Compressed and powdered charcoal

Compressed charcoal is made from powdered charcoal mixed with a binder and formed into round sticks, square-profiled blocks, or the cores of charcoal pencils. Compressed charcoal is heavier, denser, and breaks less easily than willow or vine charcoal, making a very dark mark that can be difficult to erase. Powdered charcoal can be used loose for laying down large areas of tone by smudging or working the powder into the paper surface with a rag, finger, or rolled stump or tortillon.

Smudging and erasing

Various tools can be used to shape or "draw" into charcoal by moving the powdered marks around to smudge

Charcoal pencils
Encased in wood that can be sharpened, these are suited to detailed work, producing fine lines. Use a white pencil for highlights.

Peel & sketch pencils
These pencils are light and portable, making them ideal for sketching. Simply peel off the paper to reveal the point once it has worn down.

Wood and vine sticks
The classic form of charcoal, these charred sticks create the smoothest marks. You can use the end and side of the stick.

Charcoal block
This compressed form of charcoal is solid and stable, and is good for laying down large areas of dense tone.

Sharpening block
A sharpening block has removable sheets of coarse sandpaper and provides firm support when shaping delicate vine charcoal sticks.

Sandpaper
Use sandpaper to refine points of compressed charcoal that have been shaped with a knife or pencil sharpener. Rub gently and evenly.

Craft knife
A sharp knife is useful for shaping hard charcoal blocks or compressed charcoal pencils into customized points. Always cut down and away from your body.

them or by lifting off the pigment to lighten tones. Paper tools such as compacted "stumps" or tightly rolled "tortillons," can be used to smudge, blend, or draw in charcoal, as can rags, kitchen towels, tissue, and chamois leather. Your finger is also a great option for precisely controlled smudges and marks. Kneadable erasers are useful for rubbing or lifting out charcoal—they are malleable and can be shaped to match the area you wish to erase. For more precise mark-making, plastic erasers can be cut to a point and used like a drawing tool to remove lines.

Sharpening charcoal
Sharpen vine sticks using sandpaper or a sanding block. Hold the stick against the surface and rub gently, rotating the stick to develop an even point with a long taper. Keep the pressure light because vine sticks snap very easily.

Wooden and paper-wrapped compressed charcoal pencils can be sharpened with a regular pencil sharpener without breaking, or use a craft knife to shape the dull tip then refine it with sandpaper. Paper-wrapped charcoal pencils must be partially unwrapped before sharpening.

Blending sticks
These stumps are made of compacted paper with a sharp point and are used to blend, smudge, and move charcoal marks like a drawing tool.

Erasing
Mold a kneadable eraser into shape, or use the hard edge of a plastic eraser for more control.

STAEDTLER
Mars plastic

Tortillons
These tightly rolled cylinders of paper come in several sizes and are used in a similar way to a blending stick. You can unwrap the point when it is dirty.

Tortillon blending stick 5mm

Tortillon blending stick 7mm

Tortillon blending stick 8mm

Paper blending stick 5mm

Paper blending stick 15mm

Charcoal supports

CHOOSING A SURFACE TO DRAW ON

Charcoal drawings are typically made on paper—either loose or in sketchbooks—although charcoal can be used for making marks on a wide range of surfaces, from canvas and cardboard to wood or stone. Charcoal drawings must be preserved carefully and typically need to be fixed once they are completed.

A smooth, general-purpose paper, such as drawing paper, is ideal for charcoal drawing, but you can also exploit the qualities of different paper weights, textures, and tooth to affect the outcome of your drawing further.

Paper surfaces

Before starting to draw on loose paper, you should mount the sheet on a board to support the surface, securing it with clips or masking tape. Make sure the board is smooth and even, because rough textured surfaces under your paper will show through in your drawing. As a dry medium, charcoal can be used on lightweight paper without issue, typically 120-200gsm drawing paper is ideal, with heavier paper providing a firm and resilient surface for layering or eraser-based techniques. The surface texture, or tooth, of a paper plays a large part in the expression of your marks. When charcoal is applied to a very smooth paper with little tooth it may appear pale and will be easily erased. A more abrasive surface will take a greater amount of charcoal from the stick, making for darker marks. Heavily textured paper, such as pastel or watercolor paper, will pick up lots of charcoal, but will also create texture in the surface of the drawing. As an opaque, black medium, charcoal covers colored papers well, and charcoal is often used in combination with white media on toned papers to great effect.

Preserving drawings

In order to avoid unwanted smudging, charcoal drawings should be fixed once they are finished. Ideally, use a professional quality fixative in aerosol or spray form. Hairspray is often used as a cheaper and less effective alternative to professional fixative, but

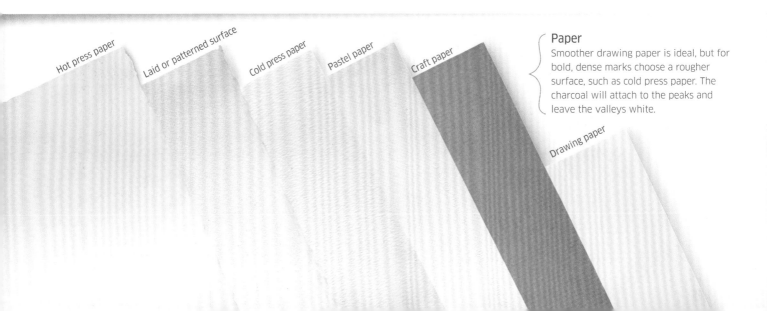

Hot press paper

Laid or patterned surface

Cold press paper

Pastel paper

Craft paper

Paper
Smoother drawing paper is ideal, but for bold, dense marks choose a rougher surface, such as cold press paper. The charcoal will attach to the peaks and leave the valleys white.

Drawing paper

Sketchbook
Choose one with heavier, slightly-textured pages large enough for the expressive gestures best suited to charcoal.

Board with paper secured
Attach loose sheets of paper to a drawing board with clips and use masking tape to secure the paper and create a frame in which to draw.

Masking tape
This is a very useful material for attaching paper to boards or masking off the edges of a drawing to create clean lines.

can lead to conservation issues. When you are storing charcoal drawings flat or in a folder, place a piece of acid-free tracing paper or drawing paper on top of each one to stop charcoal rubbing off onto the back of the drawing above.

Sketchbooks
Charcoal can be used in sketchbooks, but its propensity for smudging makes it advisable to draw on one side of the paper only, leaving the opposite page blank to protect the drawing. Alternatively, leaves of tracing paper or drawing paper can be slipped between

pages to protect them. Fix sketchbook drawings and allow to dry for a few minutes before turning to another page.

Fixing a drawing
Before you start drawing, lay your paper out flat and attach it to a board or flat surface with masking tape or clips to prevent it moving. When finished, gently brush away any loose particles. Work in a well-ventilated area and spray the fixative at arm's length from the drawing in a continuous, even layer that covers the whole surface in a light mist. Allow to dry completely.

> "The nature of your **charcoal drawing** will be determined to some extent by **the texture, tone, and weight of paper** that you work on."

Fixative spray

Fixative
Good-quality fixative spray is essential for preserving charcoal drawings. It bonds the particles to the paper to prevent them smudging or rubbing off onto other surfaces.

1 Drawing before fixing
The range of marks and tones on the paper surface can be preserved with a layer of spray fixative. Once dry, you can continue to work on the drawing.

2 Drawing after fixing
The soft tones of the fabric have been preserved, allowing the denser marks in the folds to be added on top, without smudging surrounding areas.

Gesture drawing

LOOSE, DYNAMIC DRAWINGS

Willow charcoal is a versatile and expressive medium, ideal for capturing a sense of energetic movement. When you are drawing from short poses, you need to trust your developing intuition and allow a connection to form between eye and hand as you draw. Focus on the process of looking and making marks in response to what you see, without overthinking each line.

Charcoal grips

Your whole body can contribute to the marks you make on the page—find a drawing stance that is both comfortable and engaged, then hold the charcoal with a loose grip, making marks that come from your shoulder and elbow (see also pp.38–39).

A singular line
Using the tip of the charcoal with a varying amount of pressure creates a dynamic line, which along with drawing from the elbow or shoulder contributes to the overall energy of a drawing.

Broad strokes
Even a small piece of charcoal can be used effectively. The side of the charcoal gives tone and drama to a drawing; the borders of the marks can be left as is, erased, or smudged to achieve the desired effect.

Naomi, an aerialist, posed in mid-air on her steel hoop for 1–3 minutes at a time for these studies, similar to the warm-up poses you might draw in a life-drawing class.

You will need

Willow charcoal

- Willow charcoal
- Eraser
- Drawing paper

Naomi strikes a pose

1 Gestural sweeps
Start with quick, simple lines that lightly and confidently suggest the shape and gesture of the pose. Avoid getting caught up in detail.

A changing weight of line

"Charcoal is the perfect medium to capture energetic movement."

2 Dark tone
Snap the end of your charcoal stick and use its broad edge to draw in a sweep of tone, angling the charcoal as you move to achieve a variety of widths from a single stroke.

Sweep of charcoal

Erased highlight

3 Smudged tones
Charcoal is always initially dark, but can be easily erased. Use a cloth, your hand, or a finger to lift out charcoal from the dark sweep to create more nuanced shadows.

Smudged shadow

4 Enough detail
Use the sharp edge of your freshly snapped charcoal stick to dash in small details to sculpt the form and add finesse—the face and striped stockings in this instance.

Shadow shapes

DELINEATING TONE

To improve your tonal drawings you'll need to learn to translate the shapes of light and dark that you see in your subjects into shapes of particular tonal values on the page. By drawing around your subject first, delineating the shapes that you can see, then filling those shadow shapes with tonal marks, you can create a superb tonal drawing in a few manageable steps.

■ Edges of shadow

Sometimes the edge of a shadow or object is clear and sharp; at other times, the space between a dark area and a light area is bridged by a gradient of tone. You will need to develop methods of mark-making for representing hard and soft shadow edges.

Sharp edge
You will often see sharp edges at boundaries where the tone of an object contrasts with the tone of its surroundings. Emphasizing the contrast at the boundary by darkening the dark area and lightening the light area will keep tonal shapes crisp.

— Hard shadow edge

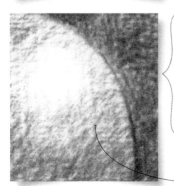

Soft tonal gradient
When light falls over a curved surface, you'll often see a gradient of midtone receding away from the brightest light. To graduate the tone, establish the dark end of the gradient first, making increasingly pale marks toward the area of light.

— A graduated tone

PUTTING IT INTO PRACTICE

PUTTING IT INTO PRACTICE

Create distinct shadow shapes on some white crockery using light from a single desk lamp, with all the ambient light blocked out by black fabric.

You will need

Hard charcoal

- Hard charcoal
- Sandpaper
- Eraser
- Drawing paper

All white crockery

1 Outline of objects
After sharpening the hard charcoal with sandpaper, use light, quick marks to plot out the overall shapes of the objects and the shadows that they cast.

2 Outline of shadows
Find further shapes of shadows within your subject and those cast by it, marking the sharp edges of shadow shapes with dark lines and the soft gradients more lightly.

3 Midtones first
Leave the light areas white and shade the shadow shapes with diagonal marks, filling the shapes with a midtone. Avoid pressing too hard or creating overly dark shadows.

4 Dark and light tones
Working from the midtones, use pale marks to smooth the gradients between areas of light and dark. Finally, use harder, darker marks to deepen the shadows where needed.

"Sometimes the edge of a shadow or object is **clear and sharp**; at other times there is a **gradient of tone.**"

Smudged tone

BLENDING VALUES

Marks made in charcoal are easily smudged and this property can be exploited to great effect. When you are moving charcoal around the page you need to do so with conviction. Make sure that your smudged marks are deliberate and considered, not a vague means of covering up an area of uncertainty, because that will become all too obvious.

PUTTING IT INTO PRACTICE

In this seascape, the white foam pools around the dark boulders on a rocky coast. Such contrasting tones provide a varied range of hard and soft edges to draw, making a distinction between soft sea foam and hard rock.

You will need

Willow charcoal

- Willow charcoal
- Cloth or paper towel
- Stumps and tortillons
- Drawing paper

A rocky shoreline

1 Reservoirs of dark
The charcoal you add to the page will be the only material that you can move around with your blending tools. Draw in large sweeps of charcoal with the side of a stick, leaving any areas of light clean.

2 Soften tone
Bunch up the cloth or paper towel over a finger, creating a soft pad, and sweep it evenly over the first layer of charcoal, lightening the dark tones while still allowing the light areas to remain white.

Blending tools

If you blend or smudge charcoal marks with a finger, the skin's grease will make the marks inconsistent and difficult to control. So, it's best to use cloths and paper towels for blending large areas, and tortillons or stumps and brushes for more specific marks.

Blending with a paper towel
A paper towel, or cloth, will allow your repeated rubs to blend areas of charcoal tones until you're happy with the smooth result.

Blending with a stump
A stump—basically paper tightly rolled into a pencil shape—can be sharpened and so allows you to blend with precision.

Creating the midtone background allows the dark boulders to stand out

3 Dark shapes
Use the broad edge of a small length of charcoal to create shapes of dark on top of the midtones, creating rocks and a distant cliff.

4 Smudged detail
Use the stump to lift charcoal off the page, lightening some of the dark areas between the rocks. Once the tip has picked up some charcoal, use it to draw the subtle shadows of the waves back into the light areas.

Subtractive tone

DRAWING LIGHT WITH AN ERASER

An eraser isn't just a way of getting rid of mistakes, it is a valuable drawing tool for drawing light back into dark. By applying a charcoal ground to a page you can start your drawing from a midtone, creating shapes of light by erasing the charcoal and exposing the white of the page, or adding more charcoal to darken areas of shadow.

▨ Drawing with an eraser

By cutting a rectangular plastic eraser in half diagonally you'll create a long, clean edge that can be used for drawing broad sweeps of light back into the charcoal as well as a sharp point for drawing precise light lines. It is also possible to buy trapezoid erasers with sharp points or pencil-shaped erasers for fine, detailed work. This technique is sometimes known as "lifting out."

Broad sweeps
Remove swathes of charcoal in one move with the eraser on the longer side. Press firmly and evenly, and wipe any excess charcoal off before repeating.

Sharp points
Cut the point to the right angle for your purpose and control it with your finger close to the tip to apply firm and constant pressure to remove the charcoal.

In this drawing, the subject is light itself—the low winter sun creates window panes on the floor of a studio block. It's an exercise using perspective, too.

You will need

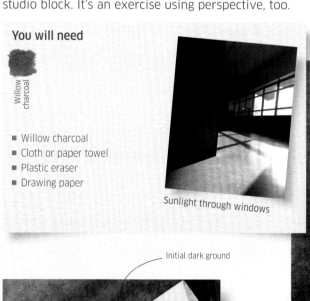

Willow charcoal

- Willow charcoal
- Cloth or paper towel
- Plastic eraser
- Drawing paper

Sunlight through windows

Initial dark ground

Midtone charcoal ground

1 Charcoal ground

Use the broad edge of your charcoal to quickly cover the page with black, then swiftly sweep a folded cloth or paper towel over the surface to lift some of the charcoal off, creating a wonderfully even midtone.

2 Rubbing out
Use the broad edge of an eraser to draw in shapes of light, applying plenty of pressure to ensure clear marks. Wield the eraser like a brush, drawing shapes directly without relying on outlines. Re-darken areas if your shapes go awry.

"An eraser isn't just a way to get rid of mistakes, it is a valuable drawing tool."

3 Return to the darks
Apply the charcoal to darken parts further, sharpening up the edges of some of your shapes of light and establishing the darkest darks in your drawing.

4 Finer highlights
Using the sharp edge of the eraser, bring more nuance into the highlights—you will most likely find that you can never quite return to the white of the page.

Judging tonal value

READING TONE AND COLOR

Drawings made exclusively in black charcoal on white paper are monochromatic—they simplify the subject to a gray scale. Learning to judge the tonal value of an area of color is an important—but quite difficult—skill to hone, but making drawings of brightly colored items will help you to judge the relative tones of colors more clearly.

■ Tone and color

Our perception of the hue (color) and saturation (intensity of pigmentation) of a color often overrides our perception of its tonal value. Try to imagine how a colorful subject might look as a black and white photograph as you draw it.

In full color
Bright colors draw the eye—in this image, the saturated orange hue of the clementine immediately asks for the viewer's attention. It is hard to judge the relative tone of the pieces of fruit when the color information is so intense and overwhelms the tone.

In black and white
If the same image is seen in black and white, the focus shifts away from the bright fruits. When the colors are reduced to their tonal component, it might be surprising to notice that the green lime and red apple are almost the same tones.

The highlight on the purple grape has a similar tone to the red apple in monochrome

PUTTING IT INTO PRACTICE

When drawing in black and white, it can sometimes help to let your focus on the subject wane so that you notice the differences in light and dark without being distracted by the color.

You will need

Hard charcoal

Charcoal pencil

- Hard charcoal
- Charcoal pencil
- Sandpaper for sharpening
- Tortillon
- Eraser
- Drawing paper

A fruity selection

A sharp charcoal line

1 Initial sketch
Using a hard charcoal stick sharpened with sandpaper, make a simple line drawing of the fruit, similar to the initial line drawing on pages 84-85. Focus on getting the outlines and composition right.

2 Midtones
Use the hard charcoal to shade these outlines with midtones, leaving any bright areas as white paper; the yellow on the light side of the banana, for example, is almost as light as the white background.

3 Blending tone
Use a tortillon to smooth the charcoal to an even midtone in all areas of the drawing that require it. Don't worry if you overblend; any lost detail can be re-established later.

4 Look for the light
Add highlights into the midtones using an eraser. Flick your eye between one piece of fruit and another to judge how light and dark each appears in relation to its surroundings.

5 The darkest darks
Take a sharp charcoal pencil and introduce darker tones; you can use the compressed charcoal to extend the tonal range further than was possible with the previous charcoal.

Lightest lights

Title **The Viaduct at Randalstown**
Artist **Jake Spicer**
Medium **Willow charcoal**
Support **Drawing paper**

Shadow shapes

≪ See pp.84–85

The bridge has been drawn as a series of light and dark shapes, with the outlines of these shadow shapes marked out in willow charcoal, and filled in with tonal marks.

Judging tonal value

≪ See pp.90–91

The autumnal colors in the distant trees have been translated into a grayscale in this black and white drawing, which shows the relative tones of colors.

Tone smudged with a stump

≪ See pp.86–87

The ripples in the river are smudged in with a stump, using charcoal lifted from distant trees to create dark shapes around the highlights.

Showcase drawing

This viaduct provided an ideal subject for exploring the techniques described in this section, with the dark shapes of the arches surrounding abstract shapes of light sky that lent themselves to using an eraser as a drawing tool and flowing water that could be rendered in smudged marks.

Tone smudged with a cloth

≪ See pp.86–87

The dark tones of the bridge and road have been smudged and lifted away with a folded cloth to create a smooth midtone.

Subtractive tone

≪ See pp.88–89

At a late stage of the drawing, highlights and light shapes of the sky have been lifted out from the charcoal with a kneaded rubber eraser.

Gestural drawing

≪ pp.82–83

A quickly moving figure has been sketched in loosely over the top as she walked by the bridge. The loose marks add contrast to the tonal work of the scene.

Mass and volume

SUGGESTING FORM THROUGH MARK-MAKING

To create the illusion of 3D form in a 2D drawing you need to develop a language of marks that suggests the direction of a surface. Curving contour marks, for example, imply a rounded form, and these can also be layered to create tone, which helps to reinforce the mass of the subject.

▧ Drawing contours

A linear drawing is inherently flat—to give the illusion of form without relying on strong lighting, you can use contour marks that describe and follow the subject's surface, thereby suggesting whether the space between the lines is concave, convex, or flat.

Outline shape
With a loose hold on the charcoal pencil, quickly establish the shape of your subject. The flat, linear drawing will serve as a foundation as you add contour marks.

Curving cross-contours
Imagining how the shape of your subject would feel to the touch, use curved cross-contour lines to describe the form. Build up your marks to suggest both tone and the direction of the surface.

Cross-hatching
Where the previous marks curved around the form, your next marks can be made in the other direction along the form to create a lattice of marks, building up a darker, cross-hatched tone.

When thinking of a subject that would embody mass at a glance, the cow is a perfect example. As well as being massive, the directions of marks needed to sculpt its forms on the page are easily evident.

1 Underlying shapes
Starting a drawing with big, simple shapes can help to establish a structure on which to build your observations. Rounded forms under the chest, circular joints, and a blocky head help anchor the masses of the body.

2 Foundation for contours
With a freshly sharpened charcoal pencil, draw in the lines that bow and stretch between the voluminous masses of the cow's body, creating a light outline.

You will need

Charcoal
pencil

- Charcoal pencil
- Sharpening tools
- Eraser
- Drawing paper

An inquisitive cow

"Develop a vocabulary of curving cross-contour marks to suggest the direction of a surface."

3 Contour marks

To describe the direction of surfaces, use cross-contours to sculpt around the figure to give it form. The rounded belly is a good place to start, with more complex directional marks crossing the shoulder and neck. If you're drawing from life (not from a photo), it's easier to judge surface directions.

4 Reinforcing cross-hatching

Once the main contours of the body have been established, you can develop the mass further with cross-hatching marks made along the length of the body and over the rest of the animal—these marks serve to further describe the form and deepen tone.

Toned paper

TONAL STUDIES ON BROWN OR GRAY

The world around us is predominantly made up of midtones—we rarely see darks that are as black as charcoal or whites as bright as bleached paper. Using toned paper provides a base to create a tonally varied drawing quickly, using charcoal to deepen shadows and white chalk for highlights.

▨ Starting with the midtone

When working on toned paper, you will be actively adding the light tones. Use lighter marks or hatching to draw shapes, looking for changes in light to describe form. Be selective with dark tones and add highlights at a late stage to avoid the chalk and charcoal mixing.

Starting shape
Use simple outlines to describe the main shape, noting the areas of shadow and marking the transitions between highlights and shadow. Pay attention to the direction of the main light source and sketch in any cast shadows.

Darks added
Look for negative shapes (see pp.40–41) to define the shaded areas and describe them with dark tones, following the object's form with the direction of your marks. Use the darkest tones at the base to anchor the object to its shadow.

Highlights added
Using a white chalk or Conté crayon, add the brightest highlights where the light hits the surface, leaving the paper to read as the midtones. Again, follow the shape of the object with your marks, softening the edges to fade.

In this drawing, the strong top light creates areas of highlight and deep shadow, drawn in chalk and charcoal. The warm brown paper is used as the unifying midtone.

1 Initial sketch
Use a charcoal pencil to quickly sketch the main outlines to establish the gestures and poses of the interacting figures and the major shapes in the scene, such as the chair and table, using loose marks.

2 Shadow shapes
Draw in the key shadow areas and reinforce the sketched outline with bolder, more confident lines, looking carefully at the subject to check your observations.

"Toned paper creates a harmonious base for tonal drawing."

You will need

Charcoal pencil

- Charcoal pencil
- White Conté crayon
- Sharpening tools (craft knife and sharpening block or sandpaper)
- Brown paper

Chess players

3 Dark midtones

The brown paper provides the midtones in the figures and chess set. Develop the darker midtones with charcoal contour marks that curve around the forms of the figures, using simple hatching and blending.

4 Highlights

Use a white Conté crayon to pick out the brightest highlights on the figures and chessboard. Keep the marks selective to ensure they retain impact, and consistent to accurately portray the direction of light.

Chiaroscuro

LIGHTING FOR DRAMATIC CONTRASTS

The word *chiaroscuro* comes from Italian. It literally means "light and dark" and refers to the defined and dramatic distribution of tone within an image. When you want to explore this type of tonal drawing, think of the object in front of you as the light itself. Varying the direction of the lighting will create a very different subject to draw.

Directional lighting

Before you get started with the hands-on tonal drawing, explore the possible lighting options before settling on a particular set-up. See the examples (below) for how the skull's appearance changes just by tweaking the direction of the lighting. Use black fabric to block out the ambient light around your subject for best effect.

Lit from the front
Lighting angled at the front of the skull, as here, allows you to see the entire boundary of the skull's surface clearly, as well as a range of interesting shadows. You can glean many details from a long look under this lighting.

Lit from the side
The super-bright highlight on the right-hand side of the skull shows where the light first hits the object. The left-hand side is poorly lit and so the details are difficult to resolve and almost fade into the backcloth.

Lit from below
Angling the light source upward to illuminate the lower parts of the skull means that the top side of the skull is in shadow. The circular hole of the orbit and nearby features, including the teeth, are more clearly visible.

To maximize the visible details, light your subject from several directions. Choose a light-colored object so that you clearly see the shadow shapes, without the distraction of color variations.

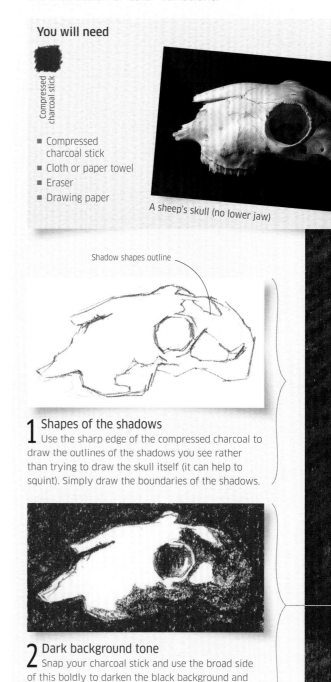

You will need

Compressed charcoal stick

- Compressed charcoal stick
- Cloth or paper towel
- Eraser
- Drawing paper

A sheep's skull (no lower jaw)

Shadow shapes outline

1 Shapes of the shadows
Use the sharp edge of the compressed charcoal to draw the outlines of the shadows you see rather than trying to draw the skull itself (it can help to squint). Simply draw the boundaries of the shadows.

2 Dark background tone
Snap your charcoal stick and use the broad side of this boldly to darken the black background and darkest shadows on the skull, while allowing the highlights and midtones to remain white.

3 Contrast reduction
Sweep a cloth or paper towel lightly and confidently over the drawing, darkening the white paper to a midtone. You can then choose where to add the highlights back in.

4 Identifying the highlights
Use an eraser to draw shapes of bright light back into the midtone. Initially, use the broad edge of the eraser, but switch to its sharper point for the smaller details.

5 Definition of the darks
Return to using the sharp edge of the previously snapped charcoal stick to selectively emphasize the darkest shadows. Try not to overwork the drawing.

Tonal compositions

STUDIES OF LIGHT EFFECTS

The success of a well-resolved drawing doesn't just rely on an effective rendering of the subject, but also on abstract arrangements of shapes in its composition. Divide a sketchbook page into sections and create a series of thumbnail sketches that focus on the arrangements of light and dark in different views of your subject.

■ Cropping a composition

When deciding on a particular view to draw, it's a good idea to explore various compositions with quickly sketched-out thumbnails. Cropping a composition will help you to change the relationship between the subject and the picture plane. You can crop into a sketch to make it smaller, change from landscape to portrait shape by erasing, or enlarge by redrawing the boundary —all three will change the picture plane's dimension.

Initial crop
In this landscape scene, the gate in the fence is a central feature, but the eye is also drawn into the distance by the disappearing treeline and path. The foreground is quite empty on the right.

Altered crop
This squared-up view erases the empty foreground from the original landscape version and makes the central focus the gate itself, rather than what's in the distance.

These thumbnail sketches of the countryside were made in a sketchbook using various charcoals. The wintry sun, low in the sky, created dramatic shapes of shadows and helped to frame these compositions.

Creating focus
Here, the eye is guided along a path, to look toward the light between the tree trunks. The wide, light shapes on the right-hand side of this composition narrow toward the center of the picture plane, thereby reinforcing the direction of the path.

Using height
This L-shaped composition draws attention to the verticality of the trees. The dark mass of distant hills lies low to accentuate the height of the trees, and the path of contrails in the sky draws the eye to their upper branches.

Contrast of vertical and horizontal elements

Tonal shaping

Here, the light wedge of the path leads the viewer into the distance, flanked by the dark bank and trees. The single distant tree provides a focus and a block to stop the eye slipping off the page.

The path disappears between two hills

Messing with symmetry

A dark triangle nestles within light shapes, drawing the eye down the sweeping path. The curve of the path and the two cows on the left-hand hill create engaging asymmetry.

Leading the eye

This long landscape composition creates two opposing wedges—the light of the sky and the dark of the land. The eye naturally travels downhill to the lone tree.

Rule of thirds

A halo of light sky draws attention to the signpost, which appears as a solid and super-dark upright. The composition also conforms to the rule of thirds in the placing of the post and tree.

Careful placement of the tree

> "Abstract shapes in a composition can help you to decide what to draw."

Stippling

USING DASHES AND DOTS TO BUILD TONE

Repeated dots or dashes can be built up to create shapes and gradients of tone. This approach to mark-making requires you to develop an image gradually, increasing the density of your marks to darken some areas of the drawing, while leaving the white of the paper as a highlight.

■ Tonal gradients

Create variations in tone by grouping the dots or dashes tightly (darker tone) or loosely (lighter tone). Practice tapping the tip of the charcoal to make the dots or dashes; feel how holding the charcoal tightly or more loosely affects the mark's character and its placement.

Starting off
Covering an area loosely with dots or dashes builds an area of light tone, with the white of the paper shining through. Practice creating a tonal gradient of light tone, building up just enough density of marks on one side, compared with the other.

Build up more tone
Another useful exercise in learning how to use stippling is the creation of a midtone gradient—from a midtone on one side to a light tone on the other. Slowly and surely build up the marks so that a smooth variation in tone is visible.

Complete the gradient
If you continue to build on the midtone gradient, you'll create a gradient of tone from dark to light, with the left side (as here) having the highest density of marks and therefore the highest density of tone; note how hardly any white shows through.

Use strong directional light against a dark backdrop, as here, to make it easy to see the tonal contrasts in your subject and translate them into your drawing to build up form.

1 Limits of subject
Start by dashing a few construction marks onto the paper to establish proportions and placement of features. When you build up gradually, like this, it's really useful to have this initial guidance.

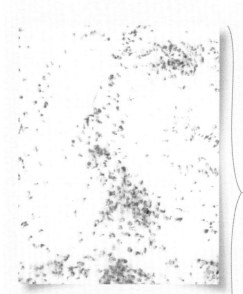

2 Loose concentrations of marks
Start with a loose distribution of marks, continuously and mechanically stippling, all the time flicking your eyes from the subject to the drawing—leave the light areas white.

"Groups of small dots sitting closely together appear as an area of tone in a drawing."

You will need

Willow charcoal

- Willow charcoal
- Drawing paper

Portrait under strong light

3 Building tone
Create denser areas to reflect the darker areas of the subject, constantly leaning back from the drawing to see how the image resolves itself as a whole. The form of the face will soon begin to appear.

4 Directional marks
Once you're happy with the form of the drawing created by the stippling, finish off by reinforcing certain edges with marks that accentuate the boundaries of important shadows or draw attention to key features.

Title **The Parthenon statues**
Artist **Jake Spicer**
Medium **Hard charcoal, charcoal pencil**
Support **Brown paper**

Mass and volume
≪ See pp.94–95

The voluminous forms of the draped figures have been rendered with contour marks made in the direction of the stone's surface, following the forms of the figures.

Midtone paper
≪ See pp.96–97

Brown paper was used as a starting midtone, with darker tones built up in hard charcoal and more linear details added with charcoal pencil.

White highlights on midtone paper
≪ See pp.96–97

White highlights were selectively added to the statues in the final stages of the drawing using a white Conté crayon.

Showcase drawing

Museums contain a wealth of subjects to draw, and most welcome sketchers, with many visitors coming equipped with sketchbooks and drawings boards. These statues were drawn by combining all of the techniques used to build up form and tone explored in this chapter.

Chiaroscuro

≪ See pp.98–99

Spotlights create a dramatic contrast of light and shade over the surface of the statues, rendered by the darks and lights added to the midtones of the paper.

Tonal composition

≪ pp.100–101

Several compositions were sketched out before settling on this static arrangement, which draws attention to the weight and mass of the statuesque subject.

Stippling

≪ See pp.102–103

Dashed marks in hard charcoal were used to create a gradient of tone in the background of the drawing, adding textural interest to the large, flat area.

Aerial perspective

VARYING TONE TO CREATE DEPTH

Aerial (also known as atmospheric) perspective mimics the phenomenon where distant objects appear paler than their nearer counterparts. The further light has to travel, the more diffused it becomes. The effect is mostly clearly apparent over large distances, and it will be greatly accentuated on misty days. You can use this fact to create the illusion of depth on the page, in combination with linear perspective, by which objects appear smaller in the distance.

PUTTING IT INTO PRACTICE

The view down this wide river estuary shows how the mountains many miles away become increasingly pale and indistinct as they recede. This effect is heightened on misty days when the cloud hangs low.

You will need

Hard charcoal

- Hard charcoal
- Sandpaper for sharpening
- Eraser
- Drawing paper

Down the river

1 Underdrawing
An initial linear drawing will help you establish the basic shapes in your chosen composition. Later, you'll be able to concentrate on tonal variations between different elements of the picture.

2 Background
Draw in the lightest tones first—those that belong to the distant mountains. Err on the side of light (pale) in your tones here to ensure you allow for darker middle ground and foreground tones later.

Three planes of drawing

Separating a drawing into three distinct picture planes—foreground, middle ground, and background—can help you to vary the tonal values of your drawing to suggest depth by simulating distance. As well as rendering the background elements as paler, you can draw nearer objects in more detail and larger, with more tonal contrast.

Background
Over a great distance objects in the far background will appear paler and less distinct. The effect can be exaggerated to imply greater distance.

Middle ground
The way middle ground elements overlap background or foreground elements will help to draw attention to the contrasts between them.

Foreground
You will see more detail and tonal contrast in nearer foreground subjects, which will also appear larger than their distant counterparts.

3 Midddle ground
As you draw the middle ground features, notice how there is more variation between the highlights and the shadows (compared with those in the distance). Highlights remain darker than in the foreground and the shadows paler.

4 Foreground
Finally, complete the foreground details. Allow the white of the paper to come through for the highlights and save your darkest marks for the strong shadows. You will be able to observe and draw more detail and tonal variety in those nearer subjects.

Layered drawing

FIXING LAYERS TO BROADEN TONAL VALUE

Charcoal is easily rubbed off the surface of a page—a quality that can be an advantage in many techniques. However, when you are layering charcoal marks to create deep blacks you will find that each new layer scrapes off part of the previous layer. Using paper with what's known as a heavy tooth and spraying the drawing with fixative at each stage will allow you to build up multiple layers effectively.

PUTTING IT INTO PRACTICE

Drawing studies of bunched and draped fabric will help you to better understand the way that fabric falls when you come to draw a clothed figure. This study of loosely knotted white fabric was drawn under natural light. Using a toothed paper that allows for layering with fixative adds depth to the shadows, as well as suggesting a textural quality to the fabric.

You will need

Hard charcoal

- Hard charcoal
- Sharpening tools (craft knife and sharpening block or sandpaper)
- Fixative
- Pastel paper (off-white)

1 Initial sketch
Get to grips with the overall shape of the fabric and the interlocking shapes of its major folds. Start with a light outline, then work through the folds, drawing in the largest creases first.

2 Light tones
Build up a first layer of tone over your initial linear sketch, applying the charcoal lightly and letting the tooth of the paper pick up your marks. Spray the drawing with fixative and leave it to dry for 5 minutes before starting on the next layer.

A paper's "tooth"

Imagine seeing paper up close: you'd be able to make out all the peaks and valleys of its surface. This texture is known as tooth. For a layered drawing, choose a paper with plenty of tooth. These swatches show how the same charcoal applied with the same pressure can appear differently on varied supports.

Cold-press watercolor paper
This distinctively textured paper picks up a generous amount of charcoal.

Pastel paper
The paper's heavy directional grain is designed to trap layers of pastel, making it ideal for a layered drawing.

Drawing paper
This smooth paper has a very light, fine tooth. It is easy to rub charcoal off its surface, so it is less ideal for layering.

Loosely knotted white fabric

3 Midtones
Next, build up the midtones; this time, make directional marks that have greater weight and clarity. Deepen the tone in the folds to draw attention to the light planes of fabric. Fix the drawing again and leave it to dry.

4 Dark tones
Finally, add the darkest tones. Making sure the charcoal is sharp, pick out details in the creases of the fabric. Clarify the edges between fabric and shadow in the background and foreground. Add one final spray of fixative to the drawing.

Portraits

A STRUCTURED APPROACH TO DRAWING HEADS

Faces make for one of the most engaging subjects to draw, and drawing a portrait from life gives you time to become sensitive to the characterful shapes in your sitter's face. However, our sensitivity to expression and proportional difference can make us critical of our own portrait drawings.

■ The head at different angles

The human head viewed from different angles presents different drawing challenges. Become familiar with the shapes you might expect to see at different angles to help you lay down sound foundations in your portraits. Seen from the front, the face is roughly ovoid, while viewed from the side triangular shapes are more apparent. A three-quarter view is the most challenging angle—although one often favored by artists and sitters.

Three-quarter view
As the head turns you will see more of one side of the face—the sliver of cheek on the far side of the nose gets smaller as the cheek on the other side appears larger.

Profile
Viewed from the side, the face occupies a small portion of the head—the ear provides a useful marker point between the large masses of cheek, hair, and neck.

Stringent observation and a sound order of working are the keys to success. This portrait, drawn from life in an hour, was lit from the front with daylight to minimize shadows and focus on the features.

You will need

Charcoal pencil

- Charcoal pencil
- Sharpening tools
- Eraser
- Drawing paper

Frontal view

1 Underlying form
With a loose hold on the charcoal pencil, draw in the simple underlying shapes of the head and neck. Avoid drawing a circle or oval for the face—look for the shape of the skull and jot in quickly observed marks for the eyebrows, eyes, bottom of the nose, and mouth.

2 Tonal shapes
Using the side of the charcoal pencil, block in shadow shapes—avoid getting into the detail of the features. Use an eraser to blend the tone and to clean up highlights.

"Portrait drawing from **life** helps you to see the **shapes** and **proportions** of your sitter's **face.**"

3 Eyebrows and eyes
Set the features in the face, working from the eyebrows downward. Rather than draw features as you expect them to appear, draw the dark shapes as you see them. Draw the iris of the eye—leave the pupils until last.

4 Nose and mouth
Draw in the underside of the nose, paying attention to the distance between nostrils and eye—it is easy to make noses too long. When you draw the lips, work outwards from the dark center line.

5 Jaw, ears, and hair
Use the newly drawn features as reference points to re-establish the shape of the face, working from chin to jawline to ears with a sharp charcoal pencil. Use the eyebrows, forehead, and ears to establish the hairline. Build up marks in the hair direction.

Creating atmosphere

USING SHADOWS TO EVOKE MOOD

Tone can be a powerful emotive tool in an image. The broad tonal range of charcoal makes it an ideal medium for adding dramatic effect to a drawing, implied through contrasts of light and shade.

▓ Experimenting with lighting effects

Taking cues from the conventions of film, photography, and video art, experiment with mood-enhancing lighting by drawing the same subject lit in different ways. Use cast shadows or darkened figures to add drama and intrigue to a composition, exploiting the bold tones with a range of charcoal marks.

Uniform tones
When lit from the front right, the drawing exhibits limited tonal contrasts—any sense of atmosphere is conveyed by the subject rather than the lighting. The uniform tones suggest a tranquil scene.

Uplighting
Lighting the face from below is a common motif in horror films, eerily distorting the features. It casts dark, looming shadows with strong contrasts of tone.

Dark figure
Lit from behind, the majority of the figure is thrown into shadow, creating a halo of rim lighting around the body and lending the image an air of mystery.

This interior is lit by a single light source to the front right, creating chiaroscuro, silhouetting the figure, and throwing the room into shadow. Bright highlights are used as a stark contrast to the deep shadows.

You will need

Charcoal pencil

- Charcoal pencil
- Sharpening tools
- Kneaded eraser
- Hot press watercolor paper

Interior with a figure

1 Compositional sketch
Think about the relationship of the figure to the shapes of the light and shadow around them. This is particularly important when you are creating a sense of narrative or atmosphere in an image. Sketch in the main shapes, establishing the foreground, midground, and background elements.

2 Establishing outlines
Build on the initial compositional sketch, establishing the outlines of your subject with firmer marks before committing to tone.

3 Tonal marks
Use hatching, sensitive to the form of the figure, to develop tone in the main subject first, creating clear shapes of light and dark, and allowing some details of the figure to fall into shadow.

4 Background tone
Use simple hatching to build up light and midtone in the background, thinking about how the shapes of the shadows help to draw attention to the figure.

5 Darkest tones
Use denser cross-hatching to develop dark tones through the picture. Clean up and brighten highlights with an eraser to heighten contrasts of light and shade.

"Use stark contrasts of light and shade to evoke atmosphere and drama in charcoal drawings."

Combining charcoals

COMBINING CHARCOAL STICKS, COMPRESSED CHARCOAL, AND CHARCOAL PENCILS

Each different form of charcoal has properties that make it suited to a particular technique. The ease with which willow or vine can be erased makes it ideal for underdrawing, while the dense black of compressed charcoal makes it suitable for deep shadows. Charcoal pencil adds a precision that is difficult to achieve with charcoal sticks.

PUTTING IT INTO PRACTICE

Paths invite a viewer into the picture. This landscape, drawn from a photograph of a hilly walk, contains an array of contrasting textures suitable for drawing in different types of charcoal.

You will need

Hard charcoal Compressed charcoal Charcoal pencil

- Hard, vine, or willow charcoal
- Compressed charcoal
- Charcoal pencil
- White Conté crayon
- Sharpening tools
- Eraser
- Cloth
- Drawing paper

Path into the landscape

1 Hard charcoal
A simple stick of willow, vine, or hard charcoal could be used for making this underdrawing—most importantly, it should be a type of charcoal that is easily erased or obscured by later layers.

2 Compressed charcoal
Compressed charcoal makes a dark, dense mark that can be smudged to create a midtone. Block in the large, dark shapes with the side of a snapped stick of compressed charcoal and smudge a midtone across the page.

Choosing materials

When you are choosing which form of charcoal to use in a drawing, consider how dark its densest marks will be, how easily it can be sharpened and whether it keeps its point, how easily it can be smudged, and how easily it can be erased. If combining charcoals, you can make the most of each property.

Hard charcoal
Vine, willow, or hard charcoal lends itself to soft gradients that can be easily smudged or erased to create highlights.

Compressed charcoal
You can make a blacker mark with compressed charcoal and add strong, bold darks, but it is harder to erase.

Charcoal pencil
Perfect for adding definition and texture, charcoal pencil is a useful tool for drawings that incorporate linear detail.

3 Eraser
Use an eraser to pick out light shapes. The clouds here have been erased out of an even gradient of compressed charcoal, added at a previous stage.

4 Charcoal pencil
Use a charcoal pencil sharpened to a point to pick out foreground detail, add shadow to the underside of the clouds, and add darkest darks to the drawing.

5 White Conté crayon
As a final finishing touch, use a white Conté crayon to insert white highlights in the dark tones of the foreground.

Artist **Jake Spicer**
Title **The Garden at Fermoys**
Medium **Vine charcoal, compressed charcoal, and charcoal pencil**
Support **Drawing paper 200gsm**

Layered drawing
« See pp.108–109
This drawing was built up in layers fixed one at a time to prevent top layers scraping off the ones underneath—the darkest darks represent three layers of charcoal.

Drawing portraits
« See pp.110–11
The features of the girl in the garden—seen almost in profile—are picked out clearly with the fine point of a charcoal pencil, drawing the viewer's attention.

Aerial perspective
« See pp.106–107
The distant copse at the end of the field behind appears paler through the morning haze, suggesting its distance from the strong, darker forms of the close-up trees.

Showcase drawing

This garden scene was drawn early in the morning, in atmospheric low light. A range of different charcoal-based media was used over several layers of drawing to render the figure and the foliage as an example of all the techniques explored in this advanced section.

Creating atmosphere

≪ See pp.112–13

The tonal contrasts across the picture suggest low-lying early morning light, creating a still and quiet atmosphere, suitable to the setting and time of day.

Combining charcoals: charcoal pencil

≪ See pp.114–15

Detail in the foliage was picked out with a sharp charcoal pencil and the highlights accentuated with an eraser.

Combining charcoals: compressed charcoal

≪ See pp.114–15

Early in the drawing, large, dark masses of compressed charcoal were established and smudged with a cloth to create the midtone.

Pen and ink

Drawing with **pen and ink**

Ink is versatile, portable, affordable, available in many formats, and can be used with many different drawing tools, from dip pens and brushes to fingers, fountain pens, and markers. Used straight out of the bottle, dense black ink has a bold graphic look, but it can be diluted to make marks of great subtlety. The painterly nature of ink also allows you to create washes of varied tone and intensity to develop finished works of increasing complexity.

On the following pages, you can find out about the variety of inks and materials needed to get started. Then, practice and develop your skills with 15 pen and ink techniques, grouped into three sections of increasing sophistication—beginner, intermediate, and advanced. A showcase drawing at the end of each section brings all the techniques together.

1 Beginner techniques

■ See pp.126–37

In this first section, find out about basic mark-making, how to vary ink flow and pressure to draw lines of different widths and quality, and how to control hatching, crosshatching, and stippling to develop tone and form.

Beginner showcase drawing (see pp.136–37)

2 Intermediate techniques

■ See pp.138–49

In the second section, see how to use different drawing tools—dip pens, bamboo pens, and brushes—to control ink, and find out how to lay washes and create texture and detail monochromatically.

Intermediate showcase drawing (see pp.148–49)

Inks were first developed in 2,500 BCE in ancient China and Egypt, when carbon in the form of soot, known as lamp black, was combined with animal glue and molded into solid cakes that could be ground with water to create fluid ink. Early drawing tools were cut from hollow-stemmed plants, such as reeds and bamboo, or the quills of feathers were shaped into a nib. Brushes made from animal hair were also used for applying ink. Variations on these traditional inks and drawing tools are still in use today.

Versatile and varied

The properties of different pens and inks lend themselves to a range of drawing styles and effects, from waterproof ink for layering line and wash, to ballpoint pens or markers for working on the go.

Consider the permanence of the finished drawing and the opacity of the marks when selecting ink. Pigment-based inks tend to be more opaque and lightfast than dye-based inks, which may fade over time. Drawing ink has three main components: a color agent (pigment or dye), a carrier fluid (usually water or alcohol), and optional additives (such as gum or shellac binder). Modern drawing inks come in a rainbow of colors and myriad forms, from solid cakes to bottled fluid for dip pens.

The tools for applying ink range from traditional reed pens, which give a smooth, fluid line, to different-shaped nib pens for varied lines, and brushes for washes and blending. Although ink is a permanent medium that requires a commitment to each mark, its ease of application and response make it a popular choice with artists.

3 Advanced techniques

■ See pp.150–61

In the final section, find out about blending and layering, using colored inks and glazing techniques, and how to manipulate ink with painterly effects. Discover how to correct or incorporate mistakes in your drawing.

Advanced showcase drawing (see pp.160–61)

Ink pens

HOW TO CHOOSE YOUR PENS

The range of pens suitable for applying ink varies from traditional quill or bamboo pens and dip pens with interchangeable nibs, to fineliner pens with ink reservoirs or felt-tip markers in a spectrum of colors. A simple ballpoint pen will get you started, but experiment with different pen types to explore all the marks you can achieve.

When selecting pens, consider the type of ink they require—whether from a bottle or a reservoir—the nib shape, and their portability and practicality. For permanence, look for archival pens as these have the most lightfast ink.

Dip pens

Originally used for calligraphy and as writing tools, dip pens are the traditional way to apply ink. Bamboo or reed pens have carved nibs that make bold strokes. Their points may wear down in time but can be renewed by sanding or shaving. In a similar way,

quill pens are made from the flight feathers of large birds. They are lightweight and more flexible than bamboo pens and produce a finer line. For a more familiar-shaped drawing tool, dip pens with steel nibs mounted in holders of wood or plastic are inexpensive and more flexible. The range of interchangeable nib shapes means that you can achieve a range of lines of variable widths.

All dip pens can be used with pigment-based inks sold in bottles, and will not clog. Another advantage is that you can make washes from the same

inks that you are drawing with. However, dip pens are less portable than pens with a reservoir and tend to deposit more ink, which means that drawings take longer to dry. Their flow can also be unpredictable and they tend to blot, but artists favor their expressive nature.

Reservoir pens

Pens with an integral ink supply, such as fountain pens or ballpoint pens, are highly portable and are better suited to working outdoors or sketching. They tend not to blot, although their nibs aren't as flexible or interchangeable.

| 0.05 | 0.1 | 0.2 | 0.3 | 0.5 | #19 | #18 | #17 | #16 | Ballpoint | Ballpoint |

Drawing pens

Pens with an ink reservoir are easily portable. Technical pens with different nib sizes are ideal for precise drawing. Sets of fineliners and line painters may be available in a range of colors. Cheap ballpoints are perfect for sketching on the move.

Markers
Professional-quality markers are pigment-based, lightfast, and available in a broad color range. These twin-tipped pens give you the option of a broad chisel-tip for thick lines, or a fine tip for detail.

To achieve varied lines you will need to invest in a set of pens of different widths, such as fineliner pens, which are available in a range of colors and tip sizes from 0.05mm to 0.8mm. They create consistent lines that dry quickly.

Ballpoint pens are portable, readily available, and capable of making exceptionally subtle marks, although their dye-based ink is not lightfast. Porous point pens, such as felt-tip pens or markers, offer the artist an extensive choice of colors. Look for pigment-based pens to ensure the permanence of your drawing. Refillable brush pens have flexible sable or synthetic brush tips and either a pigment- or dye-based ink reservoir, so that you can apply the ink in a more painterly way, or mix washes for layering with line work.

Other tools
Along with brushes (see p.125), you can apply ink with anything that will make a mark. Cloth, tissue, cotton swabs, a stick, or your finger can be used to apply ink or move it on the paper surface. Use a cut-up credit card to create directional marks, or flick ink from a toothbrush for textured effects.

> "Your choice of **pen and nib** directly affects the **style** of your **mark-making** when working with **ink**. Explore all the options."

Bamboo pen

Fountain pen with cartridge

CARBON INK

Goose quill pen
The tip of a quill pen is cut by hand at the base of the feather to create a fine nib. The hollow shaft acts as an ink reservoir when dipped in a bottle of ink.

Dip pen

Medium nib

Fine nib

Pointed nib

Medium fine nib

Interchangeable nibs
Dip pen holders are available with alternative nib sizes so you can change the nib and vary the width of line, from extra-fine to broad.

Brush pen
These pens are portable and versatile. The flexible brush means you can apply ink held in the reservoir like paint.

Inks and other materials

CHOOSING A SUITABLE MEDIUM

There are two main types of drawing ink—pigment- or dye-based—and variations such as waterproof and non-waterproof, that may affect your choice when planning a pen-and-ink drawing. Ink can be used on most papers, but it is worth considering the weight of the paper and type of surface to ensure it is suited to your preferred techniques.

Some inks, and papers, are not lightfast and these are important considerations before embarking on a drawing, especially one that you intend to sell or display. To ensure that your work does not fade, look for lightfast inks or archival and acid-free papers.

Types of ink

Pigment-based ink is made up of finely ground particles and contains a binder such as shellac, gum, or acrylic resin that makes the ink adhere to the paper. It tends to be more lightfast and opaque than dye-based ink, but can clog fine pen nibs. It is best suited to use with dip pens, bamboo, reed, or quill pens where clogging is not a problem. Some pigment inks are waterproof, so that you can work over washes with line.

Dye-based inks are normally transparent and tend to fade with prolonged exposure to light. Most dye-based inks are not waterproof. These inks are suitable for use in fountain pens and airbrushes whose mechanisms clog with pigment ink.

Iron gall ink is not as common. It is a plant-based ink that changes color over time and is prized by calligraphers.

Drawing surfaces

Drawing and watercolor papers are the most commonly used surfaces for pen-and-ink work. Your choice will depend on a number of criteria, such as your drawing tools, desired texture, the wetness of your technique, and the degree of permanence you require.

Acid-free paper has been treated to slow down the rate at which it will discolor over time, and archival paper will last many years without deteriorating. Use these papers for finished works and a less expensive paper, such as drawing paper, for

Colored inks

These acrylic inks are pigment-based and have a good degree of lightfastness. They are water resistant, so that layers of color can be built up over each other.

Texture medium
Often used with watercolor paintings, this medium adds fine particles to suggest texture. Either apply to the paper or mix with a wash.

Gouache
Use white gouache alongside ink to add opaque highlights, or add water to create a wash to knock back areas that have become too dark.

Coarse medium
This coarse gel can be applied with a thick brush to the paper to provide a gritty, textured surface that resembles sand or rock. It dries to a hard film over which you can paint ink washes.

¾-inch (20mm) flat brush

No. 12 round brush

No. 10 round brush

No. 8 round brush

practice work and sketching. The weight and thickness of the paper should also be considered. In general, the wetter the technique, the heavier the paper in order to reduce buckling. Paper weights between 120–640gsm are suitable for a wide range of techniques.

The finish of the paper will affect your marks; smooth drawing papers work well with ballpoint and technical pens that deposit less ink and dry quickly, but may tear with repeated working. Watercolor papers are treated with size to affect absorbency; the more size the less absorbent.

Take care working on soft papers since the fibers can become loose and get caught in fine nibs. To alter the paper surface, use resist techniques or apply ready-made mediums to create texture.

Brushes
As a fluid medium, ink can be applied with painting techniques. Originally used for calligraphy, Chinese brushes hold lots of ink or wash and can create fine and bold lines. Watercolor brushes come in a range of sizes and work well with ink. Choose synthetic fibers over the more expensive natural brushes.

Watercolor brushes
Use synthetic watercolor brushes to apply washes of diluted ink. A flat brush is useful for laying in large areas of tone or for underpainting.

Drawing paper
Drawing paper provides a smooth drawing surface for pen and ink. Pick a heavy weight, or watercolor paper for washes.

Chinese brush
Traditionally used for calligraphy, the fine natural hairs of a Chinese brush hold ink well. The brush comes to a point for making fine lines, but can also be drawn across the paper for bolder strokes.

Black inks
Black is available in every type of ink. India ink, made from carbon particles, incorporates a binder so flows well. It produces the richest, most durable black.

Making marks

VARYING STROKES WITH A DIP PEN

A flexible steel nib is a versatile maker of marks, both descriptive and decorative. By varying pressure, turning the nib on its side, using the point, or even the back, you can create all sorts of marks that define surfaces and delineate forms. Exploit the range of marks further by combining different nibs, from superfine to chisel-edged, to invent texture and add interest with combinations of smooth, broken, or pooled marks.

PUTTING IT INTO PRACTICE

In this landscape drawing, two types of marks—short vertical lines and flattened arcs—are used to depict bare winter trees and add dramatic interest and invented texture to a nondescript woodland floor.

You will need

| 4B pencil | Dip pen with Hunt 107 nib | Dip pen with Brause 361 nib | Dip pen with Brause italic 0.75mm nib | Winsor & Newton calligraphy ink |

- 4B pencil
- Dip pen
- Hunt 107 (superfine), Brause 361 (steno), Brause italic 0.75mm nibs
- Winsor & Newton waterproof black calligraphy ink
- Eraser
- Bristol paper 200gsm

Winter woodland scene

1 Define shapes
Work over a pencil sketch of the main landscape features. With the superfine nib, draw parallel vertical lines to suggest the shape of distant trees. Lightly define the edge of the woodland floor where it meets the distant field. Leave the sky and the path white.

2 Draw ground cover
Switch to the flexible nib and draw the ground cover in the foreground, pressing hard at the beginning of each stroke to create mounded-grass shapes. Use the tip to draw thinner, wavy lines in the middle distance.

▨ Light and dark, thick and thin

Most nibs can create marks that range from delicate to bold, suggesting anything from pebbles and beach sand to textiles and animal fur. In a landscape drawing, using marks that become smaller and lighter in the distance will enhance the sense of depth. Manipulating the nib and using different pressures will produce a range of descriptive marks that become part of your drawing repertoire.

Medium nib Flexible nib Superfine nib

Nib and mark sampler
Experiment with different nibs to explore the range of marks. The marks in the top half of each of these six samplers were made by pressing the nib down; those at the bottom by using the back of the nib.

3 Adding contours
Draw the curving cross-contour texture of background trees with the superfine nib. Switch to the italic nib to draw the textured bark of the foreground tree, accenting the left side of the trunk and darkening the bark where each branch joins the trunk.

4 Fine details
Use the superfine nib to add details in the foreground on the tree bark and to darken and extend the ground cover. Draw smooth grass blades and crisp details of leaf litter and pebbles on the path. Darken the sides of the path where it meets the white field to contrast the shapes. Erase any pencil.

Line quality

CREATING EMPHASIS THROUGH LINE

Your choice of drawing tool, and the way you use it, determines the quality of the lines that are drawn. The characteristics of your line work draw the eye of the viewer, becoming part of the composition. Exploit the variety of effects, from thick and thin, to broken or uniform, to convey something about the nature of your subject.

Line characteristics

Each type of pen has its own particular line-making characteristics. If you choose the right tool, it can take less time and effort to get the effects you're looking for. Experiment freely, using the sides of pen nibs as well as the tips. Compare the effects, from brush and quill pens where you dip into the ink to produce varied marks, to liner pens that provide a steady flow of ink.

Broken line
Short strokes of a brush pen create textured marks.

Uniform line
A pigment liner pen produces a uniform line for drawing.

Angular line
A broad-point dip pen nib produces angled and scratchy marks.

Bold line
A quill dip pen nib produces both thick and thin flowing lines.

Curved line
A bowl-point dip pen nib produces flexible, curved lines.

This drawing uses variations in line weight to capture the rhythmic curves and flowing lines of garden lily blooms. The idea is to convey the flowers' abstract qualities rather than draw them with precision.

1 Initial sketch
Establish the composition with a light sketch. Plan ahead: with each dip of the quill, ink will deposit most heavily at the beginning of the line, so think about the starting points around the composition.

2 Sweeping strokes
Draw the main bloom with single, sweeping strokes, pressing lightly at the start, releasing pressure slightly to leave a small point at the end. Let the ink dry.

You will need

4B pencil Quill pen

- Soft pencil
- Quill pen
- Waterproof Indian ink (Rohrer & Klingner Ausziehtusche)
- Eraser
- Hot press watercolor paper 140 lb.

Lilies

3 Varied angles

With the quill at a low angle, use the side of the nib to draw the anthers with single, short strokes and the stem with longer strokes. Hold the quill vertically and use the tip of the nib for the thinnest lines.

4 Different line weights

Examine the drawing overall. Does the composition hold together? Adjust line weights to emphasize your focal point and bring out selected details, keeping the lines flowing and the drawing loose.

Line width and direction

DYNAMISM AND PERSPECTIVE

The width and placement of a line can contribute to a sense of pictorial space without the need for formal rules of perspective. You can convey form and depth with just a few strokes, making pen and ink an ideal choice for architectural subjects, where angles and changes of the picture plane can be caught in a few confident lines.

Line hierarchy

The difference in line weight between dominant and subordinate lines can help to clarify spatial relationships. Form and shape can be defined or implied, and angled lines suggest changing planes.

Equal weight lines	Thick and thin lines	Double lines

Overlapping lines
Line weight affects depth. Lines of equal weight create a flat image. Thick or multiple lines appear to come forward; thin lines recede.

Outline all sides	Outline one side	Implied line both sides

Outline
Use lines to suggest form. Use a solid line to outline the whole shape, or on one side with shading on the other. Imply an outline where the line stops.

Angular lines	Horizontal lines

Line placement
The nature of the line affects the feel of a drawing. Sharp, angular lines look dynamic, whereas horizontal lines look static and calm.

A low viewpoint creates interesting angled forms in this drawing of a Sicilian church tower. The zig-zag shapes provide lots of opportunity for using line weight and direction to describe the changing planes.

You will need

4B pencil | Dip pen with Hunt 107 nib | Dip pen with Brause 361 nib | Platinum carbon pen | Waterproof black ink

- Soft pencil
- Platinum carbon pen
- Dip pen with Hunt 107 nib
- Dip pen with Brause 361 nib
- Waterproof black ink (Higgins Black Magic)
- Eraser
- Bristol board 200gsm

Tower and palm tree

1 Underdrawing and primary lines
Start with a light compositional sketch, noting dominant and subordinate lines. With the flexible nib, use medium pressure to draw the wide V-shape where the adjacent wall meets the tower. Press slightly harder for the first- and second-story outer walls. Use the tip to draw the second story, and use the back of the nib to create thinner lines for the top of the tower.

2 Arches and openings

Use the tip of the flexible nib to draw the arches of the two lower stories of the tower. Let your lines thicken slightly at the apex of the ground floor arches to suggest shadow. Use the superfine nib to draw the openings in the upper stories, with minimal detail at the top.

"Convey perspective with ease using combinations of thick and thin lines."

3 Thin lines

Use the carbon pen for the thinnest possible lines at the top of the palm tree and for the stonework pattern in the tower, following the angle of the plane. Minimize detail to enhance the sense of distance. Use implied line to define the trunk of the tree.

4 Foreground details

Use the flexible nib to draw the steps and railings. Switch to the carbon pen to draw hatched lines at the steps and in the windows and arched doorways. Check the drawing overall for relative line weights, and make adjustments as required. Erase pencil lines.

Hatching and crosshatching

DEVELOPING TONE

Hatching and crosshatching consist of uniform parallel lines that are layered to create a near-infinite range of tones and gradual transitions between light and dark. The fine line and responsive touch of an ink pen are well suited to hatching, and ballpoint or felt-tip pens give you the option of creating tonal studies in color.

Controlling pen strokes

Before you draw, practice your hatching technique with tonal scales to develop consistent pressure, stroke length, and rhythm. Place your pen at an edge, release pressure through the stroke, and lift the pen at the end, letting it feather out. Try the effects of drawing with and without an outline to change the perceived edge.

Crosshatching without guidelines

Parallel hatching with guidelines

Crosshatching with guidelines

Tonal scales
Build a scale from light to dark with layers of parallel, hatched lines, or crossed lines, increasing in density the darker the tone. For straighter freehand lines, draw a light outline to act as a guide. These can be drawn in pencil and erased later.

Hatching with outline

Hatching without outline

Edge definition
Compare the effects of using an outline with hatched lines. A drawn edge creates a defined area, whereas hatching or shading without outlines creates softened transitions that can also be used to describe curves and shapes.

In this drawing of hands and fruit, very fine hatched and crosshatched lines capture the play of light over rounded forms. Outlining is minimal, and details are suggested with delicate variations in tone.

You will need

2B pencil Ballpoint pen

- 2B pencil
- Ballpoint pen
- Eraser
- Bristol board 200gsm

Peeling a clementine

1 Tonal plan
Lightly sketch your image. Create a separate tonal plan to refer to as you draw, demarcating darkest and lightest areas and transitions in between. Note areas with darkest tones and hard edges, because that is where you will begin hatching.

2 Parallel hatching
Draw very light pencil guides to keep your hatching straight. Start with parallel hatching for the dark to midtones. Starting with the darkest areas, begin each line at the hard edge and draw into the figure, lifting your pen off at the end.

3 Define form
Now add the light tones and find the lightest edges in your reference image. Look for a narrow margin of tone that defines the form. Try drawing this margin as a series of tiny hatched lines rather than an outline.

4 Crosshatching
Once the entire drawing has been covered with parallel hatching, return to the darkest areas and begin crosshatching in the same order. Don't go too dark too soon, and aim for gradual transitions from light to dark.

5 Adjusting tones and outlines
Adjust any transitions from dark to light. Draw selected outlines where there is little tone to visually separate forms from the background, such as between the fingers and the marks on the orange. Erase pencil marks.

Stippling

DEVELOPING TONE AND TEXTURE

Stippling consists of equally spaced dots or marks placed closer together or farther apart to suggest variations in tone. You can make gradual adjustments in tone with carefully ordered marks, or use quick, random marks or dashes to convey energy and suggest eye-catching texture.

▇ Smooth tonal transitions

Dot spacing determines the density of tone, and the smoothness of transitions between lights and darks. Dot size can also be used for effect—small dots look more precise and formal, large dots more expressive.

Dots and dashes

Vary marks from dots to dashes and large to small by changing pens and nibs—from left to right: a pigment liner pen, italic fountain pen, brush-tip drawing pen, felt-pen marker, and italic dip pen.

Varied tones

Use the density of the stippled marks to create a tonal scale. Start with a dark tone of tightly packed marks, then create a midtone with regularly spaced marks, and finally white paper left for highlights.

Smooth and defined transitions

Try to achieve smooth transitions for gradual shifts from dark to light (as on the left), and well-defined transitions for more clearly defined differences between dark and light (as on the right).

In this stippled drawing of a deer, a fine pigment liner pen is used to develop tone and suggest the texture of the deer's hide, while minimal lines define limbs and accentuate the sunlit highlights along its spine.

You will need

- 2B pencil
- Fineliner pen (0.1)
- Eraser
- Smooth drawing paper

Fallow fawn

Define highlights, such as the eyelid

1 Underdrawing
Lightly sketch the subject in pencil, demarcating different areas of tone. Identify key features and pay careful attention to small highlights, especially around the head, that must be preserved.

2 Dotted outline
Go over the pencil outline with widely
spaced dots to act as guides for the drawing.
Make dots around highlights and key features
of the drawing to prevent them being lost at
a later stage.

3 Darks and lights
Work between the densest concentration
of dots and the white highlights for a
convincing range of tones, using widely
spaced dots in the almost white areas. Check
your progress across the whole drawing.

4 Adjust transitions
Look back and forth between the reference
and the drawing to check the accuracy of your
tones and the graduations among them. You
may need to darken some areas or add just a
couple of marks where two tones meet.

Artist **Cynthia Barlow Marrs**
Title **Palace staircase**
Medium **Carbon pen, dip pen with waterproof ink, pigment liner pen**
Support **Drawing paper**

Line widths
« See pp.130–31
Lines of different widths–
with broad lines in the
foreground contrasting with
delicate line work in the
background–reinforce
the sense of depth.

Stippling
« See pp.134–35
The varied spacing of
stippled dots describes
the shading of the staircase
arches and columns, and
the patterns of the stonework
on the back wall.

Stippling: tonal transitions
« See pp.134–35
Clearly demarcated tonal
transitions from light to
dark describe the rectilinear
columns, and smooth tonal
transitions define the arches.

Showcase drawing

The graphic nature of this architectural scene is conveyed through simple combinations of basic pen and ink techniques. Different line widths perfectly describe angles and edges, while stippled marks and hatched lines capture shadows to give solidity and a sense of pictorial space.

Mark-making

≪ See pp.126–27

Different marks made with varied pressure are used to define the surface of the background wall, to indicate the hanging lamp and to draw the figure.

Hatching and cross-hatching

≪ See pp.132–33

Hatching defines the form of the figure and architectural features such as the handrail and staircase risers, emphasizing their verticality.

Line quality

≪ See pp.128–29

Each line has a clear and convincing beginning and end, which contributes to the strength of the overall drawing and defines the spaces and shapes within.

Scribbling

DEVELOPING FORM

Scribbling consists of random, free-form marks, made without lifting the pen, that are layered to develop form and texture. Densely compacted marks can look like wire wool; marks more widely spaced resemble tangled fishing line. Scribbling is a versatile technique you can use to build well-knit figures from the inside out.

Scribbling in three stages

A wire-frame approach is one way to draw the scribbled form. Begin with a continuous "seeking line" that spirals around the figure, followed by densely worked layers to flesh out the form, and finish with selected details.

Wire frame
Start from the core of the figure and move outward in a continuous spiraling line, using the outline to help contain and guide your spirals so they follow the shape of the figure. Keep the marks loose and open.

Fleshing out
Note areas of darker tone, and draw repeated layers to model form, using denser marks and tighter spirals to describe the shape. Vary the direction to indicate perspective or a change in angle.

Details
To complete the drawing, draw over the top of the scribbled lines, adding a few strategically placed details, such as the eyes and shading on the nose. The initial outline is now lost under the layers of scribbles.

PUTTING IT INTO PRACTICE

Strong backlighting creates near-silhouettes of the man and dog, rendered in loose scribbles, while the cast shadows are drawn in contrasting precise lines.

You will need

2B pencil

Sakura Pigma Micron pen 05

- 2B pencil
- Sakura Pigma Micron pen 05
- Eraser
- Hot press watercolor paper 140 lb.

Figures and shadows

1 Underdrawing
Make a light sketch of the image, noting details such as the dog's features that should be preserved through layers of scribbling. Plan ahead to avoid obscuring these small but crucial elements.

2 Wire frame
Start to add loose scribbles to describe the dog's head, drawing its eyes, ears, and mouth, followed by the torso and limbs. Draw the man's feet and legs, spiraling upward from the feet to the waistline and torso.

"The **loose** nature of **scribbled marks** allows you the **freedom** to build a drawing **full of expression.**"

3 Develop form
Build on the wire frame layer, moving continuously around the figures to deepen layers and solidify forms. Concentrate on joints such as ankles and knees.

4 Shadows and background
Keep the background and the cast shadows minimal, using parallel hatching for controlled edges. Check the balance between lights and darks across the drawing and adjust as needed.

Varying density

CONTROLLING INK FLOW TO CREATE LAYERS OF TONE

There are several techniques that you can use to vary the density of the ink and the marks you create. Blotting leaves ghost impressions that impart subtlety to a drawing, or use it to add highlights with sharp or feathered edges. An ink line can be partially blotted to create eye-catching variations in line weight. You can also vary the dilution of the ink to control the density of each layer, producing wash effects, useful for working from light to dark.

PUTTING IT INTO PRACTICE

In this drawing of a magnolia branch in bloom, the first layer is drawn very wet with heavily diluted ink that is puddled and blotted to create abstract petal and branch shapes, with denser layers built on top.

You will need

Bamboo pen

- Bamboo pens (large and small)
- Winsor & Newton Indian ink
- Water
- Small containers to hold ink at different dilutions
- Paper towels torn into strips
- Hot press watercolor paper 140 lb.

Magnolia branch

1 Ink underpainting
Skip any preliminary drawing and go straight in with ink. Using your most diluted ink, dip the large bamboo pen and draw the magnolia branch freely. Work quickly to establish the overall shape and extent of the branch, letting the ink flow and puddle.

Darkest ink defines the branches and petals

Manipulating ink density

Dilute ink to achieve a range of tones, ideal for layers and adding depth. For soft effects, drop dark ink into damp, blotted areas and allow it to flow and blend. For more control, use paper towel to blot and create edges.

— 100% ink
— 50% ink 50% water
— 10 drops ink 1 TB water
— Rinse water

Diluting ink
Thin ink with different ratios of water to create subtle tones. Have several mixes ready in small pots before you begin, and use your rinse water for the palest tone.

Using a torn edge
Soft, feathery effects and transitions can be achieved on damp ink by using the torn edge of a paper towel to lift off and blot the ink on the paper's surface.

Using a folded edge
On very wet ink, a folded paper towel will absorb the ink quickly and can be used to create a more defined edge between light and dark where the ink is lifted away.

2 Dragging and blotting
Using the side of the large pen, drag wet ink to create simple shapes suggesting petals. Use the tip of the pen to draw secondary branches in darker ink. Blot the sunlit edges of the main branches to create highlights.

3 Dropping in ink
While the branch is still damp, use the small bamboo pen to drop darker ink into shaded parts of the branch, allowing the ink to blend. Check the highlighted areas as the ink spreads, blotting as required to retain or lift out the lighter highlights.

5 Selected detail
With your darkest ink and the small pen, add detail to the main branch in the foreground, and fine detail to magnolia blooms midway along the branch. Leave the end of the branch and the blooms furthest away free of detail, to add to the illusion of distance.

4 Layering shapes
Continue to layer simple petal shapes and smaller branches, using the side of the pen to lay down broad areas of ink, and the tip of the pen to create finer lines.

Adding water

LAYING AN INK WASH

Diluted ink produces a wash that you can brush over large areas quickly to provide a flat base. An even-toned background takes practice to achieve but looks effective for unifying compositions, adding skies, or abstract blocks. Once the wash is dry, you can draw over it with darker (less diluted) or lighter inks to add detail.

Applying an even wash

For a streak-free wash, prop your drawing board at a low angle and prepare plenty of ink, diluting it 1:1 with water. Dampening the paper first helps the ink to flow uniformly across the surface. To preserve whites, leave them dry and paint around them or use a resist.

Initial single stroke
With your largest brush, wash clean water over the paper from top to bottom. When the paper loses its sheen, load the brush in diluted ink and, in a single stroke, draw it across the top of the paper. Excess ink will pool at the base of the stroke.

Pick up wash
Working quickly, dip your brush into the ink again, place your brush at the base of the "bead" of pooled ink and draw it evenly across in a single stroke to blend together. Repeat down the page.

Remove excess wash
At the end, draw off any excess ink that has pooled at the base by touching it lightly with the tip of a large brush or mopping with the torn edge of a paper towel. Leave at a slant to dry evenly.

The stark contrast of the swan against the flat ink wash background makes a dynamic composition, enhanced by simplifying the image to a monochrome study in blue and white.

Swan among reeds

You will need

- 4B pencil and eraser
- Dye-based, non-waterproof blue ink diluted 1:1 with water (Parker Quink)
- White acrylic fineliner pen (Derwent Graphik Line Painter, Snow)
- Watercolor brushes (no. 6 and no. 10) with good points
- Small dishes for ink
- Paper towel
- Cold press watercolor paper 140 lb.

4B pencil Parker Quink ink White fineliner

1 Light sketch and resist underlay
Lightly sketch the swan and its reflection, carefully drawing details and shaded areas. Note the curve where the neck joins the body in the reflection. Make light indicative marks for the reeds, then draw several layers of white resist with the acrylic fineliner pen—exact placement is not important at this stage.

"Lay an ink wash to achieve a uniform background that brings harmony to tonal ink studies."

2 Wash background

Turn the drawing upside-down. Dampen with clean water, painting around the swan. Lay the wash, keeping the strokes horizontal while drawing carefully around the swan. The ink will be drawn to the edge of the dry shape.

3 Tonal variations

Apply pale ink rinse water to draw the shadow lines on the body. With the tip of the no.6 brush, define markings and areas of light shading on the head and neck. Use slightly darker ink to draw the reflection and shadows.

4 Fine details

When the drawing is dry, fine-tune details on the head. Add reflected lights with the fineliner. Draw the reeds and their shadows by alternating the white pen with lines drawn with the no.6 brush tip using the 1:1 wash.

Textured papers

WORKING WITH SURFACE INTEREST

A surface with its own visual interest due to its texture can enhance the overall look of a drawing. When chosen well, textured papers complement a subject and reinforce the imagery you are trying to convey. Generally, the rougher the paper's surface, the more expressive a simple mark can be.

■ Accentuating texture

Brushes with long, soft hairs—such as the goat-hair Chinese brush—give a pleasing array of marks on textured paper. Laid flat and dragged sideways, they create broad areas of broken color. Pressed down and lifted, they leave marks reminiscent of leaves and petals or fins and feathers. Use brushes of different lengths to scale up or scale down such shapes. Reed pens, too, come in all manner of shapes and sizes.

Goat-hair Chinese brush
A brush with bristles 2 in (5 cm) long has been dragged sideways across the paper, pressed down to leave an imprint, and then used to make a line.

Pocket brush pen
A small brush pen has made marks in the same way as above but with different effects.

Reed pen
Again used in a similar way to the brush (above), a reed pen makes more distinct linear marks.

In this drawing of fish, large brush marks suggest fins and scales, while linear features are added with a reed pen. The darkest and finest details are drawn with a pocket brush pen and a reed pen.

You will need

4B pencil | Reed pen | Pocket brush pen | Chinese ink diluted 1:1 with water

- 4B pencil
- Reed pen
- Pocket brush pen
- Chinese brush
- Chinese ink diluted 1:1 with water
- Khadi rag paper 210gsm

Fish on the slab

1 Setting out the composition
Lightly sketch the main shapes in pencil, identifying the lightest and darkest areas. Notice that the belly of each fish is one of the whitest parts, and spines, fins, and tails are among the darkest.

2 Brushing in the darks
Soak the brush in the 1:1 diluted ink and, while it is very wet, place the tip of the brush at the tip of a fin or tail, then press the body of the brush down flat. Lift the brush, soak it in ink, and press it down to leave a mark on another tail or fin. Repeat the process around the rest of the drawing.

3 Modulating tones

Dilute the 1:1 ink solution further to make a medium gray. Brush this in areas where tones fall between the white of the paper and the dark gray of the tails and fins. Repeat the process to define gills, heads, and spines.

4 Detailed work

With the reed pen and the pocket brush pen, add details around the eyes, gills, and other areas of black. Draw the edge of the white tray with the reed pen, varying the line as it scrapes across the rough paper.

5 The background

Load your brush with the ink rinsing water and lay a pale wash between the upper edge of the white tray and the top right corner. Draw the brush across the paper on its side, so the paper's texture shows through. Repeat with medium-gray ink in the lower-left corner, and with darkest gray in the upper left.

Line and wash

COMBINING LINE WITH TONAL WASHES

Line and wash marries the precision of line with the tonal range of ink washes, mixed from different ratios of water to ink to create shades. Unlike watercolor, dried ink wash does not redissolve, so you can build layers and add crisp outlines for a drawing that is rich in detail and modeled form.

■ Making a tonal plan

Make a thumbnail sketch of your subject that summarizes the lights and darks to help plan your ink washes. Establish the main tones and focal point, the contrasts of light and dark, and where to leave white paper or preserve highlights. The first wash is the palest and lightest, subsequent washes are gradually smaller.

Tonal plan
A tonal sketch establishes the range of shades required, from light, middle, and dark. Brightest highlights are left as white paper. Use your plan to create a tonal scale of shades to build the composition in layers.

Ink dilutions
Create shades by diluting different amounts of ink in water. Here, the lightest tone is made with 1 drop of ink in 5ml water, the midtone 2 drops in 5ml, dark tone with 5 drops in 5ml water.

Layering shades and line
Start by laying a flat wash of the palest tone. Let it dry, then use the same ink dilution to draw the next layer. Build subsequent layers with darker washes, allowing each wash to dry between applications. Use line to define forms and add details, without outlining every element.

In this drawing of a quiet domestic scene, strong light from the window creates bright highlights that are retained by leaving the white paper. Pattern and detail are built up with several tones, using line to add definition.

You will need

- 2B pencil
- Platinum Carbon pen
- Carbon ink in dilutions of 1, 2, and 5 drops to 5ml water
- Fineliner 0.3
- Fineliner 0.5
- Watercolor brushes (no. 6 and no. 12) with good points
- Eraser
- Hot press watercolor paper 300 lb.

Sunlit seated figure

1 Underdrawing and first wash
Make a light sketch of the scene with a soft pencil, noting highlights at the window, newspaper, the side of the face and hair, and the back of the chair. Use the no. 12 brush and the 1-drop dilution to cover everything except these highlights with your palest wash.

2 First line and wash

With the Carbon pen, draw details of the figure, chair, and newspaper, taking care with the hands. Use a very light touch to indicate facial features. Use the 1-drop dilution and the no. 6 brush to deepen shaded areas on the figure and chair. Be sure to preserve the bright highlights.

"Combining detailed line with layers of tonal washes gives ink drawings a painterly quality."

3 Second layer

Use the 2-drop dilution and the no. 6 brush to draw stripes on the chair and darken shaded areas. Add delicate lines, such as in the hair, with the Carbon pen. For thicker accent lines, such as the glasses, switch to a fineliner pen.

4 Third layer

With the no. 12 brush and the 5-drop dilution, darken the walls on either side of the window. Adjust tones on the fabric with the no. 6 brush. Use the Carbon pen to draw leaves on the plant, and use the dark shade to model a few leaves.

5 Final details

Check for the balance between lights and darks, adjusting with different shades as necessary. Use line to add fine details, then erase any visible pencil marks.

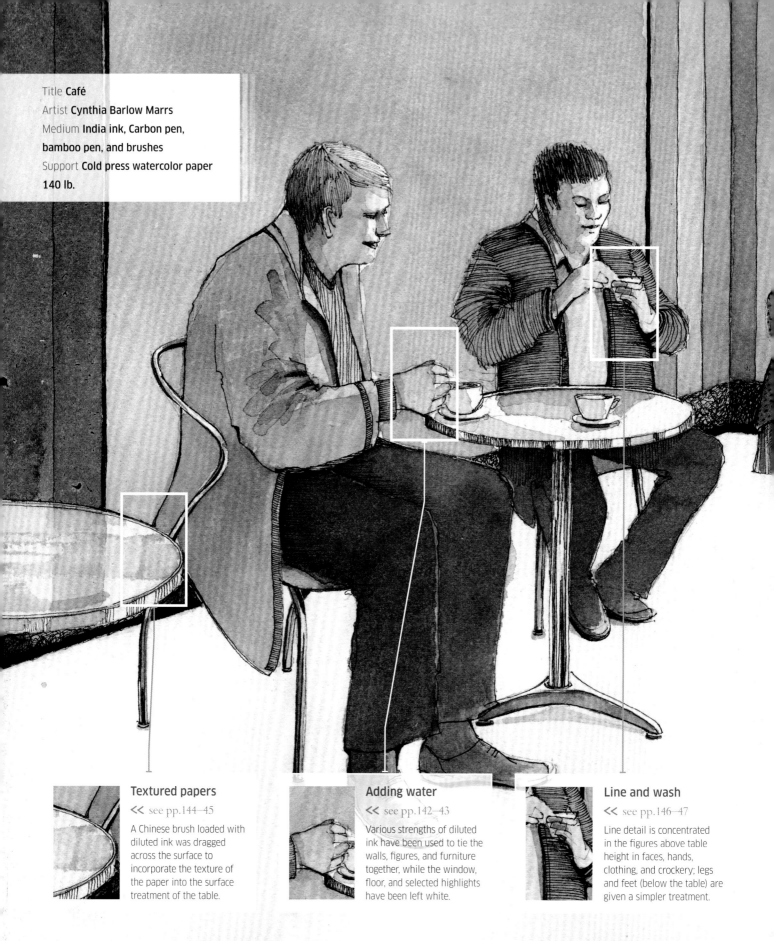

Title **Café**
Artist **Cynthia Barlow Marrs**
Medium **India ink, Carbon pen, bamboo pen, and brushes**
Support **Cold press watercolor paper 140 lb.**

Textured papers

≪ see pp.144–45

A Chinese brush loaded with diluted ink was dragged across the surface to incorporate the texture of the paper into the surface treatment of the table.

Adding water

≪ see pp.142–43

Various strengths of diluted ink have been used to tie the walls, figures, and furniture together, while the window, floor, and selected highlights have been left white.

Line and wash

≪ see pp.146–47

Line detail is concentrated in the figures above table height in faces, hands, clothing, and crockery; legs and feet (below the table) are given a simpler treatment.

Showcase drawing

This café scene features techniques from the intermediate section. The furnishings and figures are strategically placed in a composition that leads the eye from foreground to background and back again, balancing line and wash, angles and curves, and darks and lights.

Varying density: highlights

« see pp.140–41

Ink washes were blotted to suggest the fall of light on faces and on clothing, such as the sleeve and collar of the spotted jacket.

Varying density: dark tones

« see pp.140–41

Darker ink was dropped into washes as they dried in order to deepen tones on surfaces, such as the chrome tubing of the chairs.

Scribbling

« see pp.138–39

Scribbled marks adds textural interest and deeper tones to the skirting board and window frame in the background, helping to hold the composition together.

Blending and softening

CREATING SMUDGED MARKS

You can create soft, blended effects by smudging ink before it dries, or dampen non-waterproof ink and smudge it after it dries. The blended marks can stand on their own or serve as a base for further drawing, and look effective combined with hard lines and edges. This technique works well for fur, cotton balls, sea foam, and clouds.

▇ Impressionistic effects

Compare the dry and damp effects below for the range of options available when softening lines. Dampened or smudged lines provide a base for dry top layers, or develop further tones by repeating the process.

Dry Damp

- Lines are crisp on a dry surface (left) and blur on damp paper (right)
- Stroke a damp cotton swab over the lines to blend them further
- Use the ink-soaked cotton swab to draw with for thicker strokes
- Draw crisp lines on top of previously smudged marks with a dip pen
- Build layers of smudged and drawn lines for more graduated effects
- Draw dots with a dip pen and smudge with a damp cotton swab
- Repeat the process to resmudge dotted marks to create tones

In this impressionistic close-up, the cat's curly, soft coat of smudged and layered marks contrasts with the hard edges of the plant pot, drawn dry with an extra-fine nib.

1 Underdrawing
Lightly sketch the main features, noting how light plays across the eyes. Position the plant pot, tag, and paving stones. Indicate the direction of the fur with a few marks.

2 Facial features
Using the pen and lightest ink dilution, indicate the features, smudging the ink before it dries. Saturate a cotton swab and dab over dried layers to define the features.

3 Fur shapes
Draw tufts of fur with comma shapes using the dip pen and 5-drop dilution. Before the ink dries, smudge the marks with a finger or cotton swab. Build darker layers.

You will need

Black non-waterproof ink

Dip pen with Hunt 513 extra-fine nib

- Non-waterproof ink (Higgins Eternal Black) diluted 5 drops in 5ml, 10 drops in 5ml, and 1:1 with water
- Dip pen with Hunt 513 extra-fine nib

- 2B graphite pencil
- Cotton swabs
- Cold press watercolor paper 300 lb.

Fluffy pussycat

4 Indicate background

Use the back side of the nib to add thin lines on the forehead. Create a soft, contrasting edge where the light strikes the fur along the cat's back and top of its head. Saturate a cotton swab and stroke parallel lines upward. Let the ink dry and repeat.

5 Contrasts of tone and texture

Use the pen and 1:1 dilution to define the darkest areas in the nostrils and the eyes. Keep the area immediately around the nose white. Draw parallel texture lines on the pot and use different ink dilutions to feather and blend the fur and pot.

6 Add final lines

Check for any final adjustments, especially around the face. Lightly indicate the paving stones by drawing pale parallel lines with the 5-drop dilution and dip pen, then blend with a semi-dry cotton swab.

Layering with markers

BUILDING UP FORM

Markers have a semi-transparent ink that means they can be layered progressively over one another. By controlling the opacity of your marks, you can build form, color, and depth within a drawing. Colored markers make a handy tool for quick sketches.

■ Using tone and color

Controlling and building up tone and color with markers is quite similar to working in watercolors. By starting with a light color and blocking in areas, you can progressively add darker and more vibrant colors on top, building up form as you go.

Layering with one color
First, build up the subject's form using one color—a neutral gray. Layer the semi-transparent pen to create dark, mid, and light tones.

Two-color mixing
Once you've established the form, add the second color—a cool blue—to reinforce the darker tones and shadows.

Adding a third color
Selectively layering up another color—this time yellow all over the mug—creates a vivid green over the areas on the mug that were blue, while still allowing the tonal contrasts of the first color to be seen.

Drawing a simple portrait is a great way to learn how to build up tone and color coherently. Starting with the lights and moving to the darks is essential in creating a marker drawing with substance.

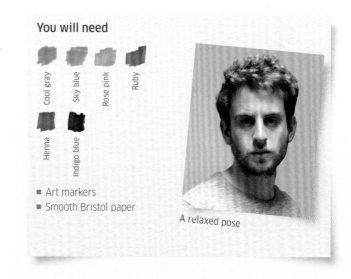

You will need

Cool gray Sky blue Rose pink Ruby

Henna Indigo blue

■ Art markers
■ Smooth Bristol paper

A relaxed pose

1 Shape and tone
Using your gray marker pen, very roughly and gently sketch in the outline of the head and shoulders. Draw in the areas of definite tonal and color differences.

3 Tonal areas
Now, using the ruby color, begin to go over the darker areas within the gray. This red layer allows you to create three different tonal values over the previous henna brown and gray layers, and the white of the paper.

4 Another layer of color
Next, add a layer of warm rose pink for the midtones on the forehead, cheeks, and neck. With a sky blue pen of a similar value, add cool shadows to midtone areas around the chin and under the cheek bones.

5 Strong highlights
With the henna brown, add depth and definition to the chin, using the pointed tip of the marker to draw marks that suggest beard stubble. Reinforce the darkest darks with indigo blue, leaving the white of the paper for the lightest lights.

"Drawing with **colored markers** is akin to painting with watercolors."

2 Focusing on the darks
With the same gray, block in darker areas such as the eye sockets, the hair, and under the chin, being careful not to layer over the grays and make them too dark. Use henna brown to add dark accents around the mouth and nose.

Using colored inks

COLOR HARMONY IN LINE AND WASH

The fine pigments in ink make for veils of color that you can manipulate to great effect. Waterproof inks can be used like watercolors, but because they do not re-wet you can layer them without disturbing what is underneath. To unify your drawing, try limiting your palette to just a few hues mixed in different proportions and layered with line and wash for detail and definition.

In this drawing of sunflowers, two-tone mixes of yellow, red, and green are combined in light and dark blends using pens and brushes to define and modulate the flowing shapes of petals, leaves, and seed head.

You will need

Process yellow · Brilliant yellow · Scarlet · Olive green · Black

- Soft pencil
- Daler Rowney FW acrylic inks
- Small bamboo pen
- Dip pen with Hunt 513EF (extra-fine) nib
- Watercolor brushes (#8 and #12 round)
- Eraser
- Hot press watercolor paper 140 lb.

Sunflowers

1 First washes
Sketch the main shapes. With the #12 brush, paint the flower centers with clear water, then drop in the mid-red mix (see "Mixing colors," opposite), letting color flow to the edges. Use the bamboo pen to pull the wet ink up into the base of the petals. Repeat the process for the leaves, using the light green mix.

2 Developing the petals
Loosely brush pale yellow over the petals, and drop mid-yellow at their base. Drop mid-red at the base of the petals, and let the color bleed. Use the bamboo pen to draw wet washes into the petals. Draw veins with light and dark green.

■ Mixing colors with a limited palette

With just three hues, you can create a range of color mixes from light to dark. Start with a base of one color and add small amounts of the others to develop the shade you need. Close color relationships in a limited palette help to create a harmonious composition.

Yellow mixes

The pale yellow on the left is made with 1 part process yellow to 16 parts water. The mid-yellow on the right is made with 1 part brilliant yellow to 3 parts water, to make a more intense color.

Red mixes

The mid-red on the left is made with equal parts scarlet, brilliant yellow, olive green, and water. The dark red on the right is made with 1 part scarlet and 3 parts olive green, creating a deep, brownish red.

Green mixes

The light green on the left is made with 4 parts olive green, 1 part mid-red mix, and 8 parts water. The dark green on the right is made with 9 parts olive green, 1 part scarlet, 1 part brilliant yellow, and 1 part black.

Yellow washes are overlaid with lines in darker reds and greens

3 Modeling forms

Use the dip pen and dark red mix to draw small commas in concentric circles around the flower center. Deepen tones at the base of the petals, using dark and light mixes to develop tone and form.

4 Adding detail

Use the #8 brush and warm brown mix to draw the stems. Wash the dark green mix over the shaded center of the flower. Use the dip pen and dark red mix to draw accents on the petals and leaves. Check the balance of color and tone.

Expressive texture

RUNS, DRIPS, AND SPLATTERS

Expressive texture in an ink drawing can bring out the tactile qualities of a subject or impart character where surface interest may be lacking. The effect can be precise or impressionistic, depending on the technique you use and your overall drawing style.

Surface treatments and ink application

Introduce texture by treating the surface with resist and watercolor mediums, and by managing the way you apply ink. Use surface treatments like candle wax resist to create coarse highlights, or a texture medium to suggest stone or rough fabric. Ink applied by splattering, scraping, or with drips and runs, adds visual variety.

Candle stub

Texture medium

Splatter

Scraping with credit card edge

Texture effects

Manipulating the surface with a resist or medium gives some control over the resulting effect. Splatter effects are more expressive and free-form, while scraping into the ink creates directional marks.

In this drawing of a Mediterranean hillside, the textured stone temple in the background contrasts with the feathered crowns of wild flowers and pockmarked, splattered rocks in the foreground.

You will need

2B pencil Black ink

- 2B pencil
- Large and small bamboo pens
- Dip pen with Hunt 513EF (extrafine) nib
- Daler-Rowney FW black acrylic ink in four dilutions: 2 drops of ink in 30ml of water, 5 drops in 30ml, 10 drops in 5ml, and 1:1
- Small dishes to hold ink dilutions
- 1-inch flat watercolor wash brush

Mediterranean temple

- #8 and #12 round watercolor brushes
- Watercolor texture medium
- Candle stub
- Cut-up credit card
- Eraser
- Cold press watercolor paper 140 lb.

1 Tonal plan and surface treatment

Draw a tonal diagram of the scene, noting main areas of light and dark, as well as soft and hard edges. Brush texture medium on the temple and foreground rocks and let dry. Rub the candle stub in selected areas to preserve highlights along the top of ground cover vegetation.

2 First washes

Prop the drawing at an angle. With the flat brush and 2-drop dilution, add a base wash on the temple and palm, retaining white highlights. Scrape a piece of credit card dipped in ink to suggest ground plants; let the ink drip freely.

"Use drips, resist, and splatters to bring an ink drawing to life."

3 Layer tones

With the small bamboo pen and the 2-drop dilution, draw the temple roof and shadows. While still damp, drop the 1:1 dilution into corners. Allow to dry. Draw the fronds of the fan palm with the edge of the cut-up card, and drag the 10-drop dilution across dark rock areas.

4 Develop detail

Referring to your tonal plan, use the large bamboo pen and 5-drop dilution to drip ink through the vegetation to deepen tones and heighten contrast. Refine the fronds on the palm. Use the extrafine nib with the 5 drops in 30ml dilution to develop the tree, shrubs, and palm fronds.

5 Finalize details

Splatter the 5-drop dilution across the rocks in the foreground and over the plants mid-slope. Add detail to the foreground rocks with the dip pen and the extrafine nib. Check the drawing for the balance between lights and darks. Erase any visible pencil lines.

Correcting mistakes

CONVERT, REMOVE, OR COVER UP

Ink may not be as remedy-friendly as watercolor, but a blighted drawing may be rescued in a number of ways. You can repair a blot by covering it up collage-style, whiting it out, scraping it off, or simply incorporating it into the final design.

■ Collaging over

In some cases, your best option may be to cover a mistake with a redrawn layer, matching the shape and, ideally, using the same paper for the repair as in the original, or a lighter weight paper of the same color.

Original before correction
The artist chose to simplify the details at the base of the tower on the left. The rectangular shape is easy to replace as one piece.

Trace shape
Draw around the main shape of the area to be replaced. Cut out an identical piece from the same type of paper.

Redraw
Prepare the new piece with the same washes used in the original drawing. Secure with a suitable adhesive such as rubber cement.

Integrate
Once the new piece is in place, redraw details to integrate it into the rest of the drawing, matching lines and tones.

PUTTING IT INTO PRACTICE

The techniques used in this drawing help to remove unwanted blots and marks, disguise mistakes, and restore lost highlights. The various remedies have been used to create a final image that looks crisp and clear.

1 Replace with collage
To disguise a mistake on this wall, the entire wall was replaced with collage, following the instructions described to the left. This technique is ideal for large areas, for ink blots that have sunk into the paper, or for blots that would bleed through a white-out layer.

2 Whiting out
Using correction fluid works well in areas that are relatively small and need little or no redrawing, since ink applied over a correction layer seldom matches the original. Here, opaque white gouache, thinned to the consistency of cream, is used to restore reflections on the car that were lost under ink washes. Apply with an extra-fine nib.

You will need

2B pencil

Chinese ink

- 2B pencil
- Dip pen with Hunt 513EF (extra-fine) nib
- Chinese Ink in a range of dilutions
- Winsor & Newton permanent white gouache
- Scissors
- Rubber cement
- Scalpel
- Eraser
- Cold press watercolor paper 140 lb.

Street scene

3 Incorporate
You can disguise mistakes by incorporating them into the scene, for example by turning them into figures, structures, or surface patterns. Here, a blot was disguised with a new window treatment. Sketch your blot conversion ideas on a copy of the original drawing, then use diluted ink to make amendments.

4 Scrape off
Small spray dots that are not too dark or dense, or that haven't penetrated the paper, can be scraped off. This roughens the paper's surface, but in small or inconspicuous areas the effect may not be apparent. Hold a sharp scalpel at a shallow angle and flick away stray surface marks. Avoid redrawing over a scraped surface.

Title **Tuscan hillside**
Artist **Cynthia Barlow Marrs**
Medium **India ink, acrylic ink, dip pen, and fineline acrylic pen**
Support **Cold press watercolor paper 140 lb.**

Colored inks

<< See pp.154–55

The color in this drawing is a combination of black India ink and olive green acrylic ink, with selected highlights in white fineline acrylic pen.

Correcting mistakes

<< See pp.158–59

Even though the large black blot at the left edge of the white road was unintended, it has been incorporated into the composition, adding visual interest to the scene.

Blending and softening

<< See pp.150–51

The distant clouds are a subtle but vital part of the composition, created with a cotton swab and the lightest possible dilution of ink.

Showcase drawing

This scene in rural Tuscany incorporates many advanced techniques that help to capture something of the rhythms and textures of the landscape, from vineyards and sloping fields in the foreground, to columnar trees, clouds, and rolling hills in the background.

Expressive texture: medium

≪ See pp.156–57

Texture medium adds surface interest to this field, allowing gray, green, and white stripes to feather into one another.

Layering

≪ See pp.152–53

Rows of pale, diluted olive green ink are redrawn with denser layers of the same ink to enhance a sense of depth and aerial perspective.

Expressive texture: splattering

≪ See pp.156–57

Olive green ink was splattered in the foreground to suggest vine leaves and defined further with India ink and a dip pen.

colored pencil

Drawing with **colored pencil**

Unlike standard pencils, whose core is made of graphite, colored pencils have a core made up of pigment and a binder (usually wax). Anyone and everyone can pick up a colored pencil and make a wide range of possible marks and effects—what's more, they're convenient to use (hardly any mess) and they come in a myriad of brilliant colors. Variations between artist and student qualities tend to reflect the ratio of pigment to binder.

On the following pages, you can find out about colored pencils and other materials you will need to get started. Then, practice and develop your skills with 15 techniques, grouped into three sections of increasing sophistication. Each section culminates in a showcase drawing that demonstrates the techniques explored throughout that section.

1 Beginner techniques

■ See pp.170-81

In the first section, discover basic color theory, as well as how to make different marks. Look at monochromatic tonal values and the difference between using pencil and colored pencils, as well as using more than one color.

2 Intermediate techniques

■ See pp.182-93

In the second section, explore optical mixing through stippling, differences between warm and cool light, how to mix neutral grays, the use of colored paper, and how to suggest textures such as wood and stone.

Beginner showcase drawing (see pp.180-81)

Intermediate showcase drawing (see pp.192-93)

Historical use

Colored pencils have a surprisingly far-reaching history. Although exact dates are unclear, there are known records of both the Greeks and the Romans using wax-based crayons—a precursor to the modern-day colored pencil—in the first century CE. Colored pencils as we know them today first appeared much later, in the 19th century, and were used for marking and checking accounts; their production for art purposes started only as recently as the early 20th century. Many contemporary artists use colored pencils as part of their repertoire, including David Hockney, who employs them in many portraits and studies.

Permanent and vibrant

Colored pencils work by rubbing off a layer of pigment-impregnated wax (or other modern binders). Unlike the layer of graphite created by a standard pencil, the waxy layer of the colored pencil cannot be easily rubbed off or smudged, meaning a greater permanence. The Fayum mummy portraits of ancient Egypt, for example, were painted with pigment suspended in wax and they are still around today—almost as brilliant and detailed as the day they were drawn.

Color options

For the most intense colors, choose professional, artist-quality pencils. Even with a basic palette you will be able to blend and mix on the page to create an almost infinite range of tints, shades, and hues suitable for any subject. To extend your technique further, use watercolor pencils to lay washes or blend soft tones.

3 Advanced techniques

■ See pp.194–205

This section instills deeper knowledge of varied techniques and expressive ways of working—capturing different skin tones, drawing with watercolor pencils, and using colored pencils in combination with other media.

Advanced showcase drawing (see pp.204–205)

Colored pencils

HOW TO CHOOSE YOUR PENCIL PALETTE

There is a wide range of colored pencils available, from basic student sets to professional quality, and water-soluble to ink-based. Your choice of pencils will depend on what you want to achieve, but always choose a good-quality version to ensure the best vibrancy and strength of color.

Out of any drawing medium, colored pencils have the greatest range of qualities—from incredibly basic sets for children to specialized and vibrant colors for the practiced artist. One advantage of the medium is that you can personalize your palette, choosing colors for a particular subject.

Quality and saturation

Artist-quality pencils have a higher concentration of pigment than the more affordable versions. With higher-quality pencils, the pigments are more finely ground, resulting in richer colors and greater consistency from pencil to pencil. Colors will vary between brands, depending on the ratios of pigment and binder. As a beginner, it's best to start with a basic and relatively cheap set from a well-known brand; once you progress you can learn through trial and error which brands may suit you and buy more expensive pencils in order to specialize.

Sets of pencils

All colored pencils are available in packs or sets containing preselected colors, as well as being sold individually. The general color sets contain a certain number of colors—12, 24, 36, up to 120—while other small sets are tailored toward certain color ranges, such as those for skin colors for portraits or earthy greens for landscapes. However, if you are starting out as a beginner and want to try a wide range of drawings, then a general color set is preferable.

Specialist pencils

In addition to standard colored pencils, you can choose from those with specialist qualities. Watercolor pencils are applied like a normal colored pencil,

Acid yellow · Yellow · Orange · Red · Rose · Deep red · Bright pink · Purple · Ultramarine · Dark blue · Blue · Light blue · Sea green · Dark green · Light green · Lime green · Olive green · Yellow ocher · Terracotta · Brown

Dry watercolor pencil

Apply watercolor pencils in the same way as normal colored pencils, using shading and blending to create a layer of pigment on the paper. The colors appear soft and muted.

Applying water

Load a watercolor brush with clean water and apply to the pencil marks to dissolve the pigment and create a wash. Move the wash to blend colors or create solid tone.

Drawing on damp paper

You can create intense, rich colors with watercolor pencils by drawing directly onto damp paper, or wetting the point of the pencil. Wait until the first wash is dry to avoid runs.

but once water is added to the marks they behave as watercolors do. The soft core of watercolor pencils makes them easy to blend and layer when dry, allowing you to create a wide variety of effects by adding water, from delicate washes to bold images.

Alternatively, you can apply watercolor pencils to damp paper to create marks of intense color. They're not permanent, so once the color is dry you can re-wet it and move it about again. These pencils allow for a greater precision than painting with a brush, and due to their practicality they are

ideal for sketching in dry colors when out and about, then working into washes later.

Inktense pencils are intensely-colored water-soluble pencils based on ink not pigment. Once Inktense marks are dry the color is permanent so you can layer them with other media, making them highly versatile. Inktense also comes in blocks, which can be used more like pastels (see pp.220–21).

Colored pencils can be combined effectively with other media, too; for example, by layering over a pastel base and adding finishing touches in gouache.

> "Colored pencils have a broad range of qualities— choose a good-quality set with a high concentration of pigment."

Basic color palette

A general set of 24 colors will provide a broad but balanced color range, suitable for most subjects.

Watercolor pencils

The soft pigment in watercolor pencils dissolves in water to create soft washes and blended colors.

Burnt umber · Black · Gray · White

Cadmium red · Orange · Cadmium yellow · Sea green · Lime green · Light green · Blue · Ultramarine · Violet · Bright pink · Brown · Black

Supports and other materials

CHOOSING A SURFACE TO DRAW ON

Having chosen your colored pencils, the next step is to think about your paper and other equipment to ensure you can complete a drawing without hindrance. You will need to consider your drawing surface, supports on which to draw, sharpeners, and brushes for use with watercolor pencils.

It is important to be aware of the surface on which you draw. Papers vary greatly between one another: if the paper is too thin for what you are trying to achieve, then it may tear; if it is too rough, then your color may not flow over the surface easily enough.

Paper for colored pencils

Standard drawing paper is readily available. The weight (and thickness) are measured in grams per square meter (gsm) and pounds per ream (lb.). A good weight is 130gsm—strong enough not to tear and will retain color well.

Watercolor paper is also measured in gsm and lb., and is a good choice for working with watercolor pencils. It is available hot press, for a smooth surface, or cold press, for extra tooth and texture. Whichever you choose, look for one about 300 lb. (640gsm) to ensure it doesn't tear when water is added.

You can also buy colored papers, which can be very useful for assessing colors and understanding how they interact. Using a colored paper as a ground or midtone adds another dimension to colored drawings.

Pencil sharpeners

A pencil sharpener is an essential part of your drawing kit—laying in color and shading will quickly blunt a colored pencil. A wide range of sharpeners is available, and which you choose will depend on how sharp a point you need and where you will be working. A desk-mounted sharpener is best for in the studio. A small handheld sharpener is perfect for drawing and sketching while out and about. Although the technique can take some perfecting, the best way to control the length and width of the point is to use a craft knife.

Water brushes
With a water reservoir attached to the brush, these are ideal for working with watercolor pencils on the go.

Fine, round-tipped brush

Thick, round-tipped brush

Flat-tipped brush

Brushes
A variety of round and flat brushes will provide a good starting point for washes in watercolor pencil. Their shape makes them suitable for detail, but they can also be used for broader strokes.

No. 3 round sable brush

No. 6 round sable brush

No. 8 round sable brush

Flat brush

Sketchbooks
You can choose from pocket-sized books for quick sketches on the go, to full-size pads suitable for large-scale life drawings or portraits. A spiral binding ensures that your page stays flat when working.

Drawing surfaces

If you are drawing on the move, then a sketchbook will be the perfect portable surface. They are available in a range of sizes and bindings—hardback, softbound, or spiral bound—and paper types, but ensure that the paper is of sufficient quality to take blended marks, and suitable for adding water if using watercolor pencils.

When working with loose sheets of paper, it is particularly beneficial to attach your paper to a drawing board with clips or masking tape to prevent it from slipping and to free up your hand from having to hold the paper in place. Make sure the board is smooth and even, since rough surfaces under your paper will show through in your drawing.

Brushes

When choosing a brush to use with watercolor or Inktense pencils, the choice is as large as that for colored pencils themselves. As a beginner, start with a set of basic round-tipped watercolor brushes in a range of sizes. As you progress you can try out other individual brushes as you learn which ones fit your specific needs.

There are many different types of brush fibers to choose from, too. The best quality brushes are made from pure sable. These retain their shape well and hold lots of water. For watercolor pencil work, a synthetic fiber brush, or mixed fiber, will be of sufficient quality for most tasks.

Water brushes are a great choice when working outdoors. They have different-shaped brushes and a reservoir that you fill with water. Brush across the tip of a watercolor pencil to load the brush with color, or use them to dampen dry marks to create washes.

Water jars
When working at home or in the studio with watercolor pencils, you will need a container for a clean supply of water. Always change the water between washes to avoid muddying colors.

Sharpening tools
Always have a pencil sharpener on hand, whether a classic handheld sharpener or a craft knife. Clean points are required for detailed work, or customize the shape of the tip for laying in color or lines of different widths.

Color theory into practice

COLORED PENCILS AND THE COLOR SPACE

Colored pencils are manufactured in a huge range of colors, shades, and tints. Choosing the "right" color for any given occasion can be a challenge. Organizing your colored pencils in terms of their hue (pigment color), value (how light or dark) and saturation (how strong or dull) will help you find the right one for the job quickly.

The color space

A way of identifying colors based on how we perceive them, the color space can help you to assess the relative values of colored pencils, and the tints and shades you create. Colors are categorized in the color space by three properties: hue (what we commonly refer to as color); saturation (how strong or dull the color appears); and value (how light or dark it appears). Use these factors to place any color in the color space: visualize a 3-D globe, where saturated colors lie in order around the "equator," becoming duller as they go deeper into the core, lighter toward the "North," and darker toward the "South."

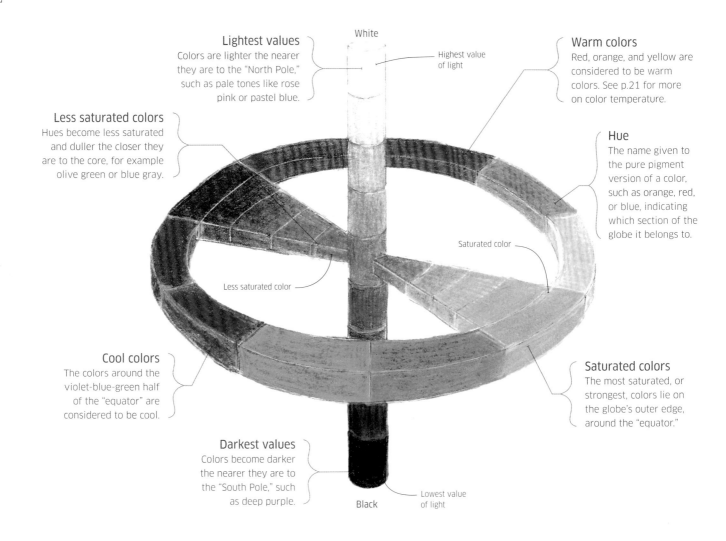

White

Highest value of light

Lightest values
Colors are lighter the nearer they are to the "North Pole," such as pale tones like rose pink or pastel blue.

Warm colors
Red, orange, and yellow are considered to be warm colors. See p.21 for more on color temperature.

Less saturated colors
Hues become less saturated and duller the closer they are to the core, for example olive green or blue gray.

Hue
The name given to the pure pigment version of a color, such as orange, red, or blue, indicating which section of the globe it belongs to.

Saturated color

Less saturated color

Cool colors
The colors around the violet-blue-green half of the "equator" are considered to be cool.

Saturated colors
The most saturated, or strongest, colors lie on the globe's outer edge, around the "equator."

Darkest values
Colors become darker the nearer they are to the "South Pole," such as deep purple.

Lowest value of light

Black

Using the color wheel

One way of arranging your colors is to follow the color wheel. The traditional color wheel starts with three primary colors (red, yellow, and blue) and may include secondary colors mixed from the primaries (orange, green, and purple), and intermediate colors. In fact, the distribution of these primary and secondary colors does not match how we perceive color. In this more accurate color wheel, red complements blue green; blue is the complement of orange; and purple blue and yellow complement each other.

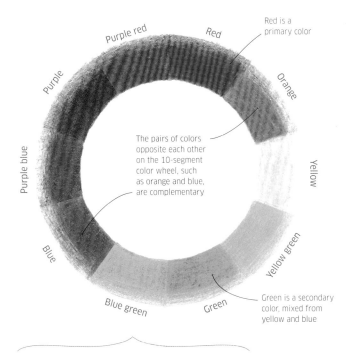

Red is a primary color

Purple red
Red
Orange
Purple
Yellow
Purple blue
Yellow green
Blue
Green
Blue green

The pairs of colors opposite each other on the 10-segment color wheel, such as orange and blue, are complementary

Green is a secondary color, mixed from yellow and blue

The 10-segment color wheel
The 6-segment color wheel (see pp.20–21) is an inaccurate model of how we actually see color. This 10-segment version extends the distribution of blue greens and gives more accurate complementaries.

Arranging colored pencils
Get to know your pencils by comparing them to the color wheel, using color space theory to place duller, darker colors toward the center and brighter, lighter tints further out on the circle.

Intermediate purple red sits between purple and red hues

Place primary colors in a ring around the wheel

Place darker and less saturated shades on the inside

Ultramarine is warm and saturated

Pure cobalt blue is cool and saturated

Add lighter tints on the outside of the wheel

Assessing your colors
Rather than relying on the names printed on your pencils, try out swatches to assess the actual colors, arranging them as described above. You will be able to see where there are gaps.

Missing hue between orange and brown

DERWEN

Creating tints and shades of one hue

When working in colored pencil, it is possible to extend a single color into a range of tints and shades by varying the pressure and number of layers you apply. To start, practice adjusting the pressure you apply and see how strong or how subtle you can make your marks with one color.

Light pressure using deep red

Changing pressure
Use the lightest pressure to achieve the palest hue, increasing pressure to darken color, and adding layers to achieve the deepest hue. Mix opposite colors to dull.

Deep red layered with green

Strong pressure with deep red

Mark-making for effect

USING A VARIETY OF MARKS TO ADD SURFACE INTEREST

Some colored pencil artists like to achieve blended colors where no marks are evident in the finished work. Others prefer the mark-making properties of pencils, and aim to achieve a variety of textures and effects across the surface of their work. Viewers will tend to focus their attention on more detailed mark-making where it falls within more loosely rendered passages.

PUTTING IT INTO PRACTICE

A variety of marks has been used to imply the soft, velvety fur of the horse; its long, loose mane and tail; the smooth, hard hoofs; and the detail around its bridle—but only once the basic form has been established.

You will need

Brown earth	Brown black	Ocher	Dark terracotta	Ginger/ orange	Deep red

Ultramarine	Lincoln green	Mid gray	Pale brown	Deep cadmium

- Colored pencils
- Hot press watercolor paper 140 lb.

Suffolk Punch horse

1 Underdrawing
Establish the major shapes in the subject. Freehand drawing will give you the best practice, but gridding or tracing is fine, too. If you've used graphite, once you're happy with the drawing, remove all excess graphite by dabbing all over your image with a kneadable eraser or Blu Tack to leave light guidelines.

2 Establish values
Keep a good point on your pencil. Working lightly, establish the main areas of value across the image using a dull brown. Keep your marks loose and consider how the direction and quality of the marks can help describe the subject.

Pencil marks

Your marks can be ordered (directional hatching or overlapping ellipses) or random (omni-directional hatching or scribbling). Using a tapered stroke will enable you to seamlessly add to, or adjust, passages of your work. You will have more control over your colored pencil mark-making if you work lightly in multiple layers. This has a less profound effect on the paper, which is prone to being indented by a pencil point.

Hatching

Omni-
directional
hatching

Crosshatching

Random
scribbling

Overlapping
ellipses

Dots and
dashes

Tapered
strokes

Scribbled
strokes

Smoothly blended, small
ellipses on the neck and rump

3 Add layers
Still working lightly, start to add light layers by increasing the number of your chosen colors. As you add layers, check that you don't lose the value range you established in the first stage.

4 Contrast detail
Leave some passages looser and contrast these with detailed areas to add a more "painterly" appearance.

Loose, random, light marks on the feet and lower legs

Monochrome

DRAWING WITH ONE COLOR

Be aware of line, shape, and value. Think of lines as being expressive—in reality, objects do not have outlines, they have surfaces that turn into or away from the light. Work lightly to start with so that lines can be erased or incorporated later. Shapes can be small or large, simple or complex. We see the transitions between shapes as edges—but avoid hard edges as shapes will look flat.

▦ Value

Value is often referred to as "tone" or "shading." Careful attention to the way that value shapes relate to each other will make your picture look real. The relationships below are all variations of the four extremes of value.

Windmill—after Rembrandt

Light against dark
Use to create key light accents that will draw the viewer's eye, as with the sail against the clouds.

Dark against light
Use to create the main dramatic shapes in the composition, such as the right side of the windmill.

Light against light
Use to introduce subtleties, as with the sail against the bright sky. Beware of hard edges.

Dark against dark
Use to draw the viewer into your picture, as with the sail against the dark side of the windmill.

Passages of strong contrast between light and dark shapes will automatically draw the eye of the viewer. If some parts of your picture are not central to the composition, keep your edges soft.

You will need

Burnt umber

- Faber Castell Polychromos colored pencil
- Hot press watercolor paper 140 lb.

Norfolk wherry

Don't worry about the detail at this stage

1 Establish shapes
With light guidelines, establish the major shapes in the subject, marking the placement of key elements. Some may be shown as light against dark. Don't draw lines you can't lose or incorporate later.

Dark against dark

Dark against light

Light against light

Light against dark

2 Choose your color
Use a kneadable eraser to remove all excess graphite—leaving a very faint image to work over. Then choose your color. It needs to be a low-value, deep color so you can develop a wide enough value range in your picture.

3 Establish the value range
Starting from the center, where you will need a wide range of values, use layers of crosshatching or other marks to establish the darkest values. Then rework a mid-value area to include a greater range of tone.

4 Add detail
Working within your value range, build up detail, paying attention to the marks you choose. Lighten small passages by dabbing with a clean kneadable eraser. Step back to judge the balance of light and dark, loose and detailed.

Order of drawing

AN APPROACH TO LINE, SHAPE, AND COLOR

It's a good idea to get into the habit of approaching a drawing methodically. The use of line in order to sketch and plan at the beginning of a drawing allows you to get the essentials down quickly. By seeing and drawing shapes within the initial outlines, you can begin to create form through tonal areas. Then, through the addition of color, your drawings will come to life! Sticking to such a methodical approach can help ensure the final image is a powerful one.

▣ Color strings

The introduction of a second color means that instead of thinking solely about tone, we must now think about color. When two colors are mixed together, we end up with a third. This third color can be varied through the differing levels of each of its component colors. A color string is a very helpful way of being able to see all the different colors that can be mixed from two.

Blue at this end of the color string

A red-blue color string
Start with red at one end of the string and blue at the other. By slowly shifting the balance of each color within the swatch, you will be able to see the range of colors possible from one end to the other.

Red overlays the blue and the color mix appears purple

This fruit-based exercise is a great way of practicing using two colors—in this case red and ultramarine—to create a drawing, concentrating on how to think about tone and form rather than realistic color.

You will need

Red

Ultramarine

- Colored pencils
- Sharpener
- Drawing paper

A citrus group

1 Simple outlines
Begin by using the red pencil to draw the simple outlines of the fruit. Try to draw the outline of the table in order to give a sense of place to the fruit, rather than letting them appear to float in mid-air.

2 A critical look
Look at how the light falls on the fruit, noting the lightest and darkest areas of tone. Slowly outline areas of notably different colors and tone. Start to dash in small details, such as the satsuma tops.

3 Drawing in monochrome
Sticking with the red pencil, create a monochromatic tonal drawing of the still life. Start to lightly and carefully block in the tonal areas previously delineated, which will begin to give tonal substance to the drawing.

4 Adding a second color
Switch to blue; your color string will help you grasp what mix you need to create different tones where. Add blue to areas that you feel need to be less vibrant, and keep areas of red pure for parts that don't.

5 Balancing the colors
After adding the blue, go back over the drawing with your red pencil, taking a critical look. Finally, look for areas that need to be dark, such as the shadows between the fruit and the outline of the lemon.

Using a limited palette

SELECTING BASE COLORS FOR MIXING

To avoid overcomplicating your drawing with too many colors to begin with, limit yourself to just three primaries. You can create a variety of hues from overlaying and blending marks, from tints to neutrals and a range of secondary and tertiary colors. Choose your base colors with the same strength to ensure overall harmony.

■ Triadic combinations

Creating a color triangle from your three base colors illustrates the possible combinations—or gamut—you can achieve, and is a useful reference before you start your drawing. Experiment with different base colors, using warm or cool tones, or harmonious colors.

Yellow, red, and blue mix to make tertiary purples

Primary yellow and red mix to make secondary oranges

Mixing primaries
Start with three primaries (red, yellow, and blue) that have the same strength. Overlap loose marks where the three colors meet to create secondary and tertiary hues (see pp.24-25).

(see pp.24-25)

PUTTING IT INTO PRACTICE

The multicolored plumage of this tropical bird is an ideal subject for working with a base of primaries. Mixes of yellow and blue produce vibrant greens, and red and yellow create warm orange tones.

You will need

Cobalt blue Vermilion Cadmium yellow Warm gray

- Faber Castell Polychromos colored pencils
- Sharpener
- Drawing paper 200gsm

Sri Lankan tropical bird

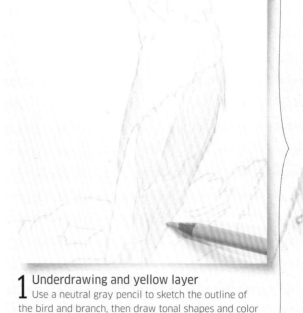

1 Underdrawing and yellow layer
Use a neutral gray pencil to sketch the outline of the bird and branch, then draw tonal shapes and color boundaries, such as on the bird's body and wing. Block in areas that contain yellow with the cadmium yellow.

Red layered over yellow creates a deep orange

Blue layered over yellow creates a brilliant green

All three primary colors combined create a rich, neutral brown

2 Red layer
Block in the red areas, using pure vermilion on the branch, and layering it over the cadmium yellow on the head and body of the bird, and areas of its wing, to make orange.

3 Blue layer
Add blue to develop the colors further. Create the greens on the wing by blending light strokes of blue with the yellow layer. Use pure blue for the beak, eye, and cool highlights, and to develop areas of shadow and define outline shapes.

4 Adding depth
Work over the whole picture with all the colors to build up depth of darker values and deeper hues. The darkest passages need multiple layers of all three.

"A limited palette of primaries will produce a variety of colors for a harmonious drawing."

Title **Cornucopia**
Artist **Jake Spicer**
Medium **Colored pencil**
Support **Drawing paper**

Mark-making: loose marks

≪ See pp.172–73

Loose, gestural marks have been used to suggest the curly fronds of the carrot tops without drawing in every detail of the leaves.

Color theory into practice

≪ See pp.170–71

Intense, highly saturated colors—such as the reds of the tomato—are balanced by duller, less saturated areas in low and high values.

Mark-making: focused marks

≪ See pp.172–73

Tighter, more controlled marks have been used to hatch around the shapes of the vegetables, building up 3-D form and color.

Showcase drawing

There is more than meets the eye in this still life of autumn vegetables.
The artist has carefully planned the composition with a light pencil
underdrawing, and then built up tone and color with colored pencils,
using a variety of loose and focused marks to suggest tone and texture.

Color composition

≪ See pp.178–79

The strong, bright diagonals
of the carrots lead the eye
into the center of the
composition, while the large
form of the cabbage holds it
on the right-hand side.

Order of drawing

≪ See pp.176–77

First the composition was
established with line, then
form built up with tone and
color, and finally details, such
as the frilled edges of the
cabbage leaves, added.

Monochrome drawing

≪ See pp.174–75

Using one color or a limited
range of neutral colors,
form, depth, and surface
texture have been
established successfully in
the mushrooms.

Optical mixing

POINTILLIST COLOR

As well as mixing colors by layering them one over another, you can mix colors optically (in the eye of the viewer) by placing lines or dabs of color side by side—a technique used by the Impressionists, called pointillism. The eye still sees individual colors, but your brain creates an illusion of more intense color. Mix secondary colors by placing complementary colors together to create brighter, cleaner hues than can be achieved by layering.

PUTTING IT INTO PRACTICE

In this life drawing, loosely inspired by the photo below, the range of tones is achieved by optical mixing. Strokes of hues close to the three primaries, but warmer and more earthy, are used to build up light and dark.

You will need

Terracotta Yellow ocher Ultramarine

- Colored pencils
- Sharpener
- Drawing paper

Seated nude

1 Light outline
Begin by using the lightest color, yellow ocher, to sketch the outline of the model and surroundings. Draw in the main tonal shapes to help plan where areas of depth need to be developed, and where highlights need to be retained. Use the color of the paper for the brightest highlights where the light falls.

2 Vertical marks
Draw vertical lines of yellow ocher to model the figure with the lightest tone. Using the same direction of lines all over gives a powerful coherence to the image. Use spaced lines for light tones, and denser marks for shaded areas.

■ Optical effects

Use strokes, dashes, or stippled dots of pure color next to each other to create vivid effects. By varying the size of the gaps between the colors, you can control the effect of space, depth, and hue—the smaller the gap, the more intense the effect. Also, the further away the viewer is, the denser the color appears.

Red stipples
Evenly spaced and sized dots of pure red give a uniform tone, conveying warmth to the viewer.

Yellow stipples
Dots of pure yellow create an intense effect used on their own, lending a yellow cast to the image overall.

Orange effect
By mixing the two colors with little space between them, you can create the effect of a bright orange hue.

3 Mixing orange
Add strokes of terracotta alongside the yellow ocher to make a warm orange. Leave the paper shining through to read as highlights, adding iridescence to the colors.

4 Adding blue
Use strokes of ultramarine to darken shadows and add cooler areas of blue light. Work into the background lightly, helping to suggest that the warmer-colored figure is in front. The pencil strokes appear as though they share the same space, creating a coherent image.

Yellow ocher, terracotta, and ultramarine are combined to build up deep shadows

Warm and cool colors

UNDERSTANDING COLOR TEMPERATURE

Colors have qualities that we associate with temperature. Such qualities also confer how they appear: warm colors have a tendency to come forward in an image, whereas cool colors recede. Sunlight can be warm in the summer and cool in the winter; using appropriate colors helps to set the season.

■ The relativity of warm and cool colors

Color temperature is not a cut-and-dried quality, but relative: it depends on the other colors nearby. For instance, cobalt blue (the truest primary) appears cool next to warm yellows, but will look warm in comparison to blues with a more greenish hue, such as cerulean.

Warm colors
Reds, oranges, and yellows are normally seen as warm colors. Such associations are probably related to the sun and fire.

Cool colors
Blues and greens are typically seen as cool. The root of the term may lie in their relationship with ice and deep water.

Warm yellow
Cadmium yellow shows a warm bias, on the red/orange end of the spectrum compared to some other yellows.

Cool yellow
Lemon yellow shows a cooler bias, closer to green. Mixing colors with this yellow will cool the resulting mix.

This still life offers a great opportunity to practice warm and cool colors, with natural light on the left and warmer artificial light on the right. Notice how the warm colors advance and cool colors recede.

You will need
- Colored pencils
- Sharpener
- Drawing paper

Orange Dark blue Cadmium yellow Acid yellow

Burnt umber Gray Sea green

Bowl of fruit

1 Rough outline sketch
Using a neutral gray pencil, first sketch the rough outlines. Then, very lightly, draw in the tonal shapes, as well as making a distinction between obviously cool and warm areas.

2 Blocking the neutrals
Block in neutral areas of color. You can then adjust these to be warmer or cooler using other colors. Since orange is a naturally warm color, be sure to leave the cool areas blank for filling in later.

3 Adjusting the warm colors
Areas such as the right-hand side of the table and the bowl's shadow are warm due to the artificial light. Use a warm cadmium yellow to go over the brights of the orange.

4 Checking the cool colors
Make the background blue to reinforce its place. Use a sea green to highlight the cool light coming in on the left. Adjust the orange in the cooler areas using an acid yellow.

5 The darkest tones
Finally, add in the darkest darks (such as the shadows) to emphasize tones. Notice whether or not the shadows are warm or cool and choose the darker colors accordingly.

Complementary colors

USING OPPOSITE COLORS TO CREATE EFFECTS

Different aspects of using colors on opposite sides of the color wheel—that is, complementary colors—can greatly enhance your drawing, whether they are used to create contrast or to desaturate colors by mixing neutral grays. Saturation with colored pencils is helpful in enhancing the appearance of depth, distance, and form.

■ Dulling saturated colors

You can adjust color saturation by layering pairs of complementary colors. To desaturate a color, or make it duller, simply add some of its complement; any mix of two complementary colors is achromatic or neutral. Such neutrals are valuable in recreating the effects of light. Control of color saturation is effective in rendering light on 3-D forms.

Color grays

Complementary spectrum
These graduated transitions from one complementary color to its opposite are like moving from one side of the color space (see pp.170–71) to the other. A range of neutrals appears in the center.

■ Using contrasts

Setting pairs of complementary colors alongside or within each other creates striking optical effects, intensifying the effect of both colors. Notice how they fight for attention, so the colors appear to pop out from the page.

Red and blue-green

Yellow and warm blue

Yellow-green and violet

Complementary pairs
These effective complementary pairs are based on the color space model on pp.170–71. Choose two hues of similar value when selecting pairs of complementaries to combine for high contrast.

PUTTING IT INTO PRACTICE

Choose a brightly lit scene to practice layering complementary colors. Bear in mind that saturated colors appear closer, and duller colors seem to recede.

You will need

Cobalt turquoise	Ultramarine	Blue violet	Leaf green	Blue reddish	
Venetian red	Burnt umber	Apple green	Dark red	Lemon	
Burnt ocher	Raw umber	Cobalt blue	Olive green	Night green	Light ultramarine

■ Colored pencils
■ Kneadable eraser
■ Pencil sharpener
■ Hot press watercolor paper 300gsm

Boat out of water

1 Underdrawing
Working over a light graphite underdrawing (for accuracy), identify the main areas of light and shadow.

2 Picking complementaries
Choose your principal colors and their color complements. In this image, a range of blues and violets contrasts with complementary yellows, greens, and reds.

"Use complementary colors to add energy and life to your drawings."

3 Dulling complementaries
All shadow colors have been dulled with their complementaries. Use multiple layers for shadows, and note the direction of light for consistency.

4 Complementary contrasts
Red has been used to indicate shadows in the grass for a suggestion of movement. Yellow-green on the masthead stands out against the violet cloud.

Colored papers

WORKING ON SUPPORTS OF DIFFERENT HUES

Working straight onto a piece of colored paper gives you the advantage of having a unifying color throughout your picture. What's more, it also helps to increase the range of colors used—think of the paper as one of your drawing's hues. Allow the color of the paper to show though in certain parts to give solid areas of color.

Creative use of color

As well as unifying the overall image and providing you with a midtone to work from, drawing on different colored papers with colored pencils can offer you a range of visual and atmospheric effects.

Simple outline

Working on a midtone grayish green, which picks up the green hues in skin, with a warm-toned terracotta pencil evocative of the earth tones in skin, helps to give this outline drawing of a hand an impression of solidity.

Shadow play

Choosing to work on a warm midtone pink means that the solid color leaps out from the page. Drawing the shadows of the hand in a darker, less vivid brown color helps to create the illusion of form and depth.

Background light

Drawing the same hand silhouetted on dark blue paper with a yellow "halo" effect is suggestive of a nighttime scene in which the figure is backlit by fire, candlelight, or even a more modern electric light source.

Using colored paper here has enabled the artist to build up darks and highlights from a midtone when drawing his own hand. Even with strong directional light, the main flesh tones are in the mid range.

You will need

Orange · Deep red · Dark blue · Ultramarine · White

- Colored pencils
- Sharpener
- Green paper

The artist's hand

1 Initial sketch
Start by using the orange pencil to lightly and roughly draw the outline of the hand. Add in some minor details, such as nails, knuckles, and skin folds.

2 Adding warm tones
Still with the orange, start to build up a tonal drawing, blocking in darker areas of the hand. Repeat with the deep red pencil to push the tonal values further and start to create the hand's form.

3 Shading in cool colors
Next, using the dark blue, shade in the darker and cooler areas. You can use the blue to adjust the mood and also counter overly warm areas from the previous stage.

4 Backlighting
Create the illusion of a backlight around the edge of the hand with a white pencil. This technique isolates the green of the hand from the paper, giving coherence and extra value.

5 Highlights and darkest tones
Finally, use the white to create highlights on the hand, such as the nails and knuckles. Then, switch to the ultramarine pencil and use it to emphasize the darkest areas.

Surface textures

STONEWORK, WOOD, GLASS, AND IRON

Focusing on texture in colored pencil is hugely rewarding, with opportunities to blend and layer using varied pressure to render rough stone, the subtle patterns of wood, solid metal, and reflective glass.

▤ Rendering glass

Glass presents several challenges for the artist, whether it is transparent or more reflective. Look for muted tones that can be seen through clear glass, using highlights to add reflections. Opaque colors suggest a reflective surface; use colors taken from the sky or surroundings, depending on light levels and angles.

Solid color for stained glass, with lighter tints suggesting reflections

Glass reflections
Here, the colored glass window is recessed into the shadows. The stained-glass surface of the top glass panels is indicated by opaque colors. Reflections of the garden are visible below, suggested with muted, soft shapes. The bright red of the stained-glass detail is laid in with solid color.

Clear glass
The clear glass in the lantern is indicated by the muted brick tones behind the casing. The glass bulb is drawn in soft gray with white highlights. An F graphite pencil has been used to lightly go over the thinly applied orange brick, and an HB pencil around the shaded top of the bulb and the crisp outline of the rim.

In this drawing, the contrasts of warm, crumbling bricks and soft, muted tones of weathered wood make a charming subject for working in layers of colored pencil combined with graphite pencil.

1 Underdrawing
Establish your composition with a light underdrawing in graphite pencil. Here, the door is placed with the window centrally in a portrait format, bordered by the characterful bricks of the wall and foreground path.

2 Stone texture
Blend browns and oranges in the bricks, with a touch of yellow ocher for the mortar. Leave patches of white paper for the salt deposits.

You will need

| Light blue | Mauve | Rose pink | Orangish yellow | Brun noisette | Rouge orange | Scarlet | Rouge anglais | Russet | Chestnut | Olive | Moss green | Light green |

- H, F, HB, B graphite pencils
- Caran d'Ache Supracolor Soft water-soluble pencils
- Transparent ruler
- Twin-hole sharpener
- Eraser
- Drawing paper 300gsm

Weathered doorway

3 Wood grain
The color of the weathered oak is a combination of soft browns and grays, using colored and graphite pencils over a light base. Observe the grain shapes and pick out knots, holes, cracks, and nails with a sharp pencil for a denser mark.

4 Metal details
The wrought-iron door hardware can be described perfectly using an HB or B graphite pencil over a lightly applied blue. Apply with varying pressure over the colored pencil, using a sharp point to add crisp edges and textured detail.

5 Hard and soft
Use a combination of orange and purple for the path, edged with loose marks in green for the soft moss between the brick cobbled path. Soften with graphite.

6 Balancing the composition
The surrounding foliage is suggested in outlines of light pencil, using an F grade. Add a few lines or part-colored details to balance the composition, making a pleasing shape on the white paper.

Title **Hubcap reflections**
Artist **Malcolm Cudmore**
Medium **Colored pencil**
Support **Hot press paper 300gsm**

Optical mixing

« See pp.182–83

A variety of blues and browns have been optically mixed in layers to create the cool grays that represent the hard metallic surface of the hubcap.

Cool colors

« See pp.184–85

The reflections of blue-gray sky and of green grass in the polished metal of the hubcap are dominated by cool colors—cold blues and greens.

Surface texture: grass

« See pp.190–191

The softer, directional nature of the loose marks describing grass are a contrast to the focused marks and harder, more abstract shapes that describe the chrome surface.

Showcase drawing

The reflections in a shiny hubcap offer several challenges to convey texture and distorted shapes. The metallic surface has been rendered using optical mixing, contrasting with the texture of the grass. A limited palette of predominantly cool colors unifies the drawing.

Complementary colors

≪ See pp.186–87

Small elements of red added to the layers of blue/brown grays add additional contrast to the predominantly green reflections.

Warm colors

≪ See pp.184–85

In a predominantly cool picture, largely made up of blues and greens, hints of yellow, red, or brown in the shadows and reflections of people add warm accents.

Surface texture: reflections

≪ See pp.190–91

The bright, reflected highlights are achieved by carefully reserving specific areas of the white paper and final detailing with an eraser.

Skin tones

SEEING THE COLORS IN SKIN

Skin is not one single color, but myriad different hues and tones. Depending on the direction and type of light and the angle of the head to the artist, completely different colors can appear in the same face at different times. The best way to draw a face is to understand more about what colors to expect and where, and then to look as hard as possible to see if you can find them.

▓ Using earth tones for skin

Old masters, such as Rembrandt, would have used only earth tones for their drawings. These are colors whose pigments come from organic materials, such as different earths. You can create an incredible array of tones and hues for skin using just these colors and, since the palette is limited, it will help to unify your picture. You can add stronger colors later to pick out highlights.

Earth tones
This portrait has been drawn using only the earth tones terracotta, yellow ocher, and burnt umber, and dark and olive greens. The warm, organic hues are suited to most skin tones.

Burnt umber creates warm, dark tones for the eyebrows and under the cheekbones

Dark and olive greens add cooler tones to highlights and shadows

Fair skin tones

Light tone Midtone Dark tone

Acid yellow Olive green Burnt umber
 + + +
Bright pink Bright pink Red
 + + +
Sea green Light blue Ultramarine

Palette for fair skin

Do be aware of the white of the paper coming through (in fact, you can choose to let it shout loud for highlights). Vary the pressure you apply to your pencils accordingly to help accentuate the sense of fair skin. Observe that light and midtones contain notes of warm blue, while ultramarine deepens the shadows.

Olive skin tones

Light tone Midtone Dark tone

Yellow ocher Olive green Dark green
+ + +

Olive green Brown Ultramarine
+ + +

Terracotta Red Terracotta

Palette for olive skin

It can be helpful to do a monochromatic tonal drawing as the base of the picture first. Here, an olive-green colored pencil was used for that purpose and it also helps to unify the whole picture. Note how the green tones are balanced by warm yellows, reds, browns, and terracotta, applied with varying pressure.

Dark skin tones

Light tone Midtone Dark tone

Bright pink Bright pink Deep red
+ + +

Purple Purple Purple
+ + +

Sea green Yellow ocher Burnt umber
 + +

 Terracotta Terracotta
 +

 Dark blue

Palette for dark skin

You don't always need to combine colors in the skin. Look at some of the lighter areas and note how one color can be used at certain points for a stronger and more vibrant hue.

To create this drawing of a laughing child, warm earth colors were used to build up a basic outline and underlying tone. Stronger blues, yellows, and reds were then added to create contrast, focus, and more lifelike skin tones.

You will need

Nero black · Prussian blue · Walnut brown · Brown ocher · Terracotta · Cerise pink · Cadmium red

- Colored pencils
- Sharpener
- Hot press watercolor paper 140 lb.

Laughing child

Add focus around eyes

1 Warm tones
Using red pencil for an initial drawing creates a warm tone for the features that will show through on the final piece, adding radiance to the face. Lightly adding a warm midtone color helps to establish form and lighting, and provides direction for the colors yet to come.

2 Dark tones
Adding darks for the features brings a focus to the drawing. Concentrate on the eyes, in particular, because they will be the areas of highest contrast. Layering lightly applied pencil strokes will produce a more complex and nuanced representation of the various colors and tones of the skin.

3 Cool blues
A Prussian blue for subtle midtones and dark areas in the hair complements the warm earthy skin tones. Build form by introducing colors such as terracotta and brown ocher to build skin tone, and cadmium red for blush on the cheeks and warm shadows around the eyes.

"Combine **warm earth tones** with a limited palette of **cool blues, vivid reds,** and **muted yellows** to create a successful and **realistic portrait.**"

Mixed media

USING MORE THAN ONE DRAWING MEDIUM

Combining different media in your drawings extends your options and possibilities. Pastels work well with colored pencils; use them to lay broad areas of foundation color, over which you can apply colored pencil to develop detail and subtle color values and tones. Consider the requirements of all your media when choosing a surface, for example use a paper with tooth to hold pastel pigment that is also resilient enough for blending.

■ Layering, burnishing, and blending

This process enables you to blend different colors to produce a wider variety of hues and color values and a smooth, graduated effect with light and shade. Eliminating pencil strokes results in even layers of color. Continual burnishing will produce a shiny surface that is resistant to adding more color. Spray with fixative, allow to dry, and continue over-layering.

Layering
Starting with the lightest hue and finishing with the darkest hue, layer your colors over each other. Work the pigment into the support as evenly as possible. This process is generally more effective on smoother surfaces.

Saturate the surface with color

Blending and burnishing
With a colorless blending pencil, use strong pressure to blend and burnish the colors together. Some pencil brands will produce clots of pigment. These can be eliminated by gently scraping away the excess pigment with a scalpel.

Use a colorless blending pencil

The arrangement of pebbles and patterns created by the flowing stream and refracted sunlight provides an interesting abstract image drawn in blocks of pastel color and detailed colored pencil.

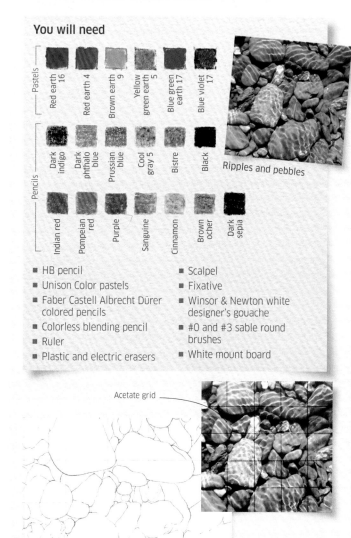

You will need

Pastels: Red earth 16, Red earth 4, Brown earth 9, Yellow green earth 5, Blue green earth 17, Blue violet 17

Pencils: Dark indigo, Dark phthalo blue, Prussian blue, Cool gray 5, Bistre, Black

Indian red, Pompeian red, Purple, Sanguine, Cinnamon, Brown ocher, Dark sepia

Ripples and pebbles

- HB pencil
- Unison Color pastels
- Faber Castell Albrecht Dürer colored pencils
- Colorless blending pencil
- Ruler
- Plastic and electric erasers
- Scalpel
- Fixative
- Winsor & Newton white designer's gouache
- #0 and #3 sable round brushes
- White mount board

Acetate grid

Grid drawn on support

1 Scaling up the composition
Drawing a grid over the photograph on acetate helps to scale up the image and act as a compositional guide. Transfer the grid to your support and draw a pencil outline of the pebbles.

2 Apply soft pastel
Working from the top, apply pastel using your fingers to blend and spread the color, pushing the pigment into the paper.

3 Foundation pastel layer
Complete the intense pastel layer. Use tissues or cotton swabs to vary the density of the marks, keeping edges clean with an eraser.

4 Lifting out with eraser
Starting at the top, use an electric eraser to lift out the ripple shapes, varying the pressure to change the line width. Apply fixative.

5 Overworking in colored pencil

Start to build the fine detail and make any adjustments to colors and tones with layers of colored pencil. Lay down colors and blend as necessary, working from the top down to prevent smudging and contaminating colors. The pastel foundation will provide a smooth surface for drawing.

6 Blending and burnishing

Use a colorless blending pencil to blend and burnish the colors evenly, eradicating pencil strokes and minimizing graininess. Strengthen dark tones between the pebbles to suggest form. Use a sharp scalpel to lightly scrape away any buildup or "clogging" of pigment.

7 Adding highlights in gouache

Use a fine sable brush to apply white gouache for highlights and to reinforce the ripples. The opaque quality of gouache will be retained over the pastel and pencil layers.

Ripples lifted out using an eraser

Foundation layer of pastel provides intense color

"Combining different media and **techniques**
in one drawing is a great way to extend
your **working practice**."

Watercolor pencils

ADDING WASHES TO YOUR DRAWINGS

Water-soluble pencils give you all the benefits of watercolors while maintaining the practicality and control of colored pencils. You can create washes of color to block in large areas, or work directly into a wet surface for bold and vibrant color. Make sketches on location, then work into them with water back in the studio.

■ Blending marks with water

There are an infinite number of ways to use watercolor pencils, combining washes with pencil marks. The main difference is whether you add water after the color has been laid down in order to create a wash, or wet the paper and draw onto it to intensify the strength of the mark.

Building a wash
Lay down an even layer of color, load a brush with clean water, and apply it to the surface to create a light wash. To build up the color, add subsequent layers of pencil and blend with a wet brush.

Drawing onto wet paper
Apply clean water to the paper surface with a damp brush or spray bottle, and draw with your pencil. The marks will blend into the paper surface, concentrating the pigment to create rich layers of color.

PUTTING IT INTO PRACTICE

This patternlike image of water lilies is built up with watery washes of background color overlaid with drawn details worked into a damp surface, perfectly recreating the vibrancy of the flowers.

You will need

Brown | Light green | Lime green | Ultramarine | Blue | Bright pink | Violet

- Watercolor pencils
- Sharpener
- Watercolor brush #6 round
- Cloth
- Water
- Spray bottle
- Hot press watercolor paper 140 lb.

Water lily reflections

Outline the pinkish green lily pads against the dark water

1 Initial outlines
Draw in the outlines and shapes of tonal areas using the bright pink pencil. Don't press too hard just yet, in order to ensure you don't end up with any unwanted marks shining through.

2 First wash
Shade in the main areas of color using the pencils, without pressing too hard. Once the colors are blocked in, use a brush to apply water to create washes and push the colors around—you don't need to be too precise.

3 Building depth
To darken areas further and give depth, apply shading again and add another wash of water. Use the brush to even out any existing marks by adding more water. The initial lines will prevent bleeding between colors.

4 Controlled details
Now add in details, such as flower petals, by wetting areas first, either with a brush or by spraying the surface, and then drawing into them with the pencils in order to create intense and more precise areas of color.

Title **Flamenco dancer**
Artist **Malcolm Cudmore**
Medium **Colored pencil**
Support **Hot press paper 300 gsm**

Skin tones: dark

≪ See pp. 194–97

These are not portraits, so
the colors of faces are
simplified. A warm palette of
pinks, reds, and burnt sienna
is used to describe the skin
tones of the performers.

Optical mixing

≪ See pp. 182–83

The sense of artificial lighting
in the dark, subterranean
club is built up by "glazing"
layers of color over the
background, conveying a
warm glow from the lights.

Complementary colors

≪ See pp. 186–87

The pinks, reds, and oranges
on the extravagant frills of
the dancer's dress contrast
with the cool blue shadows
on the white fabric.

Showcase drawing

This detailed drawing, full of movement and energy, brings together all the colored pencil techniques, using mark-making to contrast detailed forms and soft shapes, and exploiting color relationships and principles of perspective to draw the eye through the wide-format composition.

Mark-making

« See pp.172–73

Layers of colors are laid down in different directions, suggesting movement. A variety of short, dashed marks implies the textures of the fabric.

Monochromatic color

« See pp.174–75

The background is expressed in value rather than color, with neutral grays mixed from dull blues and browns, providing a contrast with the saturated oranges.

Skin tones: light

« See pp.194–97

The paler skin tones of the audience members sitting in the darker recesses of the room are cooled and darkened with blues and browns.

Pastels

Drawing with **pastels**

One of the attractions of pastels is their immediacy—simply pick one up and start using it right away. This easy handling makes for a versatile medium, and one you can exploit with different marks to create different effects—from broad, sweeping strokes of layered and blended color to precise, detailed marks. The rich and glowing colors of pastels offer a wealth of visual mixing, allowing the artist to both paint and draw at the same time.

On the following pages, you can discover the qualities of each type of pastel and their versatility, which papers and supports to use, and other materials you will need. Then, practice and develop your skills with more than 30 pastel techniques—arranged in beginner, intermediate, and advanced sections. Each section concludes with a showcase drawing that brings together a range of techniques.

1 Beginner techniques

■ See pp.216–41

In the first section, you discover how to make marks with all types of pastel. What's more, you'll learn the importance of pressure, when to blend, how to work with color, and how to mix the most useful colors.

2 Intermediate techniques

■ See pp.242–67

In the second section, explore the world of paper (textured and colored), learn how to layer pastels, create realistic visual textures, and use complementary, warm, and cool colors confidently.

Beginner showcase drawing (see pp.240–41)

Intermediate showcase drawing (see pp.266–67)

Pastels used by artists for creative expression and exploration have been around for a long time—favored for life studies and preparatory drawings—but it wasn't until the 1870s, when Edgar Degas started using pastels to create his great impressionistic studies of ballet dancers, that he transformed pastel from a "mere sketching tool" into a high-status artistic medium. Other artists followed suit, including Henri de Toulouse-Lautrec, Pierre-Auguste Renoir, and Paul Gauguin, all exploiting pastel's freedom of color and expression.

Intense colors

In Renaissance times, pastels were available only as black, white, and red—a far cry from the huge spectrum of colors available today. Pastels are basically pigment mixed with a binder of some kind, which is then rolled or pressed into a stick; the binder is what gives the particular pastel its richness and layering ability. The best pastels are almost pure pigment, which is why they offer such brilliant color with a high level of saturation. You can strengthen color further through fixing and layering.

Easy to use and versatile

Pastels are available in varying degrees of hardness and softness and are often wrapped in paper for easy handling, color identification, and labeling. No need to ponder about brushes, pastels are designed to work with just your hands (well, fingers) as a blending tool, building layers of color that mix in the eye. Many artists find pastels instinctive to use. You can use them for abstractions, atmospheric landscapes, still life drawings, or detailed portraits—they work with every type of subject.

3 Advanced techniques

■ See pp.268-93

This section explains more subtle but useful techniques—drawing figures in motion, portraying skin tones, creating focal points, capturing the qualities of water, and working on a textured surface.

Advanced showcase drawing (see pp.292-93)

Pastels

THE COLORFUL WORLD OF PASTELS

Pastels offer a good way in to working in color. More expressive than colored pencils, but more manageable than paint, they fall somewhere between a drawing and a painting tool, and come in a staggering array of colors that can be layered and blended. Different types of pastel, made with different binders, offer the artist a range of drawing qualities.

Pastels come in several types: soft and hard pastels, oil pastels, and water-soluble pastels. All pastels are a combination of pigment and binder shaped into a stick that's easy to hold. The type of binder used determines the properties the pastel will have.

Pastel properties

The type you choose to use will depend on the effect you want to create, or style you like to draw in. Soft pastels, for example, are infinitely blendable and smudge easily (they break and crumble easily, too), but they do generate dust during drawing and need fixing to keep the pigment particles on the support. Soft pastels come in a myriad of colors.

Hard pastels, on the other hand contain more binder and less pigment. This means that their colors are not as intense but the big advantage is that they crumble less easily. Hard pastels are ideal for preliminary sketches, base layers, details, and finishing touches.

Oil pastels do not crumble, smudge, or release dust. They contain just as much pigment as top-quality soft and hard pastels, and produce clean, bright, intense colors. What's more, they don't require fixing, but since they never completely dry, special care needs to be taken to protect completed work. They are dissolvable in solvents to create washes of color and lend themselves to vigorous work–layering with washes and scraping back.

Water-soluble pastels may come in a more limited range of colors, but you can blend them with water, move the medium with a brush, and use the brush to mix and "paint" the colors you want. If you're happy using a brush, these pastels offer exciting creative interpretations, used dry or wet.

Pastel pencils
When what you need is the precise control to add fine details, then choose pastel pencils. These useful tools combine well with soft and hard pastels.

Buying pastels

As with many artistic media, pastels are available in two qualities: student quality for beginners, and the more expensive artist-quality versions. You can buy individual pastels, but if you're buying pastels for the first time it may be more economical to buy a starter set that you can add to with different colors when you need them over time. In fact, some pastel artists believe it's better to buy fewer good-quality pastels than a great number of cheaper and poorer-quality ones, since they so often produce disappointing results.

Various manufacturers group particular colors into useful sets: for example, if you're keen on drawing outdoors, then a landscape set or an earth tones set may be worth exploring; if you're more of a portraitist, then the skin tones set may well appeal.

The different brands use their own individual formulas to manufacture pastels, and each offers its own colors and varies in the way it feels in your hand and loads onto the page. Perhaps you can try some out in a local art shop or at a community art group before deciding which brands you prefer.

> "Different brands of pastel use individual formulas and colors; each varies in the way it feels in your hand and loads onto the page."

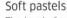

| BE 29 | BE 28 | BE 26 | Y 12 | Y 10 | Y 9 | Y 7 | Y 1 | YGE 12 |

Soft pastels
The level of color, immediacy of use, and blending possibilities make soft pastels a fantastic medium. The choice of colors is huge.

| BG 9 | BG 8 | A 52 | A 51 | A 50 | BV 12 | BV 11 | BV 10 | BV 9 | BV 7 | GREY 28 (WHITE) | GREY 36 (BLACK) |

Pastels and other materials

MAKING THE MOST OF THE PASTEL MEDIUM

Quality pastels are expensive because they're literally packed with pigment, so it's good to know that you won't need much else in the way of expensive equipment when working in pastel; most other handy items are commonplace art materials. And once you've started creating artworks, find out how best to protect your pastel masterpieces.

Other useful equipment

Depending on the type of pastel you're using, there are certain pieces of equipment and ways of working that will make all the difference to your finished artwork. Handy items include masking tape, a scalpel blade or craft knife, binder clips, a drawing board, and an easel to work at.

Dust-free working

There are many advantages to using soft pastels and only really one downside—the creation of dust during drawing. Because pastels are basically finely ground pigment mixed with a binder, tiny particles of pigment are released onto the page and anything not attached to the surface of the paper or support is free to travel. Follow these tips for clean drawings:

Work upright—working at an easel rather than flat at a table ensures that any pastel falling off your support falls down and off the page, minimizing smudges and muddying of colors.

Roll up sleeves—avoiding inadvertent smearing of drawn marks.

Draw in a well-ventilated area—restricting exposure to dust.

Protect drawings—covering each drawing with a layer of acid-free tracing paper limits smudging of pastels.

Handy items for oil pastels

Oil pastels use oil or wax to bind the pigment before it's shaped into a stick and wrapped in paper. Because of its oily nature, the pigment sits in more of a layer and it can be scratched off—a process known as sgraffito (see pp.218-19)—to add texture to certain areas of a drawing. There are special sgraffito tools, but you could also use a craft knife or even a toothpick.

Oil pastels
Created as cylindrical sticks of pigment and wrapped in paper, the pigments are bound together with wax and oil. Oil pastels have a distinctive consistency, being more akin to working with paint in many ways.

There may not be dust with oil pastels but there can still be mess, so a stash of paper towels is handy to keep your fingers and pastels clean.

Protecting pastel artwork

As mentioned before, soft and hard pastels require fixing to prevent loose pigment particles from falling off the support and onto items around it. However, if you're drawing on sanded papers (see pp.215 and 244–45), then the need to fix along the way is lessened. Pastel fixative is a chemical that comes as a spray and is easy to use—just make sure you apply the fixative lightly in a well-ventilated area. Be aware that fixative darkens colors.

Oil pastels don't require fixing, as such, but as the oil in their makeup doesn't dry (unlike oil paints) the pigment can still be rubbed off or smudged once you're finished. It's a good idea to protect the surface of a finished drawing with sheets of acid-free tracing paper or pop it straight into a frame behind glass. If left unprotected, a drawing can attract dust. In fact, all pastel drawings are best stored—and enjoyed—behind glass.

> "There are many advantages to using soft pastels and only really one downside—the creation of dust during drawing."

Soft and hard pastels
The nuances of which pastels are softer and which are harder depend on many factors and vary with the manufacturer. With practice, you'll discover which you prefer to use and which brands are your new favorites.

Pastel supports

CHOOSING THE RIGHT KIND OF SURFACE TO DRAW ON

Because pastels are a soft medium, they need a surface with some texture to capture and hold the pigment. As with the pastels themselves, there is a large number of papers and surfaces (what are known as supports) to draw on. As well as specially designed pastel paper, you can draw on all manners of papers, cards, textured surfaces, and even wood.

A paper's "tooth"

The surface texture–or "tooth"–of a support is what holds the pastel pigment. When working with soft pastels, much of the pigment falls off a super-smooth paper that has little tooth, so what you want is some surface grain or grit. It's worth trying out various types until you find the support that works best for your style.

Paper properties

Knowing the weight, strength, and properties of paper is important to pastel artists. Since you may well be doing a lot of rubbing, blending, and vigorous drawing, you'll need a responsive paper with plenty of tooth that is strong, too. Papers come in various sizes and formats and are available as individual sheets or pads in a number of different sizes. You can also get preprimed gesso boards for a super-textured surface, or prime your own surface in a number of ways.

Colored papers

Working on different colors of papers can change the effect of your pastel drawings to no end (see pp.246–47). As well as white and cream, many pastel papers come in a range of midtones and black. Colors that work well as a base for pastel drawing range from neutral grays, blues, and greens to strong reds, purples, and oranges.

DIY pastel supports

You can create your own, handmade surfaces to work on, including primed wood (see pp.278–81). Papers and board can be transformed into a surface with a suitable tooth using a textured primer–such as pumice ground, acrylic ground (using sand), gesso, or a

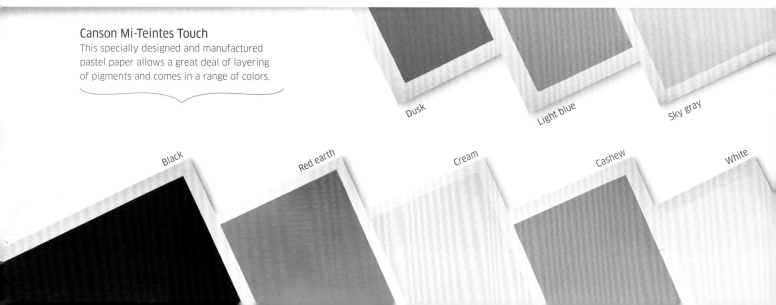

Canson Mi-Teintes Touch
This specially designed and manufactured pastel paper allows a great deal of layering of pigments and comes in a range of colors.

Dusk

Light blue

Sky gray

Black

Red earth

Cream

Cashew

White

Sand

Sienna

Earth

Black

Priming with gesso
Add texture to a board or paper surface by brushing on a textured ground, such as gesso. If the result is too rough, you can sand it back.

Sennelier sanded papers
These fine sandpaper-grain papers, which come in a large range of colors, are just one of the many pastel papers available to work on. The fine tooth of these holds the pastel color well, allowing for layering over the colors, which contributes to the effect and atmosphere of a drawing.

semi-opaque acrylic wash. Some need diluting before they're ready to use. Be aware that papers below 640gsm may need stretching first.

Sketchbooks
On the whole, sketchbooks contain smooth and lightweight paper, which is not ideal for pastel drawing. But since you can take your sketchbook everywhere, it's a great resource for dashing down colors as a memory aid,

as well as capturing certain forms or compositions. Remember to fix the pastels, as necessary, or interleave some tracing paper.

Specialist pastel papers
The pastel artists in this book use a range of papers best suited to the medium of pastel—these papers have surfaces that allow for a great deal of layering and can grip on to pigment particles. Here are a selection from different manufacturers: Canson Mi-Teintes Touch 350gsm, Sennelier La Carte 360gsm, Clairefontaine Pastelmat

360gsm, and UART premium sanded pastel paper 400gsm. This last pastel paper comes in various levels of grit: from the largest tooth (240 grade) right up to the finest tooth (800 grade).

Pastel fixative
You can use fixative creatively (see pp.216) to selectively darken colors or simply apply to ensure your pastel artworks remain as brilliant as the day they're finished.

Sennelier colored papers
As well as having a sanded surface ideal for working in pastel, the papers come in a range of colors from off-whites to near-blacks.

Peach

Antique white

Light blue green

Green

Dark blue gray

Mark-making in color 1

EFFECTS WITH HARD AND SOFT PASTELS

You can draw with a hard or soft pastel to make different marks, just as with other media. What's striking is that everything is in bright color. Discover how to blend or layer colors to recreate the myriad hues you see.

▨ Creative use of fixative

You can think of fixative as a "tool" in its own right in regard to pastel drawing. Yes, it does fix the color and pigment in place (most useful at the end of a project), but it also darkens the colors. Both of these qualities also enable you to achieve other effects.

Layer pastel with fixative
One way of using fixative creatively is to mask certain areas of a drawing and then darken the unmasked areas with fixative. This swatch shows an area of flat tone, with light, mid-, and dark tones blended together.

Masked strips
Use strips of plain white drawing paper, attached with masking tape at the edges, to block out areas that you want to keep light.

Darkened bands
Spray the entire piece and then remove the strips to reveal the darkened areas exposed to the spray. Some bleeding happens.

You can combine hard and soft pastels together in a number of ways, using expressive, eye-catching marks. Once learned, you can apply these basic techniques to draw all sorts of subjects.

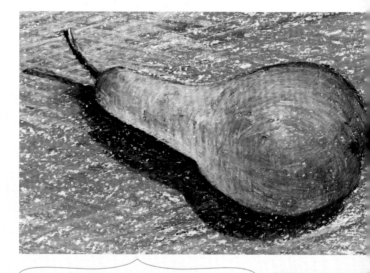

Hatching and cross-hatching
Use lines following a particular direction (hatching) and the opposite direction (cross-hatching) to combine colors. Curved lines on the pear help to describe its form, too.

Layering and feathering
Rather than blending colors smoothly, you can load the paper generously with color and allow the layers of pastel colors to mix visually (see pp.224-25). Here you can see the varied marks are interwoven and layered (see pp.228-29).

"Find the mark-making techniques that work best to create colorful drawings."

Blending

Merge one color into another to create seamless color transitions by blending. Use a finger or a cloth to gently rub one or several colors (placed side by side) into one another (see pp.224–25).

Scumbling

A way of applying colors to imply texture is to use one lightly over the other—a technique known as scumbling. Try using the side of soft pastels over hard so that the underlying colors don't move (see pp.268–69).

Optical color mixing

Placing dots, dashes, or lines of colors side by side will give the impression from a distance of colors merging and blending. Placing solid blocks of complementary colors side by side, as here, will maximize vibrancy (see pp.262–63).

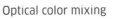

Mark-making in color 2

CREATING COLOR EFFECTS WITH OIL PASTELS

In contrast to hard and soft pastels (see pp.216–17), mark-making with oil pastels allows the artist to explore a more "fluid" process of pastel drawing, utilizing the buttery qualities of oil pastels themselves.

■ The benefits of oil pastels

Some artists favor using oil pastels because they offer a "cleaner" way of working—they are dustless (unlike hard and soft pastels) and if kept within their paper wrappers your fingers stay clean. However, liberating oil pastels from their wrappers will open up a whole gamut of mark-making techniques for you to use.

Cross-hatching
Using overlapping short strokes can lead the eye through and over different areas of your drawing while at the same time creating a visual mix of colors.

Sgraffito
This technique is useful for adding detail. Apply oil pastel in layers, then scratch into the top layer with the pointed tip of a scalpel to reveal the color beneath.

Tinting
Create a lighter version of a color (what is known as a tint; see p. 24) either by applying less pressure with the pastel or by adding white on top.

Scumbling
This light, playful technique uses short marks in pastel to build texture. One color can be layered over another very different base color to great effect.

Dry blending
Drawing or working one pastel into another is dry blending; an alternative dry-blend technique is to gently rub one color into the other with a finger.

This study of a woodland carpeted with bluebells includes areas of bright sunshine and cool shadows—a perfect set-up to put the techniques into action to create a warm and vibrant oil drawing.

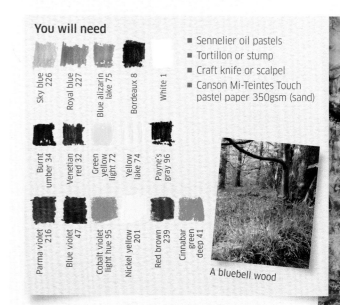

You will need

Sky blue 226 · Royal blue 227 · Blue alizarin lake 75 · Bordeaux 8 · White 1

Burnt umber 34 · Venetian red 32 · Green yellow light 72 · Yellow lake 74 · Payne's gray 96

Parma violet 216 · Blue violet 47 · Cobalt violet light hue 95 · Nickel yellow 201 · Red brown 239 · Cinnabar green deep 41

- Sennelier oil pastels
- Tortillon or stump
- Craft knife or scalpel
- Canson Mi-Teintes Touch pastel paper 350gsm (sand)

A bluebell wood

1 First marks
Use the tip of a dark oil pastel to create the underdrawing. Include a broad range of strokes, with different levels of pressure, to create a good framework. Then, you can build a tonal guideline for the positions of the trees, grasses, foliage, and bluebells.

2 Cross-hatching colors

Following the direction of the grasses, tree trunks, and background foliage, cross-hatch several colors together. Allow some of the paper to show through, as if an extra color.

3 A seamless blend

Use a fingertip—you could also use a tortillon or stump (see p.79)—to gently blend one color into another to create a seamless overall finish. Blending here is particularly useful for the tree trunks.

4 Final details with sgraffito

Using the sharp edge of a scalpel blade, scratch through the layers of oil pastel to add detail and very thin lines. Scratching through to the pastel paper itself reveals another color, creating visual interest. Do be careful, though, not to cut or tear the paper.

Using water-soluble pastels

HOW TO WORK WITH PASTEL AND WASH

Water-soluble pastels are incredibly versatile, combining all the advantages of drawing and painting in one. Mix washes, work wet-in-wet, draw dry for texture, or blend with a brush for smooth transitions.

■ Painterly effects

Think of each pastel as a tube of paint—you can use the solid color on the paper, or mix washes and tints in a palette by adding water and then applying with a brush. Apply solid areas of dry pastel for intense colors, or mix light glazes with added water for a more translucent effect. Use a dry brush to apply a wash for broken color effects.

Solid tones

Vigorously work water-soluble pastels in desired areas of your support to saturate them with rich applications of color. You can use a damp brush to create dense, strong tones of color. Build layers in a similar way.

Masking

Use masking tape or masking fluid to block out areas. Work over them with wet or dry pastels. Clean, white areas are left when you remove the mask.

Dissolving water-soluble pastels to create a wash

Use a brush loaded with water to create a wash, mixing and blending colors to create flat, semi-transparent areas of color.

PUTTING IT INTO PRACTICE

The mixture of colors and textures in this semi-abstract still life—from ceramics and glass to flowers and textiles—is reflected in the different techniques using water-soluble pastels applied both wet and dry.

You will need

Sun yellow 0200
Tangerine 0300
Scarlet pink 0320
Hot red 0410
Shiraz 0600
Deep rose 0710
Apple green 1400
Ionian green 1320
Antique white 2300
Dark purple 0750
Violet 0800

Multicolored still life

- Derwent Inktense water-soluble pastels
- Watercolor brush, #8 round
- Flat wash brush
- Palette
- Watercolor paper, cold press, 140 lb.

Solid color is applied for the leaves

Light layers of different colors

Linear strokes of pure color

1 Initial drawing

Apply main areas of color with lots of light and delicate linear strokes of dry pastel, one over the other. Don't be too heavy-handed when drawing the initial composition since the marks will be permanent. You will build colors at a later stage.

2 Wet-in-wet

Mix tints from pastel shavings and load your brush. Apply broad washes, working into the colors before they dry to blend on the paper. Build layers to intensify tones and add depth.

3 Sharp edges

Place strips of masking tape where you want to have really sharp edges. Paint clean colors in the areas you want to intensify. Once dry, remove the tape to reveal super-sharp egdes.

4 Dry texture

Use dry pastels over dry marks to add some sparkle and highlights in the lightest colors. Apply different pressured strokes to create variations in subtle colors.

Varying pressure

CREATING DIFFERENT TYPES OF LINE

Using varied pressure is like changing the shape and size of your brush when painting and offers a range of expression from light, feathery strokes to bold, energetic lines. Different pressures can be used to create visual textures, tonal gradations, and optical mixing effects (see pp.216–17). Using a light touch means you can lay down more layers of color, while using heavy pressure deposits more pigment to create intense areas of color.

PUTTING IT INTO PRACTICE

The solid forms of the truck and the feathery grass in the foreground are rendered by using different strokes with a variety of pastels. Remember that the softer the pastel, the lighter your touch needs to be.

1 Light pressure
Add areas of color by building layers gradually. Remove the wrapper and use the full length of the pastel's side to apply the base colors. Always use light pressure with soft pastels, and skim the surface of the paper. Use scumbling and glazing techniques (see pp.216–17) to create luminescence in the base layer.

2 Medium pressure
Increase the pressure slightly to continue to build layers. Make short marks next to each other in different colors to create optical mixing (see pp.216–17) or blend the pigments as you work, overlaying dark colors over light.

You will need

 Spruce blue 305
 Lime green white 199
 Vivid orange 133
 Light orange 135
 Deep yellow ocher 145
 Mild green 549
 Pthalo green 557
 Dark ocher 183H
 Dark olive beige 309

- Nupastels
- Mungyo pastels
- Terry Ludwig pastels
- Rembrandt pastels
- UART premium sanded pastel paper 320 grade

Old truck in field

 Burnt carmine 265
 Violet 100
 Turquoise 110
 Turquoise 120
 Turquoise 130
 Turquoise 360
 Green 620
 Green 120
 Green 230
 Green 570
 Green 390
 Green 370
 Green 310
 Red 240
 Violet 330
Neutral 160
Neutral 230
Neutral 130
Neutral 210
Dark orange 235.3
Dark gray 704.3

3 Heavy pressure

Use a hard pastel with a sharp edge to make intense, opaque, solid marks to add highlights or define edges. Bold dabs of color applied with heavy pressure will help to focus the viewer's eye.

4 Energetic strokes

Apply descriptive marks for the grass with a heavier pressure, using rapid application to create texture and movement, resulting in soft shapes that contrast with the solid form of the truck. Have fun making these marks!

Layering versus blending

TO BLEND OR NOT TO BLEND?

Blending with a finger or another tool (such as a rag, or foam packaging), produces work with a smooth surface and softened detail. If you leave work unblended, the many colors used in the layers will be visible, each adding to the final, sparkly effect. The blending technique is a useful alternative to layering, giving you visual options that you can use to expand your working practice, and the tools are always at hand!

LAYERING

The trick with layering is to apply the pastels with a light hand. That way, the tooth of the paper stays more available for further pastel colors. A sanded paper (see pp.242–45) can accommodate many layers.

You will need

Red 9 Gray 32 Blue violet 3 "Additional color" 52

Blue violet 12 Yellow 11 Yellow green earth 12 Yellow green earth 18

Red 13 Green 33 Gray 27

- Unison pastels
- UART premium sanded pastel paper 500 grade

A vase of tulips

1 The base layer
Using the sides of the pastels, block in simple areas of color for the different values—light, mid, and dark. This layer provides a foundation for subsequent colors.

All the colors used are discernible here

Use the tip of a pastel for the highlights

2 Layering the colors
Start to build colors, using light strokes so that broken color from the underlayers is still visible. Work on the larger areas of color first, before concentrating on more solid marks to add details and the hard edges of shadows. Add depth and vibrancy with crisp highlights.

◼ Choosing the effect

What effect do you want to achieve—bright and expressive, or subtle and solid? Layers of color blocks and strokes look exciting, vibrant, and complex; blended layers appear muted and simplified. You could experiment with both methods for the same subject, as below, to compare the effects.

Layering pastels
Overlaying layers and strokes of pastel keeps all the vibrant hues visible, producing a complexity of colors.

Blending with a finger
Use your finger to rub and blend the colors together, pushing the pigment into the paper to smooth transitions.

Blending with a tool
Using a piece of rag or a soft-surfaced tool saves your fingers but is best for large areas and not detailed parts.

BLENDING

Whether you choose to use your finger or a different tool, blending colors that sit alongside one another creates a super-soft and more muted approach than using layered pastels alone (see left).

You will need

Yellow 12 · Blue violet 10 · Red 8 · Yellow 11
Blue green 9 · "Additional color" 14 · Red 12 · Green 9
Blue green 12 · Green 33 · Green 14

- ◼ Unison pastels
- ◼ UART premium sanded pastel paper 500 grade

1 The base layer
Start by blocking in the three base values of light, mid, and dark, using the side of the pastel for even coverage.

Use a finger to blend colors in smaller areas

A soft and blended background

2 Blending the colors
Overlay a subsequent layer of color and blend the layers. Use a tool for larger areas—it is easier to keep clean when working from area to area and will save your fingers. When using a finger to blend smaller areas, wipe it clean before moving on to where you don't want colors (or values) to cross.

Understanding value

UNLEASHING FREEDOM WITH COLOR

Understanding value is at the heart of good design and expression with color. Value is the lightness or darkness of a color. Imagine a scale running from white through grays all the way to black. Each color has a place on a similar continuum. If a color is light, it's a light value; if it's dark, it's a dark value. But it's not easy to see value—it takes practice.

▧ Organizing pastels by value

It's helpful to sort all your pastels into three values—darks, lights, and those in between. Once you organize your colors in this way, you will always have the right color in the needed value whenever you need it. A selection of greens illustrates this below.

A full range of values
In this pastel thumbnail, the colors run the full range of values—from the very dark tree, through the mid-green ground to the very light sky.

A sketch in low key
The key of a drawing (see p.25) describes its overall value. Here, the colors used are at the darker end of the value scale.

A sketch in high key
The opposite is true here, since the overall drawing is pale and bright; it uses colors from the light end of the value scale.

The key of a drawing (see p.25)

Set up a mirror. One of the best ways to see value is to squint—your eyes then see more in black and white. So, squint at yourself and simplify what you see into three values—light, middle, and dark; then do a quick thumbnail. By creating a black-and-white drawing of the right values, you can then choose any pastel of the same value for the colored versions.

The middle value is a dark gray

Black, gray, and white
This version serves as an enlarged thumbnail sketch. Using your thumbnail sketch, draw the outlines of shapes on sanded paper. Then take a black pastel and fill in the dark areas. Do the same with your white pastel in the light areas and with a gray in the middle value areas. This gives you a foundation for the other versions.

Darkish blues (low key)
In this low-key drawing, all the colors you use need to come from the darker end of the value scale. Choose a selection of blues from very dark to a mid-value blue to use as your lightest pastel. When you have finished the drawing, squint to see that all three values are clearly visible.

The darkest blue corresponds to the black in the first sketch

The pink is the darkest value

Wild colors
This version shows that as long as you choose a pastel color from the correct value (light, middle, or dark), you can use any color to express your artistic wishes. Notice how all these bright colors still retain their place.

The yellow is the lightest value

Warm colors (high key)
In contrast to the low-key version, this drawing uses colors from the lighter end of the value scale. Even so, when you squint, you will still see the three values clearly. For this one, choose colors that are warm—pale yellow, orange, and pink..

"One of the best ways to see value is to squint. By doing so, your eyes start seeing more in black and white than in color."

Feathering

USING THE TIP OF THE PASTEL

Feathering is the making of quick, light, linear, parallel strokes with the tip of the pastel to modify a base color. Feathering can be vigorous and make a statement, or understated and quietly do its job. It is most useful in revitalizing an overworked area that's become dull, but has many other uses.

▨ Applications of feathering

Feathering can be used to: soften edges, add vitality or richness to a dull or flat area, rebalance warm and cool colors, add more color variation in a small area, tone down bright color, or color harmonize—bringing a color from one part of a drawing into another.

Softening an edge
Feathering the yellow in short strokes across the green softens and breaks up the hard line between the colors.

Adding variation
A solid area of blue is made more interesting by the addition of another, cooler blue, in a similar value to the first color.

Warming a cool area
Feathering this yellow pastel (of a similar value to the blue) over an area of the blue adds warmth to that area of the drawing.

Toning down a bright color
Choosing a green pastel (the red's complementary color) to feather over an area of bright red tones down its intensity.

A simple scene of a beach, sky, and boat offers plenty of opportunity to practice your feathering technique. Learn by doing; you'll notice the effects of lightening, enlivening, and darkening first hand.

You will need

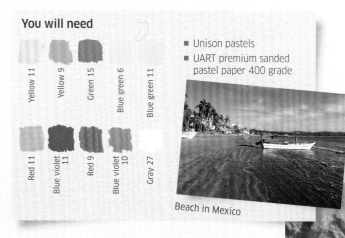

Yellow 11 Yellow 9 Green 15 Blue green 6 Blue green 11

Red 11 Blue violet 11 Red 9 Blue violet 10 Gray 27

- Unison pastels
- UART premium sanded pastel paper 400 grade

Beach in Mexico

1 Blocking in big shapes
The middle value dominates while the dark value takes up only a small area. This drawing will mostly use colors at the light end of the value spectrum. Apply the pastel liberally, but with a light touch.

2 Cooling and warming
The second color cools the bright yellow base layer but still allows its warmth. Let the drawing take you on a journey of exploration. Here, the yellow base layer has led the way.

3 Lightening the beach
The rather large area of beach in the image is one overall value, so use feathering here to lighten a small part of it to bring in some variation and visual interest.

4 Enlivening the sky
If the sky starts to look a little flat, use small strokes of the original yellow over the top of the blue to help inject some vitality and vibrancy to this part of the drawing.

5 Cooling and darkening the sea
Use feathering both to cool and to darken the small area of sea above the boat, otherwise the water there could appear too light and too warm to fit the scene.

Blocking in

ESTABLISHING THE BIG SHAPES

Simplifying your subject into three main values (light, middle, and dark) can help you establish the "bare bones" of your drawing. Block in big shapes using the side of your pastel with three colors—one each of a light, middle, and dark value. Be careful to use a light pressure because you don't want to fill up the tooth of the paper on this first layer.

▦ Planning a composition in terms of tonal value

When working from life or from photos, try to simplify what you are looking at into the three main values—a dark value, a middle value, and a light value. Some areas will merge, so it may end up looking like an odd arrangement of shapes and nothing like the subjects.

Make a thumbnail sketch
Use pencil, charcoal, or pen and ink (whichever you prefer) to create a small sketch. Simplify into the three values.

Block in the values
Transfer your drawing to pastel paper, then with pastel, block in the three values as they correspond to your sketch.

Layer up
Build up a second layer and further layers. Refer often to the thumbnail to ensure you keep the three values distinct.

This scene of a figure almost silhouetted against a window clearly shows the three values—light in reflections of sunlight off the wall, middle on areas of the figure and chair, and dark in the shadows.

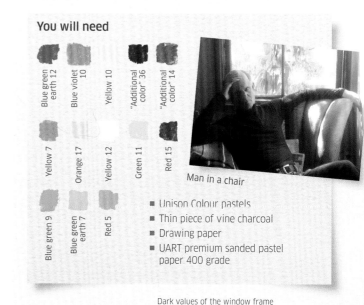

You will need

Blue green earth 12 · Blue violet 10 · Yellow 10 · "Additional color" 36 · "Additional color" 14

Yellow 7 · Orange 17 · Yellow 12 · Green 11 · Red 15

Blue green 9 · Blue green earth 7 · Red 5

Man in a chair

- Unison Colour pastels
- Thin piece of vine charcoal
- Drawing paper
- UART premium sanded pastel paper 400 grade

Dark values of the window frame contrast with the light of the window

1 Thumbnail sketch
This small thumbnail of the subject done on drawing paper with pencil shows the three basic values. Refer to the photo and you'll see that there are choices to be made—what is going to be light (the white of the windo above), what is going to be dark, and what is going to be a middle value? The middle values, in particular, are quite nuanced, especially where there is variation in color.

2 Blocking in the main values

Transfer the drawing to the pastel paper lightly using the charcoal. Choose three colors to represent the three values and block these in. You can see there is no need to worry about the details or losing the outlines at this stage.

3 Adding layers

Now it's time to add more than one color to an area of a single value. For instance, overlay a purple over the blue in the dark values, red over blue in the middle values, and a pale blue and green over the light-value areas behind the figure.

4 Charcoal outlines

Restore the anatomy—the face, hands, and a few other parts—using the vine charcoal, then continue the work of layering the colors to portray these and other details of the subject, adding more variation and interest to the surface.

Lightening colors

USING WHITE PASTEL TO LIGHTEN

When using a limited palette, there aren't always enough light colors to express what you see—a pale yellow, a light blue, a soft green. Applying a color and then lightening it by going over it with a white pastel will often solve the problem. Then, you can add more color ever so lightly, as needed.

■ A light touch

The trick to wielding the white pastel well is to use a light hand. Keeping the pressure light allows the orginal colors to show through. It also means there's more "tooth" left in the paper to add more colors over the top of the white layer, if necessary.

Lay down the base layer
Using the broad side of your pastels, lay down some solid color—for example, blue and green, as here—on pastel paper.

Add a layer of white
Assess the colors. If you want a lighter version, then apply a layer of white pastel lightly over the base layer (blue and green).

Reinforce the base colors
To achieve just the right color, apply yet more blue and/or green until the color matches what you imagine or what you see.

Lift the darks
In a different example, you can use the same blue and green to lighten a dark pastel often with just one layer.

This captured still life of a white plate with light background and pale-yellow butter gives us a great opportunity to see lightening with white pastel in action, when working with a limited color palette.

1 Charcoal outline
Dash down a light and energetic outline of the still life, roughly placing all the different elements of the composition and making sure the proportions are right. Outline the shapes of tone and color.

2 A trio of colors
Take the green, yellow, and blue pastels and lay down those three colors in their values, working within the outline. Don't press too hard at this stage.

You will need

Additional color 30

Green 9

Blue Violet 10

Yellow 10

Gray 27

- Unison pastels
- UART premium sanded pastel paper 320 grade

A breakfast plate

3 A layer of white

Deftly apply the white pastel in a light layer to help lighten each of the three colors within the drawing. If you go overboard, simply reapply a little of the original color until you're happy.

4 Final details

Now is the time for putting in highlights (the white around the perimeter of the plate) and final details on the knife (in blue). Use the pastels as minimally as possible to achieve the desired effect.

Darkening colors

USING BLACK TO CREATE DARK SHADES

When using a limited palette, you may find that you don't have a very dark pastel when you need it for night scenes, for example. Many artists choose not to use a harsh black on its own but you can adapt it to good effect. Applying black pastel as your darkest shade gives you a solid base. Add a layer of another dark color from your palette, such as deep red, green, dark blue, or purple on top. Then go back with black to make a denser dark.

PUTTING IT INTO PRACTICE

When the sun has set and the sky is ablaze yet everything else is losing its color and the trees look dark against the sky—this is a perfect time to use a black base for building intense shades.

You will need

Gray 13 · "Additional color" 30 · Green 13 · Blue violet 17 · Blue violet 16

Blue violet 10 · Gray 2 · "Additional color" 15 · Blue violet 15 · Blue green 4

Red 5 · Yellow 10 · Yellow 12 · Gray 27

- Unison pastels
- UART premium sanded pastel paper 400 grade

Road at night

1 Blocking in main tonal values (dark, mid, and light)

Use pure black pastel to block in the shapes of the darkest tone, using blue for the midtone, and yellow for the lightest parts of the sky. Look for the dark shadows of the cars and use black to describe the shapes. Keep this underlayer loose, but ensure the color is even.

2 Color added over black

Layer the darkest colors available over the black, changing the direction of your marks to follow shapes. Work over the mid and light tones at the same time, building color. Look for shadow colors that link to the shadow-forming objects.

Working with black

Black has no color and can appear harsh. Look for colors in shadows and dark areas and add these over the black to soften the effect, while still retaining the dark intensity of the underlying black. Working more black into the additional color layers will help to blend the shades for a natural effect.

Pure black
Apply a base layer of black pastel with an even pressure. Ensure you cover the paper, but not too heavily.

Dark color layer
Add a dark color over the black. The color shade will not appear as dark as the black and will stand out from the base.

Building depth
To intensify the darkness, apply more black judiciously. Do this with the tip of the pastel and use a heavier hand.

Dark green over the base black describes the tree shapes against the light sky

3 Adding density
To intensify the density of darkness, add more black in places over the dark colors, blending as you go. Use the tip of the pastel to add marks, applying pressure to create solid strokes.

4 Final adjustments
Refine the illusion of light coming through the trees by adding dashes of warmer colors where the sky is pink.

Blue over black intensifies the shadows on the road

Mixing neutrals

CREATING MUTED COLORS

Rather than reach for a brown or gray pastel, you can mix both vibrant and subtle neutrals from pure colors. By layering complementary colors, such as red over green, you mute the initial color and create a grayed version. Using different pressure as you mix also varies the tones you create.

▧ Neutrals with different tonal values

The trick to mixing neutrals is to try to mix colors in the same value range—those that have the same strength or tone: light, middle, or dark. For example, pure yellow is a light value so will mix best with pale mauve rather than a bright violet, to produce a light neutral. The examples below show three values of blue mixed with corresponding values of orange to mute the base color, using the tip of the pastel for loose blending.

Light values

Middle values

Dark values

Light, middle, and dark values created with the side of a pastel

In this painting, the subdued tones of the street scene are rendered with a range of neutrals mixed in light, middle, and dark tones from complementary colors. Cool and warm values are used to add depth to the shadows.

You will need

Red 13 · "Additional color" 43 · Blue violet 12 · Yellow 1 · Yellow green earth 12 · Yellow green earth 18 · Red 9 · Blue violet 10

Blue violet 4 · Blue violet 8 · Orange 5

- Unison pastels
- UART premium sanded pastel paper 500 grade

Street detail, Budapest

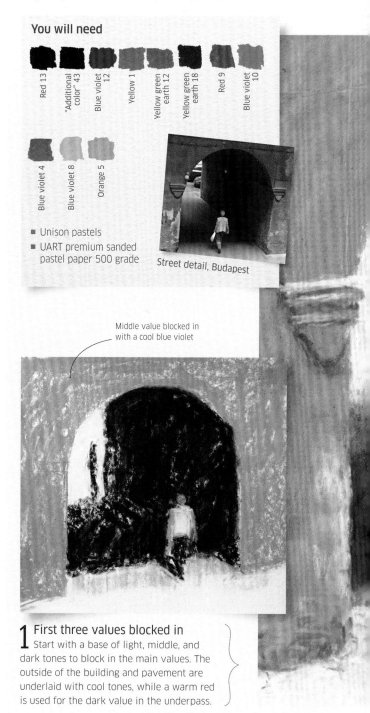

Middle value blocked in with a cool blue violet

1 First three values blocked in
Start with a base of light, middle, and dark tones to block in the main values. The outside of the building and pavement are underlaid with cool tones, while a warm red is used for the dark value in the underpass.

2 **Mixed complementary colors**
Add yellow over the violet, green over the red, and orange over the pale blue to create neutrals. Each color in the layer mutes the intensity of the other.

"You can **mix** both vibrant and subtle neutrals from pure colors."

3 **Warm and cool neutrals balanced**
Enhance the layers with more colors, balancing similar warm and cool values in similar strengths. In the shadows, a warm red is worked over the green, and a cool blue is added on the pavement.

4 **Accents of color**
Toward the end of your painting, use pure color accents against the neutrals to add focus points. The yellow jacket is blocked in and contrasts against the blue shadows, making it pop forward.

Mixing greens

CREATING A RANGE OF GREENS

You may have a couple of greens in your limited palette, but these may not give you the variety of color that you want. You'll no doubt have a couple of blue and yellow pastels in your set, so maximize your available greens by mixing blues and yellows. Interesting greens also result from layering a green over a base color.

■ A spectrum of greens

Try mixing all your blues and yellows in different combinations. And don't worry that you can't always use blues and yellows of the same value. In the strips below, one half is yellow, the other blue. The resulting colors are created by gently layering one color over top of the other.

Yellow and blue of equal light value

Yellow and blue of equal middle value

Yellow and blue of middle and dark value

Yellow-green with purple of equal middle value

Blue-green with red of equal dark value

Mid-value yellow-green with dark red-violet

As with many outdoor scenes, there are plenty of greens to capture—green building, grasses, coconut tree fronds, and reflections. Use a combination of blues, yellows, and greens over a base color.

A red, mid-value base color

1 Blocking in the first values

The two yellows here are used along with the blues to mix a range of greens, while the two reds form the base layer for the application of your green pastels. Block in the areas of colors in the appropriate places, keeping your marks loose and lively.

2 Mixing the greens

Next, grab your blue pastels and layer these over the yellows in the sky and the grasses, and then capture the water. Notice the blue violet added to the dark yellow thatched roof—this helps to create a neutral color.

You will need

Green 1 | Yellow green earth 18 | Green 15 | Yellow 1 | Yellow 9 | Yellow 10 | Yellow 12 | Red 14 | Red 10 | Blue violet 10 | Blue violet 4 | Blue green 9 | Blue green 6

- Unison pastels
- UART premium sanded pastel paper 400 grade

A lush tropical scene

3 Interesting mix of greens

With a base of dark red and a lighter red, layer two greens in the appropriate value over the reds. Notice how the base layer affects the greens, making them more natural and slightly neutralized. It also adds interest to the green of the building.

4 Concentrating on the non-green areas

Now give your eyes a break from the greens and focus on layering up the other areas of the drawing that aren't green—the roof, sky, wall, fence, and tree trunks. You'll be ready to take another look at the greens.

5 Adjusting the created greens

Assess your drawing, looking in particular at the highlights and darkest tones. Lighten and darken the mixed greens and continue to layer to achieve the right colors. Add further details all over the drawing until you're happy with it.

Artist **Robert Dutton**
Title **Moorland light**
Medium **Unison and Rembrandt pastels**
Support **Canson Mi-Teintes Touch pastel paper 350gsm (tobacco)**

Layering vs. blending

<< See pp.224–25

Loose, expressive pastel strokes have been layered over each other to create the transition from warm, rich purples in the foreground to cooler blues in the distance.

Lightening colors

<< See pp.232–33

Layering white or a lighter color over midtone blues using the side and tip of the pastel has created a soft blend between the colors, suggesting mist and rain.

Mark-making

<< See pp.216–17

Experimenting with linear directional marks to define colors has created a richly textured surface that is evocative of moorland heathers and grasses.

Showcase drawing

This atmospheric moorland drawing filled with luscious color, energy, and expressive marks includes many of the techniques demonstrated, explained, and explored in the beginner section. Both hard and soft pastels have been used to create this layered, textured painting.

Varying pressure

« See pp.222–23

Applying different colors with varied pressure has been used to contrast softer, more recessive areas of the landscape with bold, intense flashes of color and light.

Feathering

« See pp.228–29

Gradual transitions have been achieved using a pastel tip to feather edges between colors of different values, while feathering similar values enlivens the surface.

Darkening colors

« See pp.234–35

Using black and other dark-colored pastels layered over or under rich, warm reds, oranges, and yellows has created atmospheric shadows in this drawing.

Paper texture

SELECTING THE RIGHT PAPER SURFACE

Pastels can be used on many surfaces, the best being those with some sort of texture or tooth. Very smooth paper won't "grip" the pastel, while heavily textured paper can "eat up" your pastel stick. Smoother papers are suitable for sketches, while sanded papers will take many layers. It's a personal choice.

◾ Textured papers

Compare the marks made on different papers to assess the ease at which the pastel moves across the surface, the intensity of the mark, the layering capacity, and the textural effect. The tip and side of a blue pastel have been used, green layered over, and the blue smudged.

The smooth side of Canson Mi-Teintes (cream) lets pastels move freely

BFK Rives printmaking paper (white) has a soft, smooth surface

Hahnemühle Premium Velour (yellow) has a velvety surface that grips well

The rough side of Canson Mi-Teintes (cream) adds an interesting texture

Clairefontaine PastelMat (maize) holds multiple layers of pastel

Arches cold press watercolor paper (140 lb.) adds texture

The smooth side of this pastel paper is used for this drawing, meaning that soft pastels are laid down quickly with minimal layering of colors.

You will need

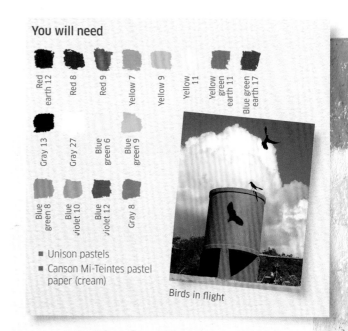

Red earth 12 | Red 8 | Red 9 | Yellow 7 | Yellow 9 | Yellow 11 | Yellow green earth 11 | Blue green earth 17

Gray 13 | Gray 27 | Blue green 6 | Blue green 9

Blue green 8 | Blue violet 10 | Blue violet 12 | Gray 8

- ◾ Unison pastels
- ◾ Canson Mi-Teintes pastel paper (cream)

Birds in flight

1 Light first layer

Apply the pastel in three values with a very light hand. The paper doesn't have much tooth so you don't want to fill it on the first application, since you are limited in the amount of layering you can do.

2 Develop color

Add colors in the correct values over the first layer—light over light, dark over dark, to develop the picture. Build darker values in the clouds to give form; you can always lighten it in the next layer.

"Textured papers are most suitable for sketches, while sanded papers will take many layers of color."

3 Unify tones

Use a pale blue pastel to skim over the entire cloud area. This unifies and lightens the whole, even the darker areas that looked too dark at first.

4 Clarify shapes

Add lighter tones to give form to the main shapes, over the water drum and background trees, maintaining the values. Your pastels may start to slide over the surface as the tooth is filled; if so, it's time to stop.

WORKING ON SANDED PAPER

This drawing uses a sanded paper that has a more pronounced tooth, resulting in intense color, greater coverage, and ability to create multiple layers compared to the previous drawing.

1 Block in main values
Apply saturated layers of color for the three main values of dark, middle, and light, using the same colors as the previous drawing. In this drawing, the hills become a dark value rather than a middle value.

2 Add color layers
Work over the base values with a layer of color, adding turquoise in the sky, light blue on the clouds, and red on the water drum. Add green over the hills to slightly lighten and mute the intensity of the dark blue. A layer of green over the foreground plant begins to give it shape and form.

3 Clarify edges and colors
Add orange on the front of the water drum to warm and lighten it, and to help create the feeling of volume. Indicate the shadows of the birds that will be added at the end, and begin to work on some of the details. The grain of the paper will retain clear edges of drawn shapes.

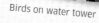

- Unison pastels
- UART premium sanded pastel paper 320 grade

Birds on water tower

4 Fine tune details
Vary the yellows on the main wall with strokes of color. Fill in the sky to intensify the color by covering the light specks of paper color coming through. The toothed surface will continue to accept pigment to create a depth of vibrant color.

Sanded papers

A more heavily textured surface accepts more pigment as it becomes embedded in the paper, leading to intense colors and multiple layers. Rough surfaces create broken color, which can be used to enhance texture and vibrancy in a drawing. Sanded papers create smoother transitions.

Pastel Premier paper (buff) has enough tooth to withstand reworking

UART premium sanded pastel paper 400 grade accepts multiple layers

Canson Mi-Teintes Touch sanded paper (cream) has a mid-grade tooth

Richeson premium pastel paper (sand) has quite a coarse tooth

Sennelier pastel card La Carte (antique white) holds colors well

Art Spectrum Colorfix (natural) has a moderate grip on pastel color

Using colored papers

HOW A PAPER'S COLOR AFFECTS YOUR DRAWING

The paper's color becomes an integral part of the final look of the piece. Choosing one subject and a selection of colors can illustrate how working on a different colored paper can affect the outcome—notice the effect of paper color using the same pastel palette.

PUTTING IT INTO PRACTICE

This drawing has a full range of values, warm and cool colors, a neutral color, and bright colors. Inspired by a pink daisy, the artist has used her own color scheme.

UART pastel paper 280 grade: Cream
Most hues will look darker against a light-colored paper. Notice how dark most of the colors look above.

Clairefontaine PastelMat: Buttercup
Working on a creamy paper gives the whole drawing a warm glow. Also, see how the purples are enhanced by their complement.

Clairefontaine PastelMat: Dark Gray
A neutral mid-value paper means lights and darks show up strongly against it, while the mid-colors in the range blend in.

You will need

Yellow 8 | Yellow 12 | Blue violet 3 | Blue violet 10 | "Additional color" 34 | Green 14 | Red 8

- Unison pastels
- Colored papers (see individual drawings for details)

Daisy in a bottle

Pastel Premier: Terracotta

The red and dark purple all but disappear on terracotta paper, while green stands out against its similar-value complement.

Art Spectrum Colorfix: Olive Green

A similar value to the terracotta paper, this greenish tone offers a less vibrant undercolor and allows the colors to sing.

Art Spectrum Colorfix: Black

Notice how all the colors look lighter—and brighter—against black. See also how much the black shows compared to other papers.

Complementary colors

CREATING VISUAL EFFECTS AND HARMONY

Placing complementary colors next to each other makes both appear brighter and is useful for highlighting points of interest. Use pairs of colors to draw the eye, intensify shades, and connect different elements. Create neutrals by mixing complementary colors to add harmony but juxtapose the colors occasionally to re-engage the viewer.

▮ How complementary colors work together

Generally speaking, warm colors advance and cool colors recede. Red and green, which tend to be closer in value than the other complementary colors, tend to "vibrate." For optimum optical effect, use pairs of complementary colors in different ratios to one another. Think about the whole composition, and balance the use of one or the other complementary pair so as not to overpower the image or lose detail.

Red and green
Notice how the small red square within the larger green one appears to "float." This is useful for highlighting a feature.

Yellow and violet
Here the larger yellow square appears to advance against the violet. This effect could be used to add depth.

Orange and blue
By offsetting the orange square inside the blue, greater emphasis is placed on the blue itself, making it warmer, too.

This landscape comes to life with the dynamic use of red and green, blue and orange, blending colors in the shadows and carrying brights through the middle ground and into the distance to connect the elements.

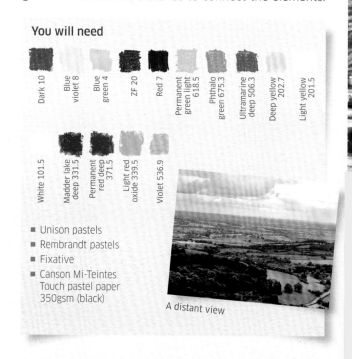

You will need

Dark 10 · Blue violet 8 · Blue green 4 · ZF 20 · Red 7 · Permanent green light 618.5 · Phthalo green 675.3 · Ultramarine deep 506.3 · Deep yellow 202.7 · Light yellow 201.5

White 101.5 · Madder lake deep 331.5 · Permanent red deep 371.5 · Light red oxide 339.5 · Violet 536.9

- Unison pastels
- Rembrandt pastels
- Fixative
- Canson Mi-Teintes Touch pastel paper 350gsm (black)

A distant view

1 Planning your painting
Establish the main design and composition with a loose drawing using a midtone color. The purple used here helps to keep the shadow tones warm, and the dark paper creates a great base for the shadowy foreground and adding depth later to the underlying sky. Note the high horizon line; see the rule of thirds (p.19).

2 Blocking in
Loosely place "local" areas of color, using strong colors in the front and lighter ones at the back to give a sense of recession. Blocks of blue tones are highlighted with strokes of yellow, helping to define and emphasize this area.

3 Creating definition
Intensify the depth of color in shadows, either by overlaying colors or by spraying with fixative. Define some areas by juxtaposing complementary colors, such as blue and orange in the fields, so that they stand out against the shadows.

4 Adding visual interest points
Apply strong areas of complementary color to draw the eye and connect the landscape. Just a few strokes on the red rooftops make them "zing" out against the green fields—an artists' trick that was popular with the Impressionists.

Layering

BUILDING COLOR WITH PASTELS

Layering allows you to capture a vibrant luminescence that is unique to pastels. Apply color with a light touch, keeping the layers within the same temperature and value ranges—layering cool and warm colors can result in muddied hues. Start with hard pastels to block in color and then use softer pastels for highlights, using techniques such as scumbling to mix colors.

You will need

Grayish blue 727.7
Light ultramarine 505.10
Ultramarine deep 506.2
Medium aqua blue 570.9
Ultramarine 505.3
Prussian blue 508.5
Prussian blue 039
Violet 100
Violet 390
Red 150
Red 240

Red 010
Green 570
Bohemian green light 548
Green 390
Green 310
Red oxide 315
Wine red 223
Deep carmine red 212
Rose carmine 235
Faded orange 138
Light vermilion 202

Deep vermilion 225
Orange 208
Vermilion orange 203
Vivid orange 133
Medium orange 231.3
Light orange 236.5
Apricot 165
Pink beige 407
Light cream 149
Yellow 070
Yellow 060

- Rembrandt pastels
- Mungyo pastels
- Terry Ludwig pastels
- Fixative
- UART premium sanded pastel paper 320 grade

Offering a peach

PUTTING IT INTO PRACTICE

The velvety texture and color range of a peach skin is portrayed through layers that are blended on the page, scumbled, and glazed, using a wide palette of colors to build up the intensity, while keeping the effect vibrant. When building up layers in this way, you may want to apply fixative as you go (see also pp.252–53).

Keep edges soft

1 Blending
Use pastels of a similar consistency to physically mix layers of color on the paper, gently moving the pastel back and forth. You can use your finger or a tool to blend (see pp.224–25), but take care not to dull the colors.

2 Scumbling
Apply light over dark to change value and color. Use a light touch—you want to barely skim the surface to allow the underlayers to shine through. For just a hint of color, tap on some pastel from your fingertip.

3 Erasing
To remove unwanted marks or too many layers of pastel, use a stiff bristled brush to gently scrub off the mark. Previous layers of color will reappear and it will bring back the tooth of the paper to add texture.

4 Strengthening
Apply a glaze (a solid layer) over some areas to intensify the color, such as in shadows, or to tone down a value. If you are building heavy layers, apply fixative to strengthen the tone and help additional layers to adhere.

Using fixative creatively

ENHANCING TONES TO ADD DEPTH

One of the most useful aids for the pastel artist is fixative. Applied during the painting process, it will darken colors, reducing the "sparkle." Although this can be seen as a negative effect, you can use it to your advantage to deepen color and add impact to tonal areas. Either apply fixative over the entire surface, or in certain areas. You can also use masks for more control (see p.216).

▨ Strengthening colors

Assess your composition and source image, noting areas of deep color or darker tone. Apply layers of fixative to these areas as you work, checking lighter tones, too, to enhance the strength of the colors and give depth. Continue to work over the fixed area, building color and blending further for more intense results.

Before spraying
In the original painting, the tones are relatively uniform across the landscape, with only a subtle transition between the middle ground and sky. The dark trees in the foreground dominate the scene and the overall effect is slightly unbalanced.

Uniform tones

After spraying
Spray fixative has been applied over part of the surface, bringing out the colors of the sky and enhancing the tones in the fields to give them a strong presence in the composition. The dark colors of the building now link visually to the foreground trees.

Enhanced colors

PUTTING IT INTO PRACTICE

This expressive painting of a seascape is filled with drama and bright light. Fixative is used to bring out the contrast between rocks and sea, and to enhance the sky. The sky-gray paper unifies the scene.

You will need

Cadmium red P130 · Natural earth 4 · "Additional color" 9 · Dark 13 · Blue violet 8 · Blue violet 10 · Blue violet 7 · White 101.5 · Orange 235.3

Cinnabar green light 626.3 · Bluish green 640.3 · Sepia 53F · Ultramarine deep 506.5 · Burnt umber 409.5 · Burnt sienna 411.5

A dramatic seascape

- Derwent pastel pencils
- Unison pastels
- Rembrandt pastels
- Masking tape
- Craft knife
- Sharpening block
- Fixative
- Canson Mi-Teintes Touch pastel paper 350gsm (sky gray)

1 Framing the view
With the side of the hard and soft pastels, use broad, sweeping strokes to dash down the main areas of the drawing–rocks, sea, and sky. Note the dark forms of the rocks and the white water.

2 Expressive marks
Add a sense of movement with expressive marks using the side and tips of both hard and soft pastels together, blending as you go. Allow the support to show through, linking all areas.

3 **Darkening colors**
Apply fixative to deliberately darken chosen areas–even in the lighter areas of the painting. Do this several times to deepen colors even more, if desired.

4 **New layers**
Apply new layers of pastel over the heavily fixed areas–light over dark or dark over light–working in different directions to reveal the paper's tooth. Fix again if desired.

5 **Sharp details**
Add final details. Using pastel pencils for areas that require pin-sharp detail, such as the bird, will provide a focal point against an atmospheric backdrop.

Working with edges

HARD, SOFT, LOST, AND FOUND EDGES

An edge is the place two shapes meet. These shapes can be the same or have very different values. Edges can be described as hard, soft, lost, and found (see more below). Being intentional about edges will give your work more interest, depth, and vitality.

■ Using edges to best effect

The colors you use (for harmony or contrast), and whether or not you choose to smooth the junctions between them, controls the impact of your edges.

Hard edges
These four colors—each one of a different value—are in the blue family. They all have a hard edge between them.

Soft edges
The same blue colors are used, but here, all the edges between them are softened. It's noticeably different from the hard edges.

Lost edge
When shapes of the same or similar values come together, the edge is lost even when there is a hard edge.

Found edge
The edge between these two colors of different value is hard and soft. The softened edge doesn't diminish the found edge.

This partially backlit interior scene offers plenty of opportunity to look for, and use, edges to enhance the drawing. Use your observation skills to find the various types of edges throughout.

1 Blocking in the main values
By simplifying the painting into three main values, you can easily see the design in an abstract way. You can begin to see where different sorts of edges may develop.

2 Softening and hardening edges
You'll need to make deliberate choices. Usually a hard edge will advance, so creating one grabs attention; softer edges are quieter, such as those in the distance. A hard edge defines the shadow and light on the chair.

You will need

Yellow green earth 12

Red 8

Red 9

Red 10

Yellow 7

Orange 17

Yellow 11

Gray 27

Blue violet 7

Green 12

Blue green earth 7

Blue green 9

Blue violet 12

Blue violet 11

Blue violet 10

- Unison pastels
- UART premium sanded pastel paper 400 grade

Seats at a sunny window

Lost edges in the exterior scene where values are similar—only the color tells the story; squint and many of the edges are lost

3 Losing and finding edges

Notice how the curtain and wall in the upper right of the drawing lose their edge—squint and you will lose it. Lower down, the light coming in creates a found edge between the curtain and wall.

4 Tweaking the edges

The shadows on the floor are quite sharp in the photo, but recreating what we see there will draw too much attention to that lower corner. Similarly, soften the edge between the wall and the floor.

Creating aerial perspective

USING COLOR TO EVOKE DISTANCE

Aerial perspective, also known as atmospheric perspective, is a method of modulating colors to simulate distance. As well as size diminishing in the distance, color also fades: distant colors appear lighter and more muted, while those in the foreground seem stronger and more vibrant.

You will need

Violet 536.3

Blue violet 548.8

Permanent red 372.3

Permanent red deep 371.7

Light oxide red 339.5

Red violet 545.8

Light orange 236.9

Phthalo blue 570.9

"Additional color" 34

RD13

"Additional color" 10

Yellow 9

Yellow 16

JS10

Light 18

SC13

Green 29

Green 22

Yellow green earth 22

Yellow green earth 17

Light 1

- Rembrandt pastels
- Unison pastels
- Fixative
- Canson Mi-Teintes Touch pastel paper 350gsm (black)

A field in flower

In this scene over farmland, the distant hills fade into the light sky, with almost a hazelike effect. This lightness contrasts with the dark foreground and vibrant yellow flowers in bloom.

The trunk of a tree anchors the view

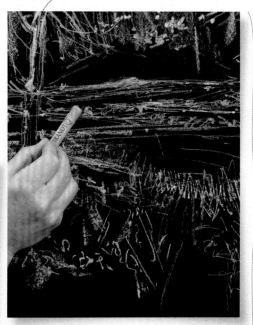

1 The main forms and shapes
Use loose marks to sketch in the horizon, the trees at the sides, and the field borders to give the starting shape to your drawing. The light purple is easily visible on the black, so it's a good choice.

"**Shadows** need to be **stronger** in the **foreground**, with **dark, saturated colors,** and **weaker** in the **distance,** with **white** added to **create tints.**"

2 Cool and warm colors
Block in freely, using the side of the pastel, the areas of warm colors (the yellow field, for instance), and then repeat for the cooler colors (such as the sky and distant hills).

3 Heightened color and detail
Make the colors stronger in the foreground to help create the illusion of distance. Add some detail to darker areas in the foreground and choose lighter tints for the background.

4 Highlights and shadows
Look at the light and shade. The shadows that are in the foreground are stronger in tone to sustain the illusion of depth. Keep vibrant highlights within the middle and foregrounds.

Fur and hair texture

USING DESCRIPTIVE STROKES

Compared to a detailed line drawing, using pastels to render fur encourages a more interpretive approach through loose strokes in a range of tones. Follow the direction of fur with expressive, fluid marks in soft pastels and use hard pastels for detail.

▨ Textural observation

Rather than trying to draw every strand individually, consider the overall nature of the fur—is it soft, dense, tufted, long, wet, or shiny? Look at the many tones and colors that can be found within the fur, noting highlights that convey a sleek or shiny coat.

Wet fur
Wet fur tends to clump together in small peaks. To create this effect, draw sharp angles with different pressured strokes, using hard and soft pastels together. Leave some areas very light to show the water glistening on the coat.

Short fur
Identify all the fur colors and apply them one over the other in a "dabbing" movement. Use pastel pencils for precise marks, to add variations in short fur.

Long fur
A lion's mane lends itself to long, fluid strokes using the tips and sides of both hard and soft pastels. Gently drag the pastel to keep it on the surface for longer.

This red squirrel was drawn with expressive marks, combining charcoal with soft and hard pastels on soft watercolor paper. The unique properties of the paper helped to add further texture to the drawing.

1 Foundation drawing
Start with loose, soft charcoal strokes using descriptive marks to outline the main shape and the darkest tones and shadows. Rework as necessary, using an eraser to lift off or correct your exploratory marks.

2 Building volume
Working over the charcoal underdrawing, define the form of the body using different tones, switching between hard and soft pastels. Concentrate on adding volume.

You will need

- Light yellow 201.8
- Light orange 236.5
- Light oxide red 339.5
- Golden ocher 231.5
- Raw sienna 234.5
- Permanent red deep 371.3
- Mars violet 538.5
- Natural earth 4
- Natural earth 2
- Natural earth 14
- Light 5
- Umber 79B
- Sepia 53B
- Sepia 53D
- Soft charcoal
- White 101.5
- Green 35
- Yellow 10

- Rembrandt pastels
- Unison pastels
- Derwent pastel pencils
- Soft charcoal
- Eraser
- Sharpening block
- Fixative
- Somerset Velvet cold-pressed watercolor paper 240gsm

A red squirrel

3 Enhancing the fur
Use charcoal for any silky dark areas and apply pastels light over dark to add a shiny effect. Feathery strokes of sharp pastel pencils enhance the "fluffy" texture.

4 Facial features
Define the face with sharp edges of hard pastels and pastel pencils. Leave a little white paper showing through in the eye to give it sparkle and add blue for a 3D effect.

5 Tonal shadows
Use sharpened dark pastels to add gentle shading to the shadow areas, particularly on the rock. Use fixative to darken colors where needed.

Warm and cool colors

UTILIZING COLOR TEMPERATURE IN DRAWING

You can create impactful drawings by being aware of the color temperature bias of your subject matter and choosing a color palette to correspond. Understanding warm and cool colors allows you to use them to enhance the mood and atmosphere of your drawings. It's also good to bear in mind the color of the paper you choose to start drawing on, because this can bring it all together.

Color temperature

We think of certain colors as warm or cool—for instance, red is often seen as warm, and blue as cool. The fact is, there are warm and cool versions of every color. Cadmium yellow, for instance, is a warm yellow, whereas lemon yellow is cool. By familiarizing yourself with a color's temperature you can work with it to create mood and accentuate contrasts in a drawing.

Warm and cool versions
Each line of primary colors has cool versions starting on the left and warm versions on the right. If you're mixing warm and cool colors together, be sure to allow one color bias to dominate more than the other. If combined in equal amounts, a flat and dull hue will result.

Using steel gray paper sets the overall tone for this winter scene. Notice the chilly blues and grays in the lake and sky, and how hints of warmth from the red sails make the dominant blue tones appear even cooler.

1 Cool tones
Use loose marks of cool colors to establish the composition. Apply pale tones in the sky to describe the outline of the hills; establish the distant horizon with the palest, lightest, and coolest tone.

2 Colors above and on the water
The surface of the lake reflects the colors of the clouds; when you apply a color in one area, be sure to mirror that color in the reflection on the water. Carry darker tones into the hills.

You will need

| Green 1 | Green 11 | RD13 | SC13 | Dark 3 | Dark 12 | Light 18 | Permanent red 372.8 | Raw sienna 234.7 |

| Violet 536.9 | Red violet 545.3 | Burnt umber 409.7 | Phthalo blue 570.9 | Light yellow 201.8 | Permanent yellow green 633.5 | Green 35 | Carmine 318.5 |

- Unison pastels
- Rembrandt pastels
- Fixative
- Canson Mi-Teintes Touch pastel paper 350gsm (steel gray)

A cool, wintry lake view

3 Darks and lights

Strengthen the cool shadows and define the dark shapes of the hills and the bare trees against the sky. Look for highlights, making them bright and stark.

4 Warmer details

To balance the dominant cool bias, add a warm hue in the distant hills and trees. Dab in the red sails (a mix of red violet and raw sienna) for a focus and some harmonious warmth.

WARM COLORS

This autumnal scene has a warm bias with bright sunlight set against cool, dark shadows. The inclusion of the cool blue tones makes the warmer landscape appear brighter and adds areas of depth, balancing the image so the warm tones don't dominate.

You will need

Natural earth 4	Dark 5	SC2	Brown earth 10	Light 1	Phthalo blue 570.9
Blue violet 548.8	Permanent rose 397.7	Cinnabar green deep 627.3	Permanent green light 618.5	Green 27	
Green 30	Blue violet 11	Natural earth 6	Yellow 10	Parma violet 216	

A warm, autumnal village scene

- Unison pastels
- Rembrandt pastels
- Fixative
- Canson Mi-Teintes Touch pastel paper 350gsm (sepia)

1 Warm base
The warm midtone paper provides a harmonious background. Start by loosely blocking in areas of warm tones, from light to dark, using subtle variations to follow the main shapes and noting where warm colors appear in the shadow areas, such as in the stone wall.

2 Cool contrasts
Lightly apply a first layer of cool colors to the sky and road, then work cool tones alongside warm colors to develop form in the trees, hills, and foreground. Make the most of interesting contrasts.

"Having a **warm or cool bias** will create **atmosphere,** which can set the **mood** and **tone** within your drawings."

3 Intensify the tone
Increase the layers of warm and cool colors to add intensity to the drawing. Note the warm purple tones in the shadows and strengthen these areas with glazing or fixative to enhance the contrast against the sunlight.

4 Refining details
In the final stages of your drawing, add bright highlights with the hard edge of your pastel and draw in sharp details, such as the cottage windows and small tree branches. These details will provide points of interest to heighten the composition.

Expressive effects

USING WASHES IN PASTEL

Water-soluble pastels allow you to both draw and paint at the same time, using delicate, controlled washes combined with energetic brushwork. Working large gives the artist great freedom of expression, with lots of free-flowing painted and drawn marks—ideal for wildlife subjects.

▨ Different glazing techniques

A glaze is a thin veil of pigment painted over another color (or wash) to create depth. How you combine glazes or washes will give different effects in your pastel drawing. Use them to darken, adjust color values, or create form.

Deepening colors
Here, the light underpainting is being darkened with a deeper wash, or glaze, applied over the top. The transparent nature of the glaze creates delicate changes in tone.

Adjusting colors
Use a glaze to subtly mix colors. Here, overlaid primary colors create secondary hues that also adjust the color temperature of the area underneath.

Opaque glazing
By applying a glaze that is more opaque (thicker) over a wash you can create 3D effects within your work. A dry brush technique also helps to suggest texture.

PUTTING IT INTO PRACTICE

The dense, soft feathers of this magnificent owl are rendered by building layers of washes, overlaid with dry applications of pastel, to capture texture and add detail.

You will need

Burnt orange 0260 · Madder brown 1920 · Bark 2000 · Mid vermilion 0310 · Sicilian yellow 0220 · Cadmium yellow 0210 · Tangerine · Thistle 0720 · Bright blue 1000 · Antique white 2300

- Derwent Inktense water-soluble pastels
- Watercolor brush, #8 round
- Flat wash brush
- Watercolor palette with large mixing wells
- Watercolor paper, cold press, 140 lb.

Eagle owl

1 Preparation
Draw your composition, marking the main outlines and darkest tones. Prepare your washes by shaving different amounts of pastel pigment into wells and adding different amounts of water. Mix all the washes before you begin.

3 Layered washes

Build up the painting with rich layers of pigment applied with expressive brushstrokes. Alternate between stronger color and more diluted wash applications, especially in the background, using glazing to vary the tones.

4 Smooth effects

For the smooth feathers, use a dry pastel like a drawing tool to create delicate blends of pigment, one over the other. Use a smaller brush loaded with clean water to move and blend the pastels together on the surface, creating smooth effects.

5 Rough texture

Use side strokes of dry pastel to depict the rougher textures, such as the bark. Layer colors one over the other with dry applications of pastel to deepen colors and create lively textures throughout.

2 Loose painted marks

Draw and paint with the brush at the same time, using lots of linear and flat washes. Allow the colors to merge one into the other to create interesting marks.

> "Glazes and washes mixed from water-soluble pastels produce painterly effects."

Artist **Gail Sibley**
Title **Summer evening in Budapest**
Medium **Unison pastels**
Support **UART premium sanded pastel paper 320 grade**

Layering

≪ See pp.250–51

Layering allows many colors to become part of the piece. Here, yellow, pale blues, purples, and greens are built up to add interest across the picture space.

Aerial perspective

≪ See pp.256–57

Using lighter, cooler colors in the background, with very small shifts in value and little definition or detail in the soft, impressionistic figures, creates the feeling of depth.

Texture

≪ See pp.258–59

A fairly coarse sanded paper grips the soft pastel as you layer it, reducing the need for fixative, and contributing to the textured and broken color effects.

Showcase drawing

This late summer scene, with its cool, raking shadows contrasted with warm autumnal colors, provides plenty of opportunity to practice intermediate techniques. Layers of colors are built up for vibrant notes, and contrasts of texture and value add to the sense of space.

Complementary colors

« See pp.248–49

The red underlayer of autumnal foliage accentuates the complementary green in the trees, making the area vibrant and eye-catching.

Edges

« See pp.254–55

The soft edges around the figures suggest movement, while the hard edges of the tree trunks and their shadows provide sharper definition and contrast.

Warm and cool colors

« See pp.260–63

The cool blue and warm red on this tree trunk reflect both the warmth of the ground and the cool expanse of the sky, linking these areas.

Scumbling

LIGHTLY USING THE SIDE OF THE PASTEL

It takes a really gentle hand to scumble successfully. The pressure you apply must be very light–like a whisper. When you scumble you thinly apply another color over an existing one, so as to create a semi-opaque layer over the color below. The main effects are to add color and texture.

▇ A breadth of varied effects

Scumbling allows the colors beneath to shine through– you're not trying to cover them. Use the side, rather than the tip, of your pastel when scumbling. You can apply the pastel in vertical, horizontal, diagonal, or circular strokes–just remember to work gently.

To cool down
A light blue is weightlessly scumbled (on the right) over the top of a warm yellow base layer to counter its warmth.

To warm up
This deep blue pastel is warmed up by the addition of the ocher color, which has been scumbled over the top (on the right).

To veil with light
Lighten a deep color, for example the red above, with scumbling strokes from a white pastel (on the right side).

To add interest
The introduction of a scumbled lime green over part of the area covered by the turquoise enlivens the visual interest.

Flat areas of color offer a good opportunity for scumbling effects: to lighten and unify, to warm a cool color, and to add interest.

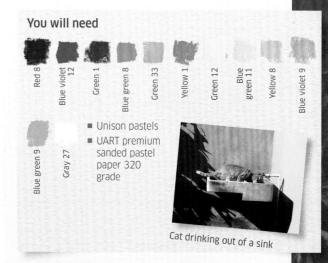

You will need

Red 8 | Blue violet 12 | Green 1 | Blue green 8 | Green 33 | Yellow 1 | Green 12 | Blue green 11 | Yellow 8 | Blue violet 9

Blue green 9 | Gray 27

- Unison pastels
- UART premium sanded pastel paper 320 grade

Cat drinking out of a sink

1 Main values blocked in
Block in the first three value areas. Here, blues were added for the dark and middle values, while a cool green was chosen for the light value area.

2 Adding warmth
In the next layers, add warm greens to the cool blues (on the wall), a warm mid-value yellow and orange-yellow (for the cat), and a pale blue (to the sun-drenched wall).

3 Scumbling to lighten

To lighten the area of wall above the cat (beforehand it may have felt dark and overly busy) scumble using a cool light blue pastel over that area of the wall.

4 Addressing the cool/warm balance

With so much blue shadow, the balance could easily tip into cool. So, boost the warmth in the wall under the sink and along the lower part of the wall with a red.

5 Enlivening the sink

If the sink appears a bit flat, scumble two of the colors used already (the mid-value yellow and the mid-value blue green) in small patches over the concrete basin to add interest.

Creating a visual focus

A JOURNEY THROUGH A DRAWING

All manner of elements work together to create drama, hold attention, and take the viewer on a journey around your drawing. Such elements include composition, size relationships, contrasts of light and dark, the treatment of lines and edges, and perspective and directional lines. Get all of these right and the viewer's eye will wander delightfully over your drawing.

▉ Maintaining visual interest

Dramatic contrasts offer great visual interest to a viewer, and so attract more attention than flatter areas of more even values. In the formal garden (right), uprights offer contrast in size with the low-level hedging, and the recession of color and size reinforces the depth in the drawing to create a compelling scene.

Features that grab attention
Great contrasts add great drama to any composition, but use such devices sparingly or they'll lose their power. Dot areas of high contrast (as here in the colors and values) around the scene to naturally attract a viewer's eye.

Dark values stand out from the crowd

Quieter features
To balance a drawing, some areas must cease to draw attention and almost form the final background for the eye to stop and move elsewhere. Areas of similar low-value colors offer a quietness and emphasize the dramatic elements.

Colors of similar value appear to merge

It pays to try out various viewpoints before settling on the scene with the most visual interest and drama. Here, the central path and hedges help to draw the eye and lead it into the middle distance.

1 Assessing the values
Start with a tonal sketch. Assessing the full range of lights and darks in your composition will help you translate these into colors. On black paper, use a light-colored pastel to create the initial framework, then build up dark tones again with a deep blue.

2 Identifying strong shapes
In this composition, the chosen viewpoint contains "squares within squares" that decrease one inside the other through the composition. Find the strong shapes and draw these first. Mix lighter tints for the hedges, for instance, which become paler as they recede toward the background.

You will need

Green 11

Green 27

Green 1

RD13

Red 12

JS5

Light 1

Permanent green light 618.3

Cinnabar green deep 627.3

Light oxide red 318.3

Burnt sienna 411.5

Turquoise blue 522.8

Phthalo blue

- Unison pastels
- Rembrandt pastels
- Fixative
- Canson Mi-Teintes Touch pastel paper 350gsm (black)

Ripley Castle
rose garden

3 Noticing texture

Give depth and interesting surface texture to forms of a similar value by using different pastel strokes in many directions. Other areas can be more even.

4 Reinforcing perspective

Follow the lines of perspective in the trellis, bricks, hedges, and path to reinforce the depth in the drawing. Ensure colors fade along these lines, too.

5 In the shadows

Placing a dark element against a light one creates drama and leads the eye. Maximize this fact when finalizing the shadows and highlights around the drawing.

Working with shadows

USING DIRECTIONAL LIGHT IN A COMPOSITION

The sun's position at different times of day will dictate how long or short the shadows are in your drawing, whether in a landscape or a still life using natural light. Notice where the shadows fall, using their shapes and tones as part of the composition. The strong contrasts created at midday lead to strong, directional shapes that lead the eye, whereas weaker tones of early evening create diffuse light and shadows that lend atmosphere.

PUTTING IT INTO PRACTICE

The light in this early spring scene casts an intricate pattern of shadows from the trees along the sunlit lane. Carrying cool colors from the sky into the shadows brings a unifying element to the composition.

You will need

- Light set 15
- John's set 10
- John's set 11
- Green 35
- Green 13
- Dark 9

- Red violet 545.7
- Light yellow 201.8
- Violet 536.7
- Prussian blue 508.3
- Light orange 236.7
- Perm. red light 370.9

- White 100.5
- Carmine 318.5
- Madder lake deep 331.3
- Burnt umber 409.7
- Permanent red light 370.3

- Unison pastels
- Rembrandt pastels
- Fixative
- Canson Mi-Teintes Touch pastel paper 350gsm (black)

Village road scene

1 Establishing tones

Loosely draw the main design and composition using a midtone color that will help to unify the different elements of the picture. Note both the highlights and the dark shadows, using negative shapes to draw the shadows of the branches on the lane and the bars of the gate in the foreground.

2 Warm and cool colors

As you develop the painting, use marks in different directions to follow the dappled nature of the light and alternate between warm and cool areas—warm areas in sunlight and cool in the shadows—to help differentiate between them.

Constructing shadows

When composing a scene with strong sunlight, consider the time of day and the position and angle of the sun, and note the corresponding strength and length of cast shadows. These shadows anchor objects in place and set the ambience of the scene when rendered correctly, taking into account the shapes of the shadows, the depth of tone, and the nature of the surface on which the shadow falls.

Shadow shapes
A low sun on the left casts shadows mirroring the shapes of the solid objects, with soft outer edges and darker tones at the base.

Short, dark shadows
At midday the sun is at its strongest and directly overhead, casting the darkest, shortest shadows with stark contrasts between light and shade.

Long shadows
As the sun sinks in the sky in the afternoon, shadows become longer and the colors stronger. Interesting shapes abound where the shadows fall.

3 Strengthening color
Spray your painting with fixative in chosen areas to darken colors and increase depth in shadow areas (see pp.252–53). Use both hard and soft pastels together to create interesting eye-catching layers of color.

4 Increase contrast
Use the darkest darks and lightest lights to sharpen up the composition and increase depth. Assess the shadows and carefully soften the edges with lightly scumbled marks with cool over warm, or vice versa, to blend the transitions.

Drawing people on the move

FOCUS ON FIGURES

One of the most exciting—but challenging— subjects is people on the move and in public spaces. But including people in your work, especially when they become the main focus, can bring a drawing to life. Sketch fleeting passers-by or position yourself in a more static scene where you can change your viewpoint to best capture the interplay between people and their environment.

◼ Observational sketches

When drawing people from life in a busy scene, it's a good idea to take reference photos and make several sketches from different viewpoints to capture changing views and compositional options. Observe the position of the figures, concentrating on spatial awareness, relative scale, shadow, and the proportions of each element, such as chairs or buildings, and using groups or individual figures to lead the eye through the composition.

The strong lines of perspective act as a guide to the scale of figures between the foreground and background

Working quickly
Try not to be daunted by subjects that get up and go while you're in the middle of drawing them. Sketch quickly and do plenty of preparatory drawings in your sketchbook to help you build and decide on a final composition later.

PUTTING IT INTO PRACTICE

You need to work quickly in a busy scene. For such drawings, it's good to simplify shapes and keep detail to a minimum; limiting your color palette, too, is ideal for fast-paced work.

You will need

Violet 536.9 | Phthalo blue 570.7 | Ultramarine light 505.8 | Light orange 236.8 | Permanent red 372.9 | Violet 536.3 | Natural earth 11 | Yellow 10 | Green 11 | Dark 5

RD 13 | Light 1 | Emerald green 46D

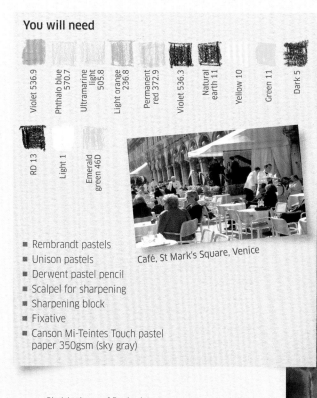

Café, St Mark's Square, Venice

- Rembrandt pastels
- Unison pastels
- Derwent pastel pencil
- Scalpel for sharpening
- Sharpening block
- Fixative
- Canson Mi-Teintes Touch pastel paper 350gsm (sky gray)

Block in shapes of fixed points

1 The basic shapes
Observe the scene and decide on your composition—be selective on what to include or edit out. Block in the basic shapes with the side of your pastels, to create an impression of figures that are seated, standing, and moving. Keep figures and objects loose but in proportion to the surroundings.

2 Adding structure

Refine your drawing, focusing on tone, shapes, and color. Observe how the light falls and place shadows loosely, especially those of the figures, anchoring them to the ground. Keep shadows light and balance the scene as a whole.

3 Interplay between figures

Pay attention to the angles of the figures—seated, standing, or moving—to develop relationships between them, using negative shapes between light and dark to help position different elements. Strengthen tones in the foreground to give depth.

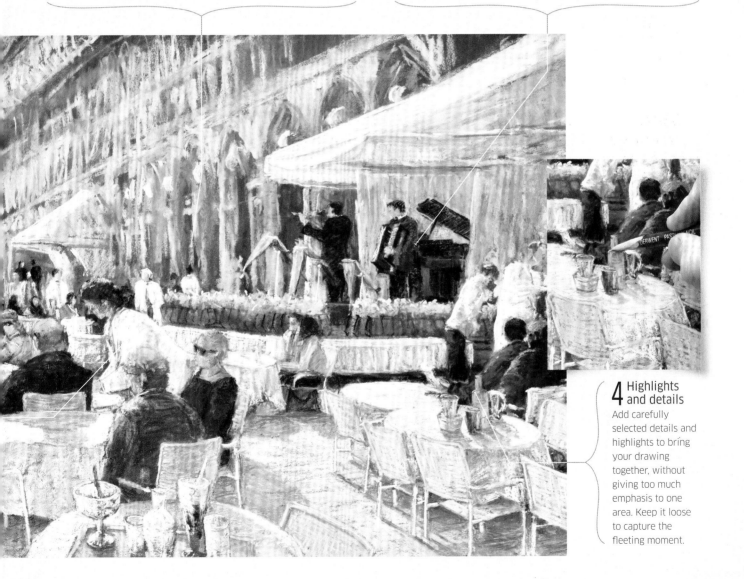

4 Highlights and details

Add carefully selected details and highlights to bring your drawing together, without giving too much emphasis to one area. Keep it loose to capture the fleeting moment.

Impressionistic buildings

ADDING ATMOSPHERE TO CITYSCAPES

Blended layers using soft and hard pastels give solidity to an urban landscape, while still being impressionistic. Hard lines and masking techniques define solid shapes, and a limited palette brings overall harmony. A high vantage point overlooking a part of the city adds to the drama.

◼ Defining forms

Buildings are naturally three-dimensional, and you can convey their shape and tone using strong contrasts between the solid, defined edges in the foreground and the lighter background. Shadows are key to defining shapes, so note where edges are sharp and anchored to the subject, or soft and graduated where they fade.

High-contrast forms
When a dark form overlaps a lighter shape it clearly stands out. In doing so it appears deeper in tone, and the difference between the light area and the dark mass is quite dramatic. This is known as high contrast.

Low-contrast forms
When a light form seems to merge or fade one into another, this is known as low contrast. The buildings in the background are low contrast since many merge into the sky behind them at the end of the street.

PUTTING IT INTO PRACTICE

Create an atmospheric drawing by blending blocks of color. Define hard shadows and lines with straight-edge masking, and add crisp details at the end to bring it together.

You will need

Light yellow 201.5
Deep yellow 202.7
Deep yellow 202.5
Cap mort. red 343.8
Cap mort. red 343.7
Indian red 347.3
Brown earth 11
Red earth 11
RD13

Indian red 347.5
"Additional color" 61
Ultramarine deep 506.5
Ultramarine deep 506.3
Gray 28
Red 6
ZF27

- Rembrandt pastels
- Unison pastels
- Masking tape
- Fixative
- Printer paper
- Canson Mi-Teintes Touch pastel paper 350gsm (black)

New York City view

1 Intense blocks of color
Draw everything in proportion. Concentrate on the main areas and be very direct. Blocki in large areas of rich color using a limited palette of hard and soft pastels. Apply soft strokes with the side of the pastels.

2 Blending layers
A surface loaded with pigment helps additional color to blend together. Use energetic marks one over the other rather than blending to utilize the surface to imply texture.

> "A reduced palette and **tonal contrasts** give **drama** and **ambience** to a cityscape."

3 Modeling forms
Switch to hard pastels to render the illusion of light and dark planes and facets, adding definition to the edges of solid forms in the foreground, such as the corner angles on buildings and rooftops.

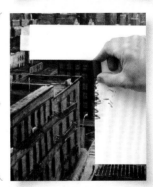

4 Sharp edges
For a crisp edge, such as the side of a building, use masking techniques with perfectly cut thin paper—printer paper works well. Hold it in place with masking tape and run the pastel down the edge of the paper.

5 Darkening shadows
Use lots of fixative to darken shadows at their anchor points but less at the outer edge of the shadows to blend tones and imply transparency.

6 Final details
Define small details, such as street markings, with the sharp edge of a hard pastel to give a few points of interest.

Textured surfaces

DRAWING WITH PASTEL ON WOOD

Wood is a versatile support and offers the pastel artist several options for adding texture to their drawing. Use light strokes on a coarse, grainy surface to create broken effects, or build areas of intense, smooth color where multiple layers of pastel become embedded in the grain. A plain wood background adds visual interest, too.

Preparing a wood support

You can construct a wooden canvas using off-cuts that are a similar depth. Most types of wood are suitable, and the rougher the grain, the more texture you can convey. Scrub the wood clean before you begin. For a gray, weathered look you can stain the wood with a wash of strong tea, followed by ironed vinegar (made by steeping iron wool in white vinegar for a few days).

Attach to battens
Select your pieces of wood, cutting them to size if necessary. Clean and prepare the pieces, staining them if desired. Position the pieces over wooden battens and nail the pieces to the battens from the front of the support.

Nail from front to back

Prime the support
Apply a layer of acrylic ground primer to the wood with a large paintbrush. This will prepare the surface to take applications of pastel where you want to achieve a coarse finish. Allow to dry. Attach hooks to the battens to hang your pastel drawing.

Cover the entire surface

The rustic nature of the wood panel complements the subject of this drawing perfectly. Layers of intense color are used for the vibrant plumage.

You will need

| Orange yellow 103 | Deep yellow 125 | Light orange 135 | Burnt carmine 265 | Wine red 223 | Vermilion 215 | Dark ocher 183 | Violet 390 | Violet 100 | Red 180 |

| Red 120 | Red 010 | Green 570 | Green 590 | Green 310 | Green 505 | Blue 350 | Violet 210 | Turquoise 070 | Turquoise 130 |

| Violet 055 | Carmine 318.7 | Carmine deep 318.3 | Ultramarine light 505.9 | Bluish green 640.5 | Ultramarine deep 506.5 | Ultramarine deep 506.2 | Prussian blue 508.2 | Indian red 347.2 | Black 700.5 |

- Mungyo pastels
- Terry Ludwig pastels
- Rembrandt pastels
- Acrylic ground primer
- Bristle brush
- Tea and ironed vinegar
- Rubbing alcohol
- Paintbrushes
- Fixative
- Wood support

Cockerel

1 Underpainting
Prepare the wood surface with primer. Lightly sketch the outline of the cockerel. Block in the main colors, starting with the darkest colors to cover the wood support and provide the base layers.

Shards of hard pastel were used to add fine details

Optical color mixing of yellow over red creates vibrant orange

Solid colors were created by embedding pigment in the grain

Pale wood support prepared with acrylic ground

2 Building layers
Work over the initial base layer with medium and firm pressure to build the color, pushing the pigment into the wood grain. Apply a wash of rubbing alcohol to embed the colors, starting with the lighter tones.

3 Optical mixing
Spray with fixative so that you can continue to build color. Vary your strokes, using a feathered effect for optical mixing in some areas to add vibrancy and texture. Use hard pastels to blend the softer layers.

4 Soft highlights
Use daubs of soft pastel to create bright highlights for the speckled pattern on the breast feathers. To avoid muddying colors, use a stiff bristle brush to lift off the highlights first, if necessary. Keep building layers of color, working dark to light and blending on the wood– you don't need to smudge with your finger because the wood will accept lots of pigment.

5 Scumbling
Using light, directional marks, apply scumbled strokes of paler pastels to describe the highlights on the feathers, both on the body and tail. These irregular layers will allow broken patches of the underlying solid colors to show through to add visual interest and additional variety.

"A grainy surface adds to the textured effect, providing a base for building multiple layers of rich color."

Skin tones

THE SUBTLETIES OF DRAWING SKIN COLORS

Conveying skin tones is all about observing. There is a vast array of tones, from light and pale to deep and dark, with temperature, light, borrowed color, and context all contributing to making each skin tone as individual as the sitter. To create a skin tone palette, look for warm and cool colors, and establish a color range, such as yellows and greens in olive skin, or purples and blues in very dark skin, from which to build a natural effect.

▦ Assessing skin tones

Evaluating the color of skin is no different from evaluating the color of any subject you wish to paint. First, determine the local color–the actual color of the skin–then decide how dark or light it is, and how saturated or muted the colors are. Choose a range of colors to match.

Pale skin tones · Olive skin tones · Dark skin tones · Medium skin tones

Pale skin tones

Tonal sketch

Even when conveying pale skin, it helps to make a tonal plan to establish the main three tones. Here there is a high proportion of highlights in the hair and where the light reflects on the skin.

Pale, cool colors are found in the shadows

Warm, light tones suggest the translucent skin

| Red 18 | Red 17 | Red 16 | Brown earth 28 | Orange 17 | Orange 18 | Red earth 9 | Red earth 10 |

| Red earth 7 | Red 12 | Red 5 | Red 9 | Red 14 | Red earth 11 | "Additional color" 52 | Blue green earth 8 |

| Blue green earth 16 | Blue green earth 12 | Blue green earth 7 | Blue violet 7 | Blue violet 8 | Blue violet 9 | Blue violet 10 |

A light palette

The translucency of pale skin means you can see the effect of blood vessels and hair growth below the surface. Combine warm reds and cool blues and greens to create a pale skin tone. Note that shadow areas are still quite light; you won't need very dark colors.

Olive skin tones

Carry some skin colors into the hair

A range of warm midtones include soft browns

Warm yellow green earth used in midtones

Tonal sketch
The main darks in this study are found in the hair, eyes, and lips. The skin is a relatively uniform midtone, but carefully observe the colors that are found in shadows and highlights to describe form.

Brown earth 25	Orange 17	Red earth 8	Red earth 9	Brown earth 28
Brown earth 29	Yellow 1	Yellow green earth 11	Yellow green earth 9	Blue green earth 16
	Red earth 12	"Additional color" (AC) 15	Red 9	

An olive palette
Olive skin tones are based on warm reds with a tendency toward muted browns, with the addition of yellows and warm greens for midtones and highlights. The modeling on the cheeks and nose uses deep red that balances the lips and dress.

"Light always affects the appearance of skin tones. Be observant rather than relying on a formulaic palette, noting the subtleties of your subject."

Dark skin tones

Tonal sketch

Although dark skin means a lot of dark colors, it is still possible to note the different tones. In general, there will be very few lights used, but they are present in the highlights.

Warm red earth provides a midtone

Cool greens and blues convey facial hair

Deep blue violet describes cool shadows

Gray 27	Brown earth 25	Brown earth 26	Brown earth 28	Brown earth 29	Red earth 12	Red earth 11	Red earth 9	Red earth 8	Yellow green earth 18
Blue green earth 16	AC 52	AC 51	Blue violet 9	Gray 8	AC 35	Blue violet 6	AC 28	Red 15	Red 16

A dark palette

Dark colors of warm browns and cool purples and blues are the basis of the dark skin palette. A warm red makes an appearance; it may be muted in the skin and brighter in the lips and nostrils, and corners of the eyes. Dark blues and purples combine for the darkest tones.

Brown skin tones

Tonal sketch

Even when the subject is bathed in light, you can still discern areas of dark, mid, and light tone. The highlights are quite bright in contrast to the greater range of midtones in medium skin.

Brown earth 25	Brown earth 27	Brown earth 28	Brown earth 30
AC 29	Red earth 10	Red earth 9	Blue violet 8
Blue violet 9	Gray 2	Gray 8	Blue green earth 8
Gray 13	Blue violet 3	Red 14	Red 15

A brown palette

Although predominantly warm with muted reds and warm browns, this palette has cool notes of blues and greens. There is a greater range of midtones and the darks will not extend to your darkest colors. Highlights contain soft, earthy yellows and pale blues.

Dark hair contains warm tones

Blue violet is used for cool reflected light

Small amounts of red earth for warmth

Warm browns combine for midtones

Finished portrait
The warmth of the portrait is enhanced and complemented by the cool background.

Drawing water
CAPTURING STILL AND MOVING WATER

Water can behave in many different ways—mirrorlike still ponds or choppy and stormy seas, with rivers, streams, and tidal currents somewhere in between. The time of day, direction of light, weather, and any visible currents will all have bearing on the colors, patterns, and shapes that are reflected in still and moving water.

■ Water surfaces with and without reflections

Water mass and surface reflection are inherently affected by what moves the mass (such as a tidal force or underwater current) or by what moves or disturbs the surface, such as wind or an object (a boat for instance) moving through it. Correct observation of the surface patterns, the direction of light, and colors within the water will create drawings of greater conviction.

Perfectly calm
Here, the water is near perfectly smooth and reflections are almost mirrorlike. The tones of reflected colors appear slightly more muted, but shapes of solid mass are mirrored almost exactly, with little distortion.

Slightly rippled surface
Where a breeze or object has disturbed the water, reflections are refracted and the rippled surface is broken. Loose or scumbled lines convey this effect, and reflections are more diffuse but still visible.

Disturbed surface
Waves and ripples create an uneven surface that can cause reflections to disappear completely. However, look for colors of refracted light on the water surface, carrying scumbled glazes from the sky.

MOVING WATER

The canals of Venice offer the perfect opportunity for practicing techniques to draw water that's in constant motion—due to passing boat traffic, sea winds, and currents.

1 Initial shaping
Begin by placing the local colors in the correct areas of your drawing. At this stage keep the marks loose and suggestive, which will convey a wonderful energy, rather than trying to hone in on any details. Bold colors work well here on the black paper ground.

> "Pay attention to **surface patterns,** directions of **light,** and the **colors** within the water."

You will need

Blue green 4	Blue green 12	ZF34	Red earth 14	RD13	Green 27	Green 30	Blue violet 4	Blue violet 8	Blue violet 9
White 101.5	Light yellow 201.5	Deep yellow 202.7	Brown ocher 57B	Ultramarine light 505.7	Ultramarine deep 506.5	Cap mort red 343.9	Raw sienna 234.5	Permanent red deep 371.9	Permanent red deep 371.5

- Unison pastels
- Rembrandt pastels
- Derwent pastel pencil
- Fixative
- Canson Mi-Teintes Touch pastel paper 350gsm (black)

Grand Canal, Venice

2 Directional strokes

Define the solid forms using directional strokes of different widths and colors. Apply side strokes of muted grays to build the soft reflections in the middle and far distance, and add depth to the water.

3 Fix then scumble

Apply fixative to hold the layers of underpainting in place. Apply lighter and midtone pastels in different directions to follow the broken light on the water surface, noting the direction of the tidal water as you work.

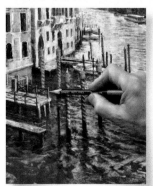

4 Final definitions

Add final highlights and work over the whole spectrum of colors. Pay attention to the wave patterns in the foreground and the darker depth of water within them. Redefine any sharp details with pastel pencils if necessary.

>

CALM AND REFLECTIVE WATERS

Pools of still water offer spectacular reflections and a variety of surface features. Here, the bright reflection contrasts dramatically with the deep, dark reflected shapes of the palms. Color choices depend on the time of day and season; this spring scene was taken mid-morning, so the colors are sharp, crisp, and saturated.

You will need

Blue violet 9
RD13
Green 30
Green 27
Green 36

Light yellow 201.5
Turquoise blue 522.8
Burnt sienna 411.9
Light orange 236.5
Cinnabar green deep 627.3
Permanent red 372.10
Permanent red light 370.5
Ultramarine deep 506.5
White 100.5

- Unison pastels
- Fixative
- Canson Mi-Teintes Touch pastel paper 350gsm (black)

A deep reflective pool

1 Sunlight and shade

Establish the areas of light and shade using warmer tones in the foreground and cooler tones in the background. Include the dark shadows of the palms, noting the mirrorlike reflection, contrasting with bright highlights. Apply strokes in different directions, alternating between the warm and cool areas. Keep the marks loose and varied at this stage to create an overall impression.

2 Intensifying color and shape

Focus on the lightest lights and the darkest darks and then all the midtones in between. Build up layers of different colors one over the other, using the tips and sides of the pastels. Use fixative and allow it to dry between pastel applications. Since the eye tends to follow the direction of the strokes, use downward strokes for deep reflections, like the palm trunk and fronds, and work across for the lighter surface reflections.

3 Surface details

All the layers that have been applied up to this stage will have created the illusion of depth in the water. Now work on the actual surface features, adding a glow to convey sparkle and light. Scumble warmer tones in lighter, soft pastels across the surface, using the side of the pastel and keeping the colors broken so that the deep water beneath is still visible.

4 Final adjustments

Assess your drawing in light of making the last tweaks–boosting dark tones and adding highlights, as well as using complementary colors to emphasize certain features, such as the pale yellow waterlilies against the pale violet water. Use bright dashes of red for the goldfish, to draw the eye through the dark passages of color and add points of visual interest.

"By choosing a **high horizon** you increase **the emphasis** on the area within the pool's reflection."

Moving to abstraction

SIMPLIFYING AND INTERPRETING

One way to work more abstractly is to take a subject—a landscape, a figure, or a still life—and simplify it by eliminating detail to discover the underlying forms. Move away from realism by experimenting with alternative colors and interpretative marks.

▨ Experimenting with abstract

Choose an image and make thumbnail sketches of various crops using simplified shapes to convey tonal detail. Experiment with color options, changing the key, temperature, or values.

Original reference

Thumbnail sketch
Simplify the landscape, looking for lines, shapes, and patterns, and translating color into monochrome.

Natural color study
Try out a color scheme, blocking in light and shade in shapes of color. These colors are closely based on the photograph.

Bold color study
Now try colors that you don't see in nature. Don't hold back—an unusual color palette is a move toward abstraction.

The strong vertical lines and contrasts of light and shade in this woodland scene translate well into an abstract palette of bold colors and free marks.

You will need

Yellow 10 Red 12 Green 12 Green 33 Green 9

Blue green 8 Blue green 7 Red 9 Red earth 12 Gray 13

- Unison pastels
- UART premium sanded pastel paper 400 grade

Dappled woodland

1 The color palette
Choose your palette and get the base colors down. Here, bands of warm reds and oranges contrast with cool greens and blues. Solidify colors by brushing with a paper towel.

2 Overlay marks
On top of the brushed base, add loose, broken marks for impressions of light, using the same colors applied in the initial layer.

3 Add the verticals
The tree trunks enhance the feel of the crop and format. Add the essence of the vertical lines in random, quickly applied marks.

4 Move beyond the photo
Add your own interpretation of colors to the lower part of the drawing not seen in the reference. Listen to the drawing—what do you feel it needs?

Title **Stilt houses on Lake Inle, Myanmar**
Artist **Gail Sibley**
Medium **Unison pastels**
Support **UART premium sanded pastel
paper 320 grade**

Impressionistic buildings

<< See pp.276–77

Rather than draw a row of similarly colored buildings, varied colors were liberally added across the drawing, using impressionistic marks.

Scumbling

<< See pp.268–69

The vastness of the sky cries out for variety in the colors used. Here, different shades of light blue are scumbled over the base color of a similar-value yellow.

Drawing water

<< See pp.286–89

The still water of this massive lake allows for beautiful reflections that are broken up slightly by the ripples made as the boat moves over its surface.

Showcase drawing

This unusual but vibrant scene in Myanmar conveys the energy of what is going on, using different techniques from the advanced section. The linear perspective used relates the artist's viewpoint and helps lead the eye around the scene, while the figures add further visual focus.

Creating a visual focus

≪ See pp.270–71

In this drawing, the eye is led up the rooftops to the right then back to the left by way of the receding buildings and the direction of the boats. It's an all-engaging scene.

Working with shadows

≪ See pp.272–73

Even though the shadow on the underside of the boat is dark, the water reflects light back onto it, warming and lightening the colors in it.

Drawing people on the move

≪ See pp.274–75

The figures in this scene, loosely sketched in action, give life and character, as well as a narrative focus to the scene.

Glossary

*Terms with their own entry are given in **bold** type.*

Analogous colors
Groups of colors that are next to each other on the color wheel, including a primary, a secondary, and a tertiary color.

Aerial perspective
The illusion of depth, especially in landscapes, where distant objects appear lighter and cooler in tone, compared to darker, warmer, and more detailed foreground objects.

Backlit
When objects are lit from behind, throwing features into shadow to create an atmospheric composition.

Blending
A drawing method in which two colors gradually merge together.

Blocking in
Applying areas of color to a drawing to establish the main areas of light and dark **values**.

Braceletting
See **Cross-contour**

Chiaroscuro
Contrasting light and shade in a drawing to add drama.

Cold press paper
A textured paper with a rough surface that holds pigment well and is good for detail. Also known as NOT for not **hot press**.

Color bias
The warm and cool properties of a color in relation to similar hues. Cadmium yellow deep has a warm, orange bias, while lemon yellow has a cool, green bias.

Color temperature
How warm or cool a color is perceived to be. The **color wheel** is divided into warm reds and yellows, and cool blues.

Color wheel
A way of arranging colors to show the relationship between **primary**, **secondary**, **tertiary**, and **complementary colors**.

Complementary colors
Pairs of colors that are found opposite each other on the **color wheel**: red and green, yellow and purple, blue and orange.

Composition
The unified whole of all the elements of an image.

Cool colors
Colors with a bluish tone. They appear to recede in a picture, so can be used in **aerial perspective**.

Contour
A line that is drawn around a curved form to create an illusion of three-dimensionality.

Cross-contour
Marks inside the contour that emphasize three-dimensional rounding or angled surfaces.

Crosshatching
Drawing criss-crossed lines to create areas of density and tone.

Dark to light
Working from a dark tone to a light tone by layering colors. Can be achieved by **lifting out** tones in graphite or charcoal drawings.

Desaturated color
A color that has been dulled by adding some of its complement. Any mix of two **complementary colors** is a "color gray."

Dynamic composition
Using strong diagonal lines to convey energy and excitement.

Edges (hard and soft)
The method of defining a subject with either clear, crisp (hard) edges, or blurred (soft) edges, achieved with different media.

Feathering
A technique using light tones or lines to make subtle transitions between colors and soften edges.

Focal points
Areas with more visual impact that help create a visual path through a composition.

Foreshortening
A perspective effect whereby a line or form is drawn shorter than its real length in order to create an illusion of recession or projection.

Form
The solid, three-dimensional shape of an object.

Glazing
Applying transparent layers or washes of color.

Graphite
A form of carbon that is mixed with clay and water and fired to make a drawing tool; encased in wood, it makes a pencil.

Hatching
A series of parallel lines drawn to indicate shadows and form. A range of effects can be achieved by varying the weight, length, direction, and angle of lines.

Highlight
The lightest tone. It can be achieved by leaving the paper white, **lifting out** tone with an eraser, or adding white accents.

Hot press paper
Paper with a very smooth surface, that is suited to pencil or pen and ink drawings, or laying washes.

Hue
An alternative word for color.

Key
The overall **value** of a painting: a light painting has a high key, while a dark one has a low key.

Layering
The method of laying one color over another to build depth or tone, or enrich colors.

Lifting out
Removing charcoal marks with an eraser to draw into existing tones to create highlights and contrasts.

Light to dark
A method of layering color from light to dark tones.

Linear perspective
A way of creating the illusion of three dimensions and depth by showing that parallel lines appear to converge in the distance.

Masking fluid
A latex fluid that is painted onto paper and **resists** media drawn over it, preserving the paper.

Medium
Used to describe materials used to draw, such as pencil, charcoal, pen and ink, or pastels.

Midtones
The range of tones between the lightest and darkest.

Modeling
A method of using tone or color to convey three-dimensional forms through light and shade.

Monochrome
An image made with a range of shades and tints of one color.

Negative space
Used to describe the shapes between objects; is as important in a composition as **positive shape**.

Neutral colors
Colors that do not appear on the **color wheel**, including white, black, gray, and brown earth tones.

Palette
Used to describe a set of colors chosen for a drawing or painting.

Perspective
The method of creating a sense of depth on a flat surface through the use of **modeling**, **linear**, and **aerial perspective**.

Picture plane
The drawing surface imagined as a window through which a scene is viewed and drawn onto.

Pigment
Particles with inherent color that can be used in drawing and painting media; usually mixed with some kind of binder.

Positive shape
The outline shape of an object that gives it form.

Pressure
The degree of exertion when mark-making, which affects the strength and density of the mark.

Primary colors
The three colors—red, yellow, and blue—that cannot be made by mixing other colors. Mixing two primary colors together makes a **secondary color**.

Primary source
An original sketch, photograph, or reference created by the artist and used to draw from.

Rag paper
A handmade paper made from cotton rag that has a natural color and textured surface.

Recession
Moving from the foreground to background. A sense of depth can be created through perspective and warm and cool colors.

Resist
Applying a material that repels pencil, ink, or a wash to preserve highlights on the paper beneath.

Rule of thirds
A compositional aid that divides a picture into thirds horizontally and vertically to make a grid. Points of interest are placed on the "thirds" lines, and focal points on the intersections.

Sanded paper
A heavily-textured paper ideally suited to pastel since its surface will accept multiple applications of both hard and soft pastels.

Saturation
The intensity and purity of a color when applied to a surface.

Scale
The relationship of sizes of elements in an image.

Scumbling
A method of applying irregular layers of color to a surface so that patches of the underlying color show through.

Secondary colors
Colors on the **color wheel** made by mixing two **primary colors** together. They are: green (mixed from blue and yellow), orange (mixed from red and yellow), and purple (mixed from red and blue).

Secondary source
A reference material sourced and used by the artist to draw from, but not original to them.

Sgraffito
A way of scratching the surface layer to reveal a contrasting color or the paper beneath.

Shade
A color darkened with black.

Shading
The technique of adding form and shape to objects through mark-making by varying the pressure or density of marks.

Shadow
An area of darkness on an object or cast by it.

Shadow shapes
The shapes of shadows, which can be used to define areas of tone in a drawing.

Stippling
The method of applying small dots or dashes to describe form and tone, or build an area of color through optical mixing.

Stump
A stick of tightly wound soft paper with a point that is used to blend, smudge, lift out, or draw into charcoal.

Support
The surface onto which a drawing is made, such as paper or wood.

Tertiary colors
The colors between the **primary** and **secondary** colors on a **color wheel**. They are created by mixing a greater proportion of a primary color into a secondary.

Thumbnail
A small preparatory sketch used to assess the main elements of a composition in terms of line, tone, and color.

Tint
A color lightened with white.

Tone
The relative lightness or darkness of a color, and gradations of light and dark **values** in a picture.

Tooth
The surface texture of paper. Some media, such as charcoal and pastels, require paper with a heavier tooth to hold the pigment.

Tortillon
Similar to a **stump**, but thinner.

Underdrawing
An initial base drawing, often in monochrome or soft pencil, to establish the main components of the composition.

Value
The tonal position of colors on a scale from light to dark.

Vanishing point
In **linear perspective**, this is the point in the distance at which parallel lines appear to converge.

Viewfinder
A device—often made of two L-shaped pieces of cardboard—to help frame or isolate elements of a subject to aid composition.

Viewpoint
The position chosen by the artist from which to draw a scene or subject. It may be bird's-eye, worm's-eye, or human-eye level.

Warm colors
Colors with a red or yellow **tone**. Warm colors appear to come forward in a picture and can be used to create **aerial perspective**.

Watercolor paper
A quality paper produced for watercolor painting that can also be used for drawing. Smooth, **hot press** paper is suitable for use with pencil; **cold press** paper has a rougher surface that is better suited to charcoal and pastel drawings, or for adding textural effects in pen and ink.

Wet-into-wet
Adding layers of wash, ink, pastel, or water-soluble pencil onto wet paper or a wash that is still wet. This produces soft, blurry edges.

Wet-on-dry
Adding layers of wash on top of color that has already dried. Painting in this way produces vivid colors with strong edges.

Index

About the artists

Cynthia Barlow Marrs is an elected member of the Society of Graphic Fine Art–The Drawing Society, the UK's only society dedicated exclusively to drawing. She served on the SGFA Council and was responsible for digital media. Based in England, Cynthia takes part every year in group exhibitions in Windsor and London, and shows her work in solo and group exhibitions in and around the Thames Valley. Her drawings appear in the book *Pen and Ink: Contemporary Art, Timeless Techniques* by James Hobbs. Cynthia's location drawings were featured in the Summer 2016 issue of the American magazine *Drawing*. Cynthia's art is held in private collections internationally.

Cynthia wrote and created all the artworks for the pen and ink chapter except pages 152–53; her work also features in the Basics section on pages 11, 15, 22–23, and 28 (top).

Graham Brace was a graphic designer for 30 years before becoming a full-time landscape artist and illustrator in 2000. His recent work focuses on the varied natural forms and patterns found within the smaller corners of the landscape. A founding member of the UK Coloured Pencil Society (UKCPS), he lives and works within the Pembrokeshire Coast National Park, Wales.

Graham contributed the colored pencil technique on pages 198–201.

Malcolm Cudmore led an eclectic early career as a musician, actor, arts administrator, and professional magician before finding contentment as a full-time artist and tutor. Based in the beautiful Waveney Valley on the Norfolk/Suffolk border in the east of England, he specializes in well-observed representational art. His subjects include the landscape and water, rural animals, and people. Painting and drawing directly from the subject where possible, he is inspired by Old Dutch masters, artists of the 19th and early 20th centuries, and many contemporary realists. He is a UKCPS silver medalist.

Malcolm contributed the colored pencil techniques on pages 170–75, 178–79, and 186–87, and the showcase drawings on pages 192–93 and 204–205.

Robert Dutton, BA, POST DIP ADV, worked for more than 25 years as a graphic designer and illustrator before becoming a full-time fine artist. His pastel and mixed media paintings have received several prestigious awards. He is a regular feature writer for *The Artist* magazine, and teaches at home and around the world. Robert is represented by several galleries throughout the UK and features in numerous exhibitions and shows, including The Pastel Society at The Mall Galleries in London.

Robert contributed much to the pastel section, with the beginner showcase drawing and techniques on pages 216–17, 218–19, 220–21, 240–41, 248–49, 252–53, 256–57, 258–59, 260–61, 262–63, 264–65, 270–71, 272–73, 274–75, 276–77, and 286–89.

Katarzyna Kmiecik is a professional artist, illustrator, and architect from Poland. She was born in Puławy and studied architecture at Warsaw's University of Technology. In August 2012, she founded an art school, "KRESKA," where she has been teaching perspective drawing to teenagers and adults ever since.

Katarzyna provided the drawings on pages 48–49, also shown on pages 12–13.

Mark Langley, based in Derbyshire, England, gathers much inspiration from the Peak District National Park. He is best known for his colored pencil work—which has been described as "photo realistic expressionism"—and his particular part-drawn style.

Mark contributed the colored pencil technique on pages 190–191.

Ashley Mortenson is a practicing physician in addition to being an artist. She received her MFA from Pratt Institute, New York, in 1998. After years of being in medicine, she returned to her first love, art, in 2016. She primarily works in pastel on paper and reclaimed fence wood. She enjoys drawing things that you can find in your own backyard.

Ashley wrote and supplied artworks for the pastel techniques on pages 222–23, 250–51, and 278–81.

Kate Parkin graduated from Camberwell College of Art with a degree in metalwork and silversmithing. Since then she has worked for 20 years within the publishing industry as a feature writer and stylist for interior magazines. Kate has recently refreshed her drawing skills and embarked on a book illustration course. Her work predominantly uses watercolor and colored pencils.

Kate developed the content for and wrote the basics section, pages 10–29, and created the drawings on pages 14 (left) and 19.

Charlie Schaffer completed his Fine Art: Painting degree at the University of Brighton in 2014. Charlie now lives and works in a studio in Whitechapel. He has exhibited in many exhibitions, including the Royal Society of Portrait Painters exhibition and with the London Group. He has been awarded a variety of prizes, including the Young Artist of the Year Award at the Lynn Painter-Stainers Prize 2014, and was shortlisted for the EWAAC Japan award 2017. He has also appeared twice on Sky Arts' *Portrait Artist of the Year*.

Charlie wrote and supplied artwork for the pen and ink technique on pages 152–53 and for colored pencil techniques on pages 176–77, 182–85, 188–89, 194–95, and 202–203.

Gail Sibley loves and is known for her work in vibrant colors. She passionately believes that understanding values will lead to freedom with color. Born in Jamaica, Gail graduated with a BFA then completed an MA in Art History from Queen's University, Canada. She has exhibited nationally and internationally, and collectors of her work can be found worldwide. Between painting and teaching (in person and online), Gail writes a highly regarded blog at HowToPastel.com. She lives in Victoria, Canada.

Gail developed the content for much of the pastel chapter, and wrote and supplied artworks for pages 224–25, 226–27, 228–29, 230–31, 232–33, 234–35, 236–37, 238–39, 242–45, 246–47, 254–55, 266–67, 268–69, 290–91, and 292–93. Her work is also shown on pages 22–23.

Katie Sollohub is a Sussex-based artist interested in documenting and recording the places she lives and works in through drawings, paintings, performance, photography, and poetry. She maintains a daily drawing practice, both digitally and on paper. Katie is also an inspirational teacher, using her own experiences and processes to help motivate others in their creative work.

Katie supplied the digital drawing text and digital artwork on page 27.

Rupert Smissen is an illustrator currently living and working in London. He studied at Norwich University College of the Arts, where he received a First-Class Honors degree in Illustration. He likes drawing, has pencils, and will travel.

Rupert drew the image for the book's jacket as well as the colored pencil technique on pages 196–97.

Jake Spicer is an artist, author, and drawing tutor based in Brighton, UK. He is head tutor at the independent drawing school Draw and is co-director of The Drawing Circus. Jake's personal work is primarily focused on portraiture and figure drawing.

Jake developed the content for the basics, pencil, charcoal, and colored pencil chapters; he wrote and supplied artworks for the entire pencil chapter except pages 48–49 and the whole of the charcoal chapter, and the beginner colored pencil showcase on pages 180–81. In addition, his life drawing features on page 14 and one of his sketchbooks on page 23.

Acknowledgments

The publisher would like to thank Kevin Johnston for permission to reproduce his photograph, which inspired the artwork on pages 222–23; Mark Vangrunsven for permission to use his cockerel photo on pages 278–81; Ofelia Warren for use of her photograph on page 283; and Craig Boyko for use of his photograph on pages 284–85. We are also grateful to Graham Webber, who worked on the companion title *Artist's Painting Techniques*, for help and advice during the planning stages of this book; Gary Ombler for additional photography; Corinne Masciocchi for proofreading; Vanessa Bird for indexing; and Emily Reid in the DK media archive.

Picture credits: Michelle Jacques / Photo: Craig Boyko © Art Gallery of Ontario (284 top right)

All other images © Dorling Kindersley Limited
For further information see: www.dkimages.com